The Photographer's Guide to
LIGHT

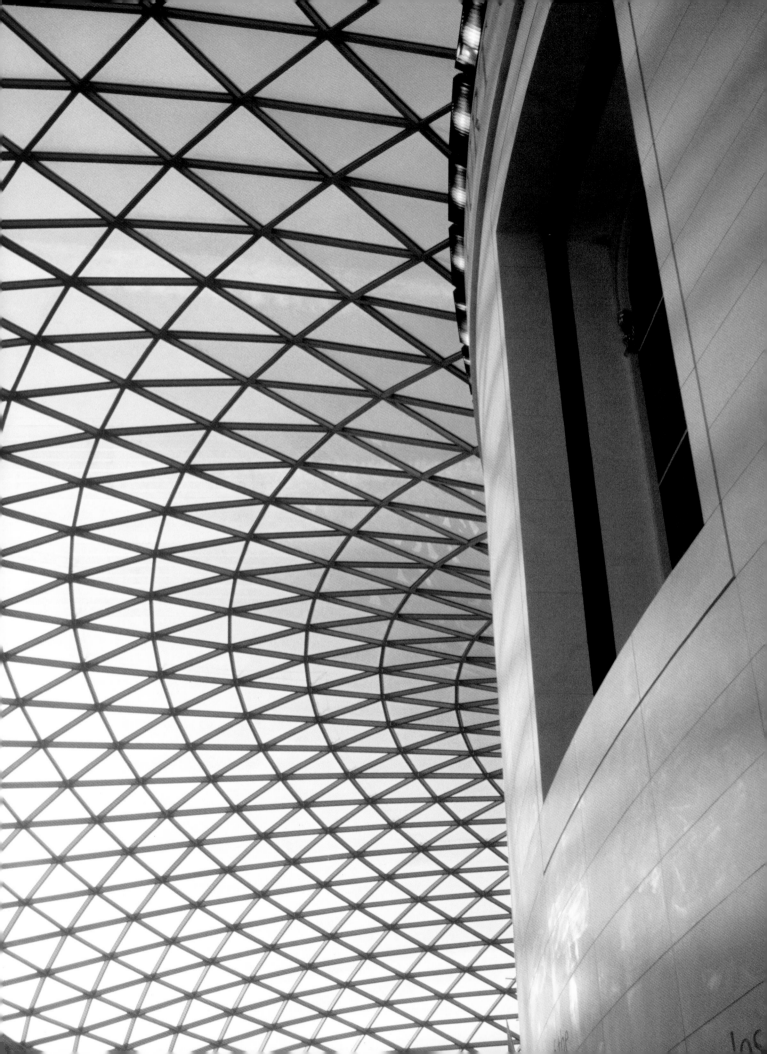

The Photographer's Guide to
LIGHT

Nigel Hicks

David and Charles

ACKNOWLEDGEMENTS

The author would like to thank Mifsud's Photographic, of Brixham,
Devon, Great Britain, for their kind assistance in loaning a number
of pieces of equipment to test during research for this book.

Great thanks are also due to Bjorn Thomassen and Peter Phelan
for provision of a few of their superb portrait and still life images
for inclusion in this book.

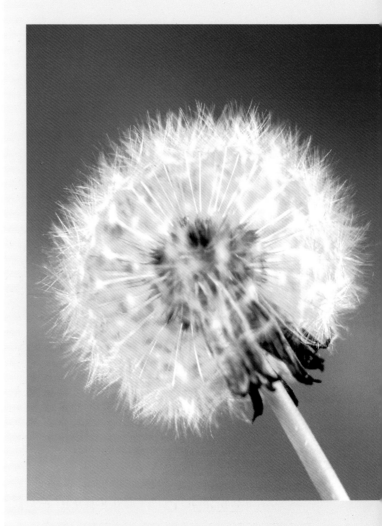

▲ The seedhead of a dandelion flower, photographed against
a sheet of orange paper. A single flashgun illuminated the
seedhead from the right, while another flashgun was used to
illuminate the background. *Mamiya RZ67, 110mm lens, ¹⁄₃₀
second, f/8, Fujichrome Provia 100F.*

(PAGE 2) A dramatic image of a part of the British Museum's
Great Court, showing a section of the library wall and some of
the glass roof, an all too rare instance of indoor photography
using daylight only. *Canon EOS 5, Sigma EX 28–70mm lens
with polarizing filter, ¹⁄₄₅ second, f/11, Fujichrome Provia 100F.*

CONTENTS

Introduction

What makes a great photograph? It is a question that any serious photographer, amateur or professional, is likely to keep asking themselves over the years, no matter how skilled and inspired they may become. I am unsure whether there is a definitive answer; beauty, as they say, is in the eye of the beholder. One variable is that people's ideas of what constitutes a great image go through fashions and fads, evolving perhaps, although, more often than not, following a cyclical pattern.

There are, however, a number of fixed reference points that can be used in the quest for the perfect image. Having a great subject helps, obviously, although some of the world's most beautiful images have been created using truly mundane objects. To my mind, there are just two critical factors in the creation of a great image: composition and lighting. Whatever your subject, the way it is arranged in the viewfinder and the manner in which it is lit are utterly crucial to the success of the final image. The novice photographer is likely be able to put the two together successfully from time to time – often by accident – but the mark of a truly skilled photographer is the ability to combine composition and lighting time and time again. For a lucky few, this success can be a matter of inspired artistic genius: for the great majority of us, it is mostly a steep and difficult learning curve (although, of course, we may also find ourselves enlightened by great leaps forward).

Across the entire spectrum of photography, from landscapes and nature to fashion and still life, the terms 'composition' and 'lighting' represent a plethora of skills built up through many years of accumulating

▼ **A lone pine tree grows out of barren red rock, seen just minutes before sunset; Zion National Park, Utah, USA. Although the rock was naturally quite red, this has been further emphasized by the reddish glow of the sunset light. Drama has been added by the diagonal lines in the rock, the tree and its shadow.** *Canon EOS 5, Sigma EX 70–200mm lens, ¹/₂₅₀ second, f/8, Fujichrome Provia 100F.*

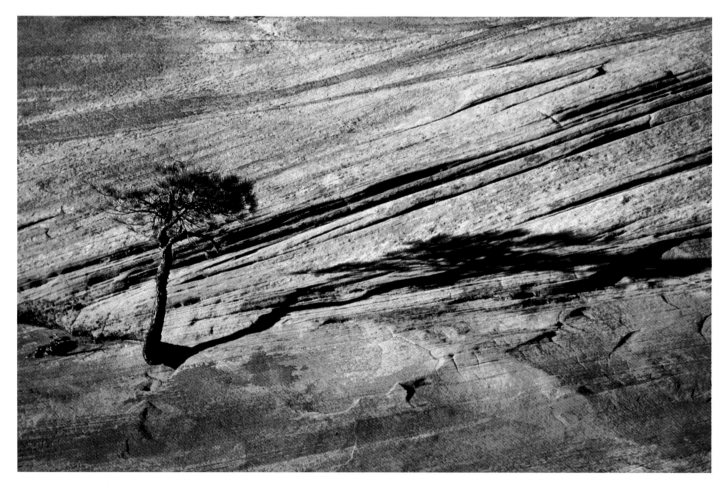

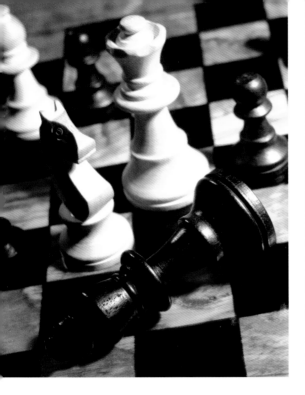

▲ This still life of a chess game was achieved using harsh directional lighting to emphasize the contrast between the light and shadow sides of the pieces. The chess pieces were lit using a single directly fired flashgun a short distance to the right of the view. *Mamiya RZ67, 65mm lens, 2 seconds, f/16, Fujichrome Provia 100F.*

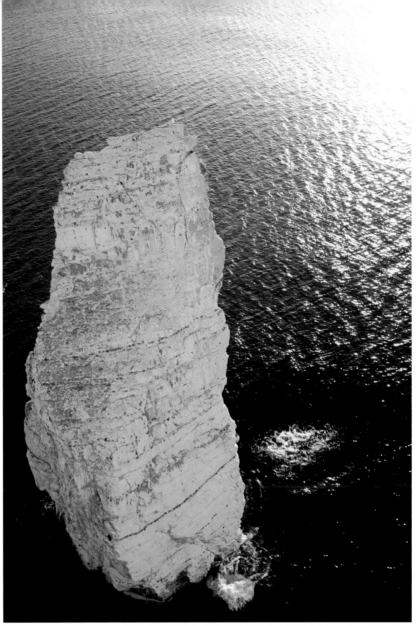

techniques and technology, gradually honed by several generations of photographers. Not surprisingly, it has turned into a pantheon of knowledge far too big to fit between the covers of one book and, for that reason, this publication focuses on just one of the two crucial elements: lighting. Even in this single arena, huge volumes could be written, so here I aim simply to give a summary of lighting techniques used in the different fields of photography, enough to whet the appetite and move you along the road towards successful lighting in your chosen photographic subjects.

THE INDOOR–OUTDOOR DIVIDE

From the lighting perspective, photography can be divided into indoor and outdoor techniques: outdoor photography uses mostly the natural available light, while indoor photography relies mainly on artificial light. Inevitably, then, the former has to wait for the right light and depends greatly

on the vagaries of what nature provides, while the latter can push ahead regardless of the time of day or the weather, making use of a variety of artificial light sources, from ordinary tungsten bulbs to expensive flash lighting systems. The indoor photographer, whether shooting portraits, still lifes or interior design, is able to create and mould their own lighting, designed to suit the subject, the intended end use of the images and the current fashion. The outdoor photographer, meanwhile, might be stuck, waiting for the rain to stop, for that cloud to move away from the sun or simply for the right time of day to arrive.

It is tempting to conclude that indoor photography with its great range of artificial lighting techniques is infinitely more skilled than outdoor photography, which appears

▲ A pinnacle of chalk stands in the sea close to cliffs at Studland, on the Dorset coast; Great Britain. Back-lit by a very low early morning sun, stacks of rock like this would normally be silhouettes. However, because the cliff I was standing on was – like the stack – made of chalk, it acted as a huge reflector, bouncing the light back and providing this stunning illumination. *Canon EOS 5, Sigma EX 17–35mm lens with polarizing filter, ¹⁄₆₀ second, f/8, Fujichrome Provia 100F.*

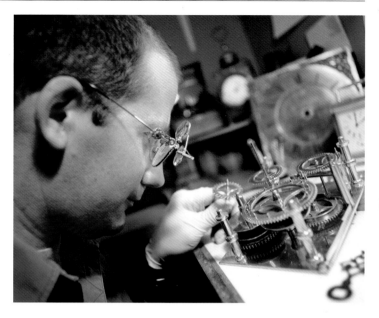

▶ A clock repairer at work, photographed using a single flash-gun mounted on his workbench, just to the right of the view. *Mamiya RZ67, 65mm lens, ¹⁄₁₀ second, f/11, Fujichrome Provia 100F.*

at times to rely simply on luck. It would be incorrect to think that. The two arenas rely on very different lighting skills, the one able to carry around its own manmade sun, always available and in skilled hands (almost) infinitely malleable. The other is dependent on the big lamp in the sky, skill here relying on knowledge of the sun's seasonal and diurnal effects, as well as on ability to predict and make use of the weather, and to show up at the right place at the right time. To a large extent, then, the photographer dependent on artificial lighting needs an extensive knowledge of the mainly specific science of electrical lighting technology. His colleague shooting outdoors needs to know about many of the subtleties and uncertainties of the natural world: about the heavens and meteorology throughout the day and from one season to the next.

THE QUALITY OF LIGHT

What the two types of photographer need to have in common is a deep understanding of the quality of light, whether natural or manmade. By this I mean such issues as the colour and intensity of the lighting used. The former will vary with different types of artificial lighting and with sunlight at different times of the day and year. Lighting intensity varies according to whether the light is shone at the subject as a strong, direct beam or as a soft diffused light. This applies equally to artificial lighting and sunlight. The former can be shone as a harsh light directly at the subject or can be diffused by being bounced off a wall, ceiling or reflector, or by passage through a translucent material. On a grand scale, the same applies to sunlight, on a clear sunny day, the subject illuminated by a bright, harsh light, at other times the light diffused to varying degrees by cloud, mist, haze, dust or air pollution.

Inevitably, light colour and intensity will greatly affect the reproduction of both subject and background in the final images, making or breaking not only the perceived technical quality of the subject's reproduction, but also the mood generated by the image as a whole – for example, warm or cold, relaxed or agitated, peaceful or dynamic.

SEEING THE LIGHT – AND MASTERING IT

For the outdoor photographer limited to using the light nature provides, one of the first crucial steps towards using it

▼ A view of the newly restored Great Court, at the British Museum, London. A beautiful example of indoor photography using natural light. *Canon EOS 5, Sigma EX 17–35mm lens with polarizer, ¹⁄₃₀ second, f/5.6, Fujichrome Provia 100F.*

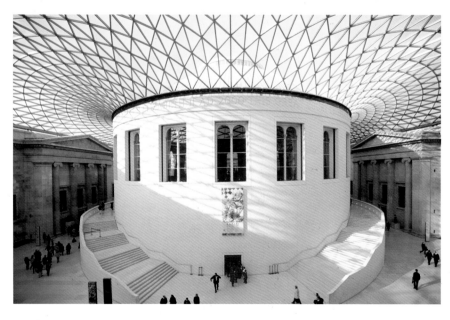

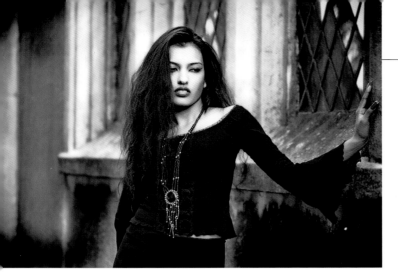

where the shadows will lie. They also should understand how different types of light source – whether daylight, flash, tungsten or fluorescent – will interact when present together, creating colour casts in different parts of the same image, effects that may need to be either overcome or exploited.

For both the outdoor and indoor photographer, then, successful use of natural and manmade light comes down to a very subtle combination of art and science; skills that are sometimes quite specific techniques, often indefinable instinct. Some can be learned quickly, others come simply from experience. This book aims to help deliver the former and provide signposts towards development of the latter.

◄ A portrait with an almost Gothic feeling to it, this image was shot on an overcast day, with a large white reflector placed in front of the subject. *Canon 10D, 28–70mm L lens, 1/125 second, f/5.6, ISO 100.*

skilfully is to learn to quite literally 'see' the light. In other words, the photographer must learn to see what is actually present, not what they think is there, for example, a warm reddish light at sunset, a cold blue at dusk or on bright cloudy days, blue light and myriad reflections bouncing off vegetation under a wide range of lighting conditions, or a harsh transition between strongly lit areas and deep shadows on bright sunny days.

This skill has to be coupled with an understanding of how film or pixel respond to and record these lighting conditions – and how that is similar to, or different from, the human eye/mind combination. Once armed with such knowledge, it becomes possible to minimize or enhance some of these factors to generate great images containing just the right amount of red, green or blue in exactly the right parts of each image, for example, or the perfect combinations of shadow and highlight areas to enhance texture and shape. However, one of the outdoor photographer's greatest skills is knowing when (and having the courage) to just leave the camera in the bag when nature is simply not delivering the light needed.

The photographer making use of artificial light that is always available, especially flash, may well not be able to see in advance very clearly, if at all, how the light falls on the subject. They will need to be able to predict what the lighting setup will do in terms of illumination when it is fired at the moment the shutter is pressed. To achieve this, they need to understand how different diffusers and reflectors affect the lighting and how it will fall across the subject, which parts will be highlighted and

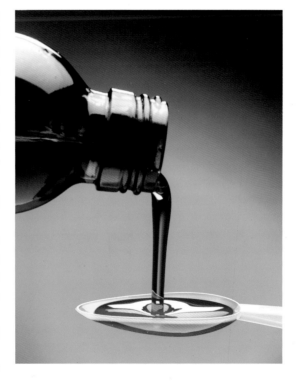

▲ In this image taken for a brochure promoting peristaltic pumps, the medicine bottle and spoon were held in place with specialized stands and supports, while an assistant tilted the bottle gently to pour the cough mixture into the spoon. Lighting consisted of a softbox placed above the set, white reflectors and mirrors to provide fill underneath the objects and a small softbox back light to provide the highlight on the cough mixture actually in the spoon. Black paper was used as the background, illuminated with a single flash head covered with a dark blue gel. *Mamiya 645 Pro TL, 150mm lens, 1/125 second, f/11, Kodachrome E100s.*

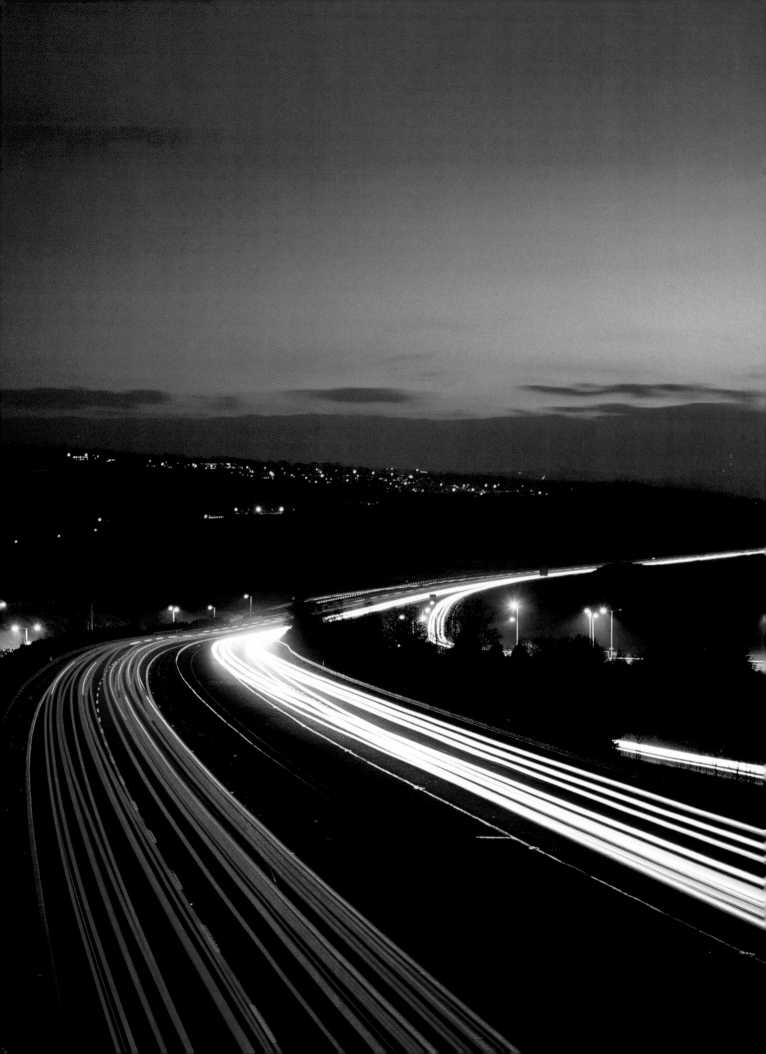

1

What is Light?

The question of what light actually consists of is one that has occupied some of the world's greatest minds for a very long time indeed. The best explanation that has emerged is that light consists of waves of energy travelling out in straight lines from a light source, such as the sun. Different sources emit waves of different energies, an energy level that is directly related to the waves' frequency and wavelength: the higher the frequency, the shorter the wavelength and the higher the energy.

The waves we see as visible light make up just a small part of this type of energy, known as electromagnetic radiation, and they fit into a relatively narrow wavelength band of the electromagnetic spectrum. At one end of this spectrum are gamma and X-rays, the highest energy waves known, and at the other, low-energy end are micro- and radio waves. Visible light fits in somewhere in the middle, with wavelengths of about 400–700 nanometres – a nanometre (nm for short) being one-billionth of a metre, expressed mathematically as 10^{-9}m.

Nature's main source of electromagnetic radiation is the stars, including our sun. The Earth is constantly bombarded with radiation from right across the spectrum, but, fortunately for us, the atmosphere absorbs or reflects away all but the visible light and a little of the infrared and ultraviolet rays. If the gamma and X-rays were able to reach Earth's surface, life would be impossible.

◀ A dusk view of a main highway, with the lights of fast-moving traffic rendered as streaks of red and white light. Near Newton Abbot, Devon, England. *Mamiya RZ67, 110mm lens, tripod, 8 seconds, f/11, Fujichrome Provia 100F.*

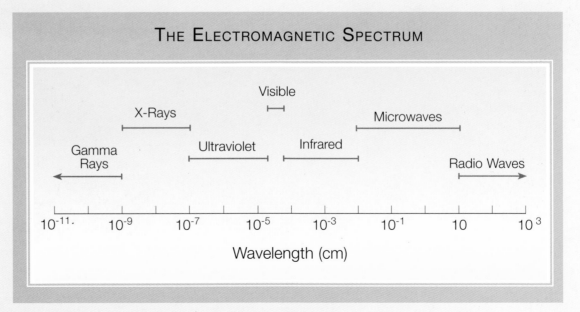

THE ELECTROMAGNETIC SPECTRUM

Visible

X-Rays

Microwaves

Gamma Rays

Ultraviolet

Infrared

Radio Waves

10^{-11} 10^{-9} 10^{-7} 10^{-5} 10^{-3} 10^{-1} 10 10^{3}

Wavelength (cm)

White Light and the Colours of the Rainbow

Visible light within this 400–700nm waveband consists of seven colours: red, orange, yellow, green, blue, indigo and violet. Their wavelengths drop, and, therefore, energy levels increase, in that order. Red has the lowest energy, with a wavelength of approximately 700nm, and blue the highest, with a wavelength of about 400nm. White light results when there is an even mix of all seven visible colours, while a colour cast occurs when one of the colours predominates, such as red often does shortly after sunrise and before sunset.

Just outside the visible band lie ultraviolet and infrared, at the blue and red ends of the spectrum respectively. Although these are invisible to the human eye, it is believed they can be seen by some animals. They play a part in photography, often helping to create blue or red colour casts in an image, despite the fact that both film and pixel are relatively insensitive to them.

A Colourful World

All the objects around us have their own colour – a fact that we may take for granted and that, if we do wonder about it at all, we may put down to the effect of surface pigments. But how do the pigments work to give us those colours?

Basically, they selectively absorb some of the colours of white light but not others; it is the colour(s) they do not absorb that we see as an object's colour. So, an object that is red is covered with pigments that absorb every colour of light except red: the red is bounced back and that is what we see. A black object is covered with pigments that absorb all the component colours of light, bouncing nothing back for us to see, while a white object absorbs nothing, bouncing all the light back at us. In nature, vegetation, for example, is green due to the pigment chlorophyll, which absorbs almost all light except green.

Of course, you can artificially change the 'apparent' colour of an object by shining

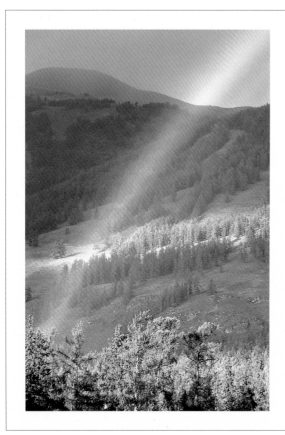

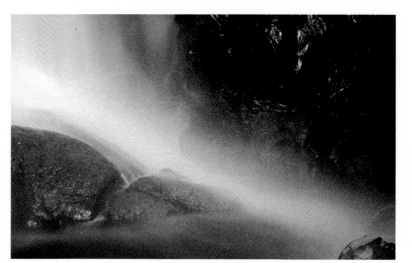

The clearest demonstration of the way in which white light consists of seven different colours is the rainbow, created by sunlight split into its component colours by water droplets in the air. The same effect can be seen in rainfall, in the spray at the base of a waterfall and in a beam of light shone through a prism. The colours are split in this way due to the ability of both water and glass to bend light that strikes them at an angle. Red is bent the least and blue the most, with the result that red is always on the outside of a rainbow's curve, while blue is always on the inside.

◄ The bright green of a plant's leaf is due to the fact that the leaf's pigments absorb just about every colour except green, reflecting this back for us to see. Alocasia leaf, Hong Kong. *Canon EOS 5, Sigma EX 28–70mm lens with 25mm extension tube, tripod, 1/15 second, f/8, Fujichrome Provia 100F.*

coloured light on it. Shine a green light on vegetation and it may well look even brighter and greener than under white light. Illuminate a leaf with blue light only, however, and it will turn very dark since the leaf absorbs most of the light and bounces only a little of the blue back for us to see.

Because light towards the red end of the spectrum has considerably less energy than that towards the blue end, red is more easily absorbed in the atmosphere, most especially by water vapour. Conversely, as mentioned earlier, blue light is more easily bent by water and it is also quite easily bounced around by dust particles and pollutants in the air. These two factors together have a profound influence on the light illuminating our world and hence on the way we photograph it. There follow a number of examples of how an 'excess' of blue light colours the world as we know it.

Deep water often appears very dark because almost all the light hitting it is absorbed, with little being bounced back to our eyes. Shallower water, especially if there is a sandy bottom, will usually look either very blue or blue-green. The explanation for this is that only blue light penetrates into the water. The red is absorbed in the surface layers, which leaves only the blue to be bounced back to us by the huge reflector that is the sandy bottom. This is of immense

importance to underwater photographers, who have to photograph in a 'blue world', something they overcome by the use of powerful white-balanced flashguns to put colour into their subjects.

Similarly, a clear sky is blue not so much because of the absorption of red light, but because all the light reaching us from any part of the sky away from the sun is inevitably light that has not come directly from the sun but has been bounced around and is, therefore, rich in blue wavelengths. Looking closer and closer to the sun, the sky becomes whiter due to the increasing proportion of light reaching us directly, hence containing a higher proportion of the red end of the spectrum.

▼ It is a blue world. The changing blue colour in the sea indicates its changing depth, the light colour in the foreground indicating shallow water with a sandy bottom, the darker area further out showing where the bottom suddenly drops away. Waimea, O'ahu, Hawaii. *Canon EOS 5, Sigma EX 70–200mm lens, polarizing filter, 1/250 second, f/8, Fujichrome Provia 100F.*

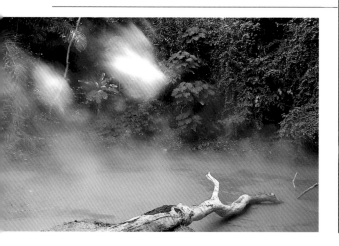

▲ Forest surrounding a pool of bubbling volcanic mud. Most of the scene is in deep shade, although a little of the steam has been caught by a shaft of sunlight. The areas in shade, both water and vegetation, are bathed in very blue light, rendering the green vegetation quite blue. However, when I was there it appeared green – my perception compensated for the colour of the light. Mt Makiling, the Philippines. *Canon EOS 5, Sigma EX 17–35mm lens, tripod, ¼ second, f/8, Fujichrome Velvia 50.*

A landscape bathed in clear sunshine in the middle of the day will generally be illuminated with white light; light that is roughly an equal mix of all seven colours. Areas in shadow on such a day, however, will contain much less direct sunlight and more light that has been bounced about, so there will be a strong excess of blue light. The human eye may miss this (or at least our mental perception of it may miss it), as we know what colours things are supposed to be and so subconsciously compensate when the lighting is 'wrong'. Similarly, cloud cover may result in an excess of blue light due to absorption of red by the clouds. In both situations, vegetation may look green to our perception, because we know it is supposed to be, but in the final images it can look distinctly blue.

Shortly before sunset and after sunrise are two of the few occasions when red light generally predominates. The reason for this is that when the sun is at a very low angle to the horizon, its rays have to pass through so much atmosphere (and hence all the junk it contains), that a large proportion of the blue light is bounced away, leaving mostly red.

Large amounts of red are also absorbed along the way, so the total amount of light energy reaching us is considerably less than it is when the sun is overhead. However, the overall balance of light colours heavily favours the red end, hence the period of glorious golden light that bathes the world at either end of the day.

Once the sun has slipped below the horizon, however, we no longer receive any direct illumination, only blue-dominated bounced light. Photograph any objects at this time without artificial lighting and the resulting images will have a heavy blue cast. The sky towards the west may remain a glorious red colour for some time, but that is

▲ The blue sky of a sunny day is due to the large amount of reflected light reaching the Earth that is coming indirectly from the sun. *Canon EOS 5, Sigma EX 28–70mm lens with polarizing filter, ¹/₉₀ second, f/9.5, Fujichrome Provia 100F.*

▼ Mid-morning sunlight, white but still low enough to give shadows of a reasonable length, can produce attractive images, although they may not have much atmosphere. Sculpture outside Kew Garden's Millennium Seed Bank, Wakehurst Place, Sussex, England. *Canon EOS 5, Sigma EX 17–35mm lens with polarizing filter, ¹/₆₀ second, f/11, Fujichrome Provia 100F.*

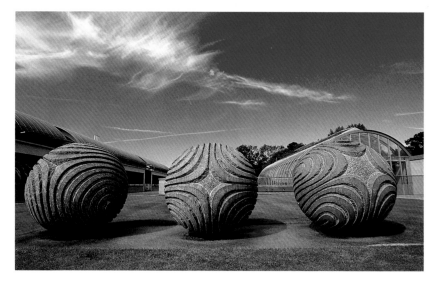

simply our view of the last of the direct sunlight shining away to the west where the sun has yet to set. Overhead, the sky will turn a beautiful deep violet colour as the final step towards darkness.

THE QUALITY OF INDOOR LIGHT

Of course there is almost always considerably less natural light indoors than outside. In a few buildings containing plenty of huge windows and a glass roof you will often find a pleasantly soft natural light that more or less retains the colour balance of white daylight. However, in most situations not only is there considerably less natural light than outside, but also what there is consists mostly of reflected light, which therefore is rich in blue.

Artificial lighting comes in many forms. The most common, at least in the domestic situation, consists of tungsten light bulbs, a relatively low-energy source that is rich in red, orange and yellow light. Fluorescent tubes and energy-efficient light bulbs, by way of contrast, both usually give off a greenish light. Such coloured lighting will inevitably affect the colours of all objects illuminated, but we nearly always fail to detect the resulting colour casts as we quickly learn to compensate for what we know to be the true colour in natural day-

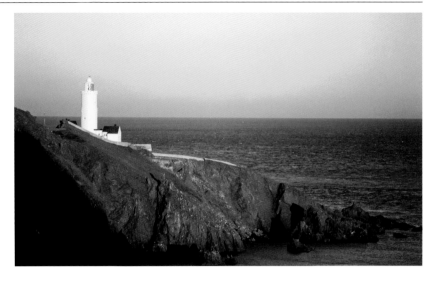

▲ **A beautiful rosy glow to both cliffs and sky during a particularly glorious sunset (occurring over my right shoulder). A perfect example of just how much the balance of light can be shifted in favour of red at the end of the day. Start Point, Devon, England.** *Mamiya RZ67, 110mm lens with polarizing filter, tripod, 1/15 second, f/11, Fujichrome Provia 100F.*

light. Film, however, will record exactly what is there: photographs taken on film under such lighting will come up with some truly ghastly colours, often causing great disappointment to the photographer. Many of these problems can be overcome with a range of coloured filters (see Three Types of Filter, page 20).

Many digital cameras, by way of contrast, contain a white-balance mechanism (see page 21 for a full description) that allows the photographer to compensate for artificial lighting colour casts, generating much more pleasing results.

In addition to filters, flash lighting is an important way of overcoming artificial light colour casting, at least for those photographers shooting on film, as these lights are specifically designed to produce light balanced to natural daylight. They generally give superbly accurate colour rendition. How to use flash and the other forms of artificial lighting successfully will be described mainly in the indoor photography chapters (Chapters 6–8).

How to go about removing these colour casts, which is a vital step towards great photography, requires an understanding of some of the technical nature of light, including the scales by which light and colour are

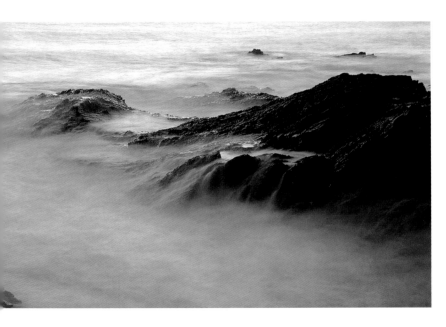

◄ **A long exposure of rocks washed with Atlantic waves shows them apparently bathed in a mist. Taken at dusk, the light is rich in blue wavelengths.** *Canon EOS 5, Sigma EX 17–35mm lens, tripod, 4 seconds, f/11, Fujichrome Provia 100F.*

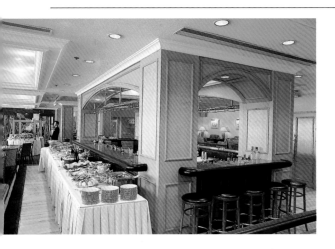

measured and the ways in which different colours interact. These are the subject of the following sections.

COLOUR TEMPERATURE AND THE ENERGY OF VISIBLE LIGHT

A convenient scale on which to measure the energy of visible light is 'colour temperature', measured in units known as Kelvin. This is a scale borrowed from the world of thermodynamics, in which zero Kelvin is the point at which hydrogen, the lightest known element, freezes, equivalent to −273°C. The colour temperature of light is related to the light radiated when a metallic incandescent light source is heated to various temperatures – red hot, for example, through orange and yellow to white and all the way up to blue.

Fluorescent and other forms of discharge lighting are not included in the colour temperature scale, since they are not incandescent light sources. In the case of fluorescent tubes, for example, light is emitted from a coating of phosphor, which glows as a result of an electric current being passed through mercury vapour.

Normal white daylight is rated as having a colour temperature of 5500 Kelvin (K), while the lower-energy red light has a colour temperature of about 2000–3500K. At the other end of the spectrum, blue light is rated at about 11,000K. Most of the commonly found light sources can be arranged along this scale, with the lowly candle way down

◄ This hotel buffet was in a room lit by tungsten lighting, but very close to a huge window that covered an entire wall. Unsure whether the daylight or tungsten would dominate, I shot on daylight film and obtained this image with an orange glow. The orange is not as intense as it would be in a room with no natural lighting however, so the window has had some impact and the overall effect is just pleasantly warm. *Canon T90, 24mm lens, tripod, 1 second, f/16, Fujichrome Velvia 50.*

▶ This young baby was photographed by placing her in front of a window through which shone a highly diffused light, and placing a large matt white reflector in front of her. The result is a portrait lit with soft, white light, with no colour imbalances despite being photographed indoors using ambient light. *Canon 10D, 28-70mm L lens, 1/60 second, f/4, ISO 100.*

▶ This simple still life illustrates the use of back lighting when photographing objects such as wine bottles and glass. Tobacco graduated filters were used in both top corners to add a little warmth to the otherwise completely white background. *Canon EOS 1Ds, 105mm macro lens, 1/125 second, f/16, ISO 100.*

at the bottom, having a colour temperature of about 1900K and the clear blue sky of a sunny summer's day way up at the top at 11,000K.

Confusingly, despite red light having a low colour temperature and blue a high one, in common terminology red light is always described as 'warm' and blue light

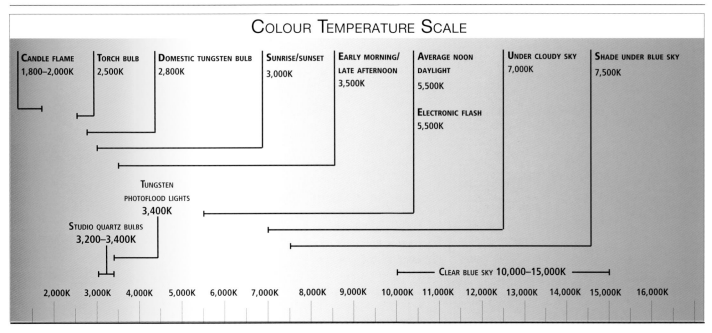

COLOUR TEMPERATURE SCALE

| CANDLE FLAME 1,800–2,000K | TORCH BULB 2,500K | DOMESTIC TUNGSTEN BULB 2,800K | SUNRISE/SUNSET 3,000K | EARLY MORNING/ LATE AFTERNOON 3,500K | AVERAGE NOON DAYLIGHT 5,500K | UNDER CLOUDY SKY 7,000K | SHADE UNDER BLUE SKY 7,500K |

ELECTRONIC FLASH
5,500K

TUNGSTEN
PHOTOFLOOD LIGHTS
3,400K

STUDIO QUARTZ BULBS
3,200–3,400K

CLEAR BLUE SKY 10,000–15,000K

2,000K 3,000K 4,000K 5,000K 6,000K 7,000K 8,000K 9,000K 10,000K 11,000K 12,000K 13,000K 14,000K 15,000K 16,000K

as 'cool', probably due to a combination of the psychological effects of the two colours and the mental associations they trigger. This is quite the opposite of what you might expect from the colour temperature scale. In coming to grips with this and learning how to remember which is which, all you need to understand is that there is little logic to any of the nomenclature and that common usage is the result of a historical collision between science and everyday English.

Since the colour temperature of average white daylight at midday is about 5500K, the blue cast common on cloudy days, in shadows in sunny weather and present at dusk, will have a higher colour temperature, typically about 7000K. Conversely, the red light typical early in the morning and late in the afternoon has a colour temperature lower than that of white light; it is commonly around 4000K and can fall as low as 3000K actually during sunrise and sunset. The implications of this and how these colour changes affect landscape photography are described in Chapter 2.

Indoors under tungsten lighting, the orange cast results from this light source having a colour temperature of 2900–3500K, well below the 5500K of white daylight. As already mentioned, fluorescent and other discharge lighting sources, despite giving colour casts, cannot be assigned

colour temperatures as they are not incandescent light sources.

PRIMARY COLOURS AND COLOUR COMPLEMENTARITY

Red, green and blue are defined as the primary colours of light (as opposed to red, blue and yellow for paint). Mixing these three together in equal proportions will produce white light, even without the other four 'intermediate' colours of the rainbow. Adding an excess of any one of them will generate a colour cast, or imbalance, towards that colour. Putting a filter of any one of the primary colours across a

▲ Nightlights as seen in this evening shot of a café viewed from a road in Hong Kong. *Canon EOS 5, Sigma EX 28-70mm lens, tripod, ¼ second, f/5.6, Fujichrome Provia 100.*

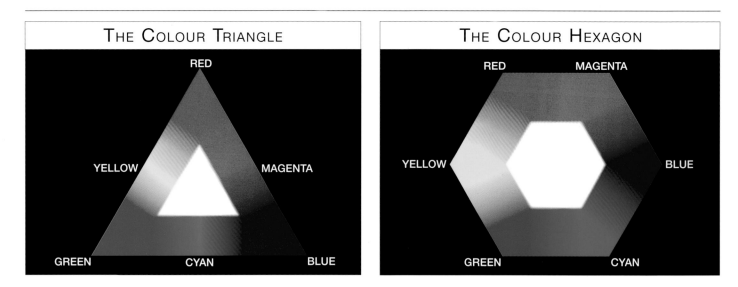

| THE COLOUR TRIANGLE | THE COLOUR HEXAGON |

THE COLOUR TRIANGLE

RED

YELLOW MAGENTA

GREEN CYAN BLUE

THE COLOUR HEXAGON

RED MAGENTA

YELLOW BLUE

GREEN CYAN

white light source will allow only light of that colour to pass through, the other two being absorbed. Adding a second filter of one of the other primary colours will cut out all light, the single light colour transmitted by the first filter being absorbed by the second.

None of the three primary colours is complementary to any of the others. Instead, the complementary colours are mixtures: magenta, being a mixture of red and blue, is complementary to green; yellow, a mix of red and green, complements blue; and cyan, a mixture of blue and green, is the complement of red. These relationships can be expressed as either the colour triangle or colour hexagon. In the latter, the six colours are positioned at the hexagon's apexes, with complementary colours directly opposite one another. In the triangle, the primary colours lie at the apexes with the complementary colours positioned halfway along the sides (thus denoting their colour mix),

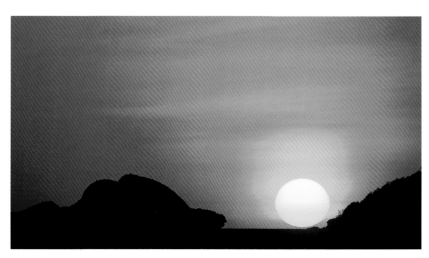

▲ The red light of a glorious sunset, the result of all the blue light being bounced away by dust and water particles in the air, El Nido, Palawan, the Philippines. *Canon EOS 5, Sigma EX 70-200mm lens plus 2x extender, tripod, ⅟₃₀ second, f/11, Fujichrome Provia 100F.*

◄ Autumnal maple leaves, normally yellow, have had their colours inverted post-photography. The result is an image showing yellow's complementary colour, blue. *Mamiya RZ67, 110mm lens, tripod, ⅟₃₀ second, f/11, Fujichrome Provia 100F.*

directly opposite the primary colour that they complement.

This colour complementarity is fundamental to large aspects of photography, unwanted colours being regularly removed from images using their complementary colour. Magenta is regularly used to remove unwanted green from an image, for example. This is described in Chapter 7.

COLOUR TEMPERATURE AND BALANCE

Used together, the colour temperature scale and the colour hexagon or triangle are immensely useful in predicting how to ensure the correct colour balance in images shot under a host of lighting conditions, whether they are photographed digitally or on film.

Standard daylight film is balanced to

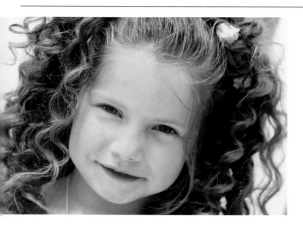

COLOUR CORRECTION FOR THE FILM CAMERA

If shooting on film, fairly small changes in colour temperature can be corrected with colour correction filters. Excess blue can be removed with a pink filter of what is known as the 81 series (A, B or C, with increasing strength). It is unusual to bother removing excess red light with a blue filter, as such a warm colour is normally considered attractive. However, if necessary it may be removed by adding a light blue filter of the 82 series (A, B and C). A Digital camera's adjustable white balance setting will have different settings for bright sunlight and cloudy conditions, making it possible for the work of the 81 filters to be done in these cameras electronically.

give correctly coloured images under white midday sunlight with a colour temperature of 5500K. Similarly, a digital camera will do the same if its white balance feature is on the sunny setting. If the colour temperature rises for any reason but the camera remains uncorrected, the resulting images will have a blue cast to them. It follows, therefore, that if the colour temperature falls and the camera remains uncorrected, there will be a reddish cast across the images. These reddish images will be said to be 'warm'; the bluish images 'cool'.

Electronic flash systems are balanced to produce light of a similar quality to daylight – that is, 5500K – making it easy to use ordinary daylight film with them. The lower energy of tungsten lighting, however, with a colour temperature of 2800–3400K,

will cause images shot on daylight film in this lighting and without the use of flash to come out very orange since the colour temperature of the lighting is below the 5500K rating of the film. This is easily fixed by either putting a dark blue colour conversion filter of the 80 series (usually 80A) over the lens or, better still, by using tungsten film. This is a type of film specially balanced for use with tungsten lighting, giving correct colours under lighting with a colour temperature of about 3200–3400K. If this film is used in daylight, the images will come out extremely blue (because the colour temperature of the light is above that for which the film is balanced) unless a strongly amber colour conversion filter (85B) is fitted over the lens. For the same reason, images shot using film under fluorescent light will also come out very blue.

A digital camera's white balance system has a tungsten light setting, electronically making the necessary colour correction. It should be remembered, however, that digital camera sensitivity to blue–red light variations and the accuracy of different white balance settings may differ between models, and may also be different from that of film. When shooting with a new piece of equipment, it may be necessary to make some initial tests to see how accurate its colour rendition is under different lighting conditions and white balance settings. Although the white balance feature on many makes of digital camera includes a custom white balance setting, some fine-tuning with filters may be needed under certain lighting conditions.

COLOUR IMBALANCE AND THE FILM CAMERA
As outlined above, when using film and shooting only under ambient light (i.e. without any flash lighting), colour imbalances can be removed by putting the appropriate filter(s) over the camera lens. This means a filter that is complementary to the colour to be removed.

◄ This young girl was photographed outdoors, but close to a large white wall that acted as a huge reflector, bathing her face in a soft, even white light free of any colour imbalances. *Canon 10D, 28-70mm L lens, ¹⁄₂₅₀ second, f/4. ISO 100.*

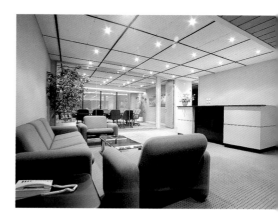

▲ This image of an office reception area illuminated with tungsten lighting and photographed using tungsten film has the correct colour balance. Look at the office in the background, however. Lit by fluorescent tubes, this part of the image has come out spectacularly blue due to the low colour temperature for which tungsten film is balanced. *Canon EOS 5, Sigma 17–35mm lens, tripod, 2 seconds, f/22, Kodak Ektachrome 64 tungsten film.*

With either the colour hexagon or triangle firmly fixed in the mind, it is possible to work out which colour filters to use to correct for which colour imbalance: a magenta filter to remove the excess green of fluorescent lighting, for example, or blue filters to clean up the excess orange caused by using daylight film under tungsten lighting. The one small fly in the ointment is the habit we have of removing excess blue light in natural daylight conditions not with the yellow filter you might expect, but with the pink filters of the 81 series. To every rule it seems there is always an exception! Having said that, sometimes colour correction in deep blue shadow areas on sunny days requires quite a strong amber filter of the 85 series.

Of course, what the photographer is doing when using filters to fiddle with the colour balance is altering the colour temperature of the light passing through the lens. While knowing which colours need to be used to correct an imbalance in the light is quite straightforward, knowing how much of that colour to use can be quite an art. Knowing both the colour temperature of the light you are starting with and that of the light you want to end up with (usually 5500K) helps enormously. Finding the correct filter or filters to achieve the desired colour temperature shift can either be done using a colour meter or by consulting filter manufacturers' charts.

An alternative way to calculate the colour temperature shift needed is to work out the *mired* (micro reciprocal degree) *shift*, which, because it is a linear scale, is actually simpler to work with than the logarithmic colour temperature scale. It is calculated by dividing one million by, first, the colour temperature of the light present and, second, that of the light aimed for and calculating the difference. Filters are usually supplied by manufacturers with both their colour temperature shift and their mired shift values. Although the former remains more popular, the most commonly used colour correction and compensation filters are named after their mired shift values (namely the 80, 81, 82 and 85 filter series).

THREE TYPES OF FILTER

Photographers using film regularly remove colour imbalances using three types of filter: colour conversion, colour correction and colour compensation filters.

Colour conversion filters are the deep blue 80 and amber 85 series filters. The former is put over the camera lens to give correct colour balance on daylight film used under tungsten lighting. The latter is used to give correct colour balance on tungsten film used in daylight.

Colour correction filters consist of the pink 81 and light blue 82 series filters, the former used to remove blue casts, such as on bright cloudy days, the latter to remove red casts. The 81 series filters are regularly used by outdoor photographers, but the 82 sees only very light usage. Their use is described throughout the book.

Colour compensation filters are used extensively by interiors photographers aiming to achieve fine control of indoor lighting balance and consist of filters in the six primary and complementary colours. Their use is covered in detail in Chapter 7, page 123.

▼ City nightlights at dusk can be a spectacular sight, especially when moving traffic can be included. Here a flashgun was fired just as a car passed by, providing a blur of lights and reflective metal in the foreground, instead of the empty road. Shibuya, Tokyo, Japan. *Canon EOS 5, Sigma 17-35mm lens, tripod, 1/10 second, f/5.6, Fujichrome Provia 100F.*

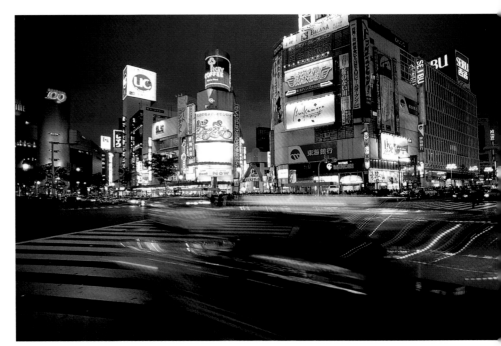

COLOUR IMBALANCE AND THE DIGITAL CAMERA

The advent of digital cameras is rapidly reducing the need for colour control with filters, at least for those that need to be put over the lens. The great majority of models come with a white balance mechanism that electronically corrects for colour imbalances, often coming with several settings for the photographer to work with, as follows:

AWB (automatic white balance)	Automatically monitors ambient colour temperatures and corrects accordingly, at least in the range of 3000–7000K. However, on some models the AWB makes the images too blue, so it may need to be treated with caution.
Bright sunlight	Balances images shot in sunlight to 5500K, so should be used only in sunny conditions.
Cloudy	Used in cloudy conditions at about 6000K, it removes excess blue light, performing the function of the 81 filters.
Flash	Balances to the colour of flash lighting, about 5500K.
Fluorescent	Removes green casts under fluorescent lighting, often balanced for the emissions of warm white fluorescent tubes.
Tungsten	Balances images for tungsten lighting at 3200K.
Custom	Allows the photographer to enter a white balance for a lighting situation whose colour temperature does not match any of the other selections. Usually achieved by photographing a white card under the lighting in question and then entering the resulting image into the custom white balance data system.

In addition to these settings, many professional-level digital cameras allow the photographer to enter specific colour temperatures, making possible some very fine tuning of colour balance for those photographers with a firm grasp of colour temperature and complementarity.

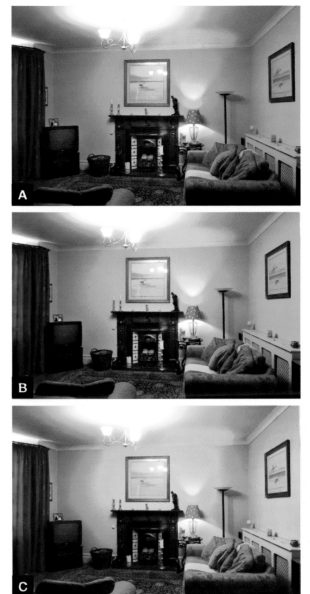

▲ A lounge lit with only tungsten lighting, photographed using a digital camera with the white balance setting on: (A) tungsten. The lighting is still quite warm, indicating that the colour temperature was lower than the 3200K of the camera's tungsten white balance setting; (B) automatic white balance (AWB). The image has less of an orange glow, indicating that the AWB gave a better colour balance than the tungsten setting; (C) sunny daylight (5500K). The colour temperature of the lighting is well below the camera setting's 5500K and so the image has a strong orange colour cast to it, just as images shot on daylight film would.

Canon D30, Sigma EX 17-35mm lens, tripod, 6 seconds, f/16, ISO 100.

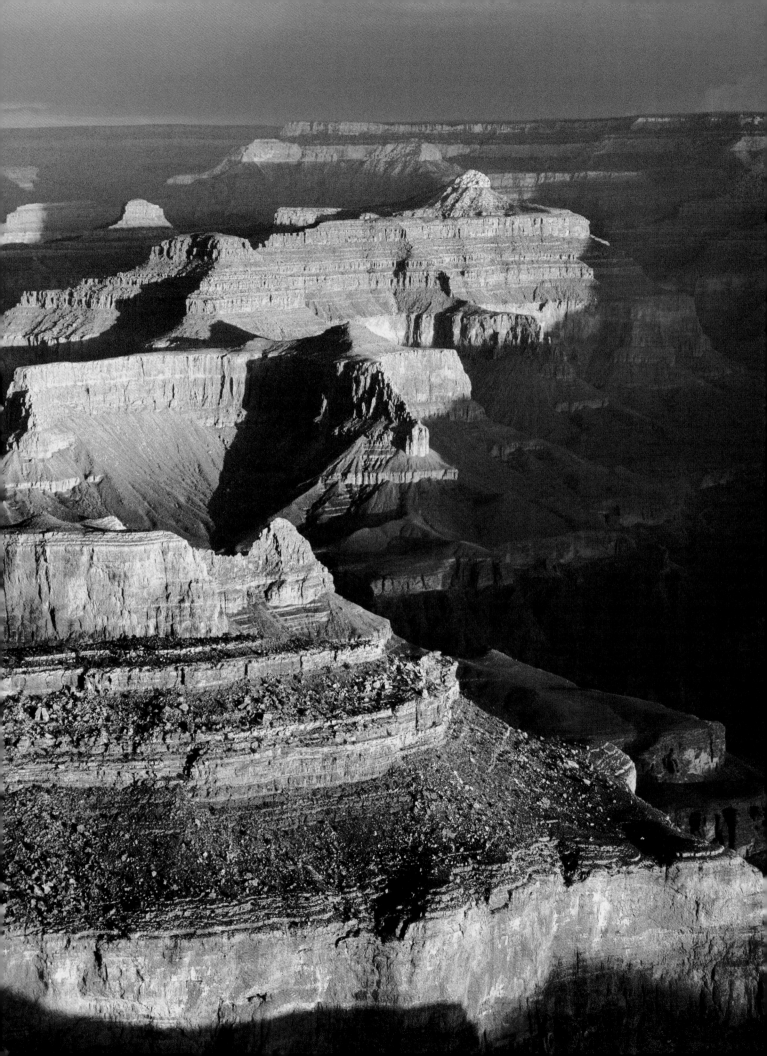

2

OUTDOOR LIGHT

Landscapes

◄ The Grand Canyon seen from the South Rim at sunrise. The cliffs' natural red colouration has been greatly exaggerated by the red light of the rising sun, while the sun's low angle has also created deep shadows in many parts of the cliffs. These have greatly increased the image's three-dimensionality, further enhanced by deliberately under-exposing the image by half a stop. Grand Canyon National Park, Arizona, USA. *Canon EOS 5, Sigma EX 70-200mm lens, tripod, 1/30 second, f/11, Fujichrome Provia 100F.*

It could be said of landscape photography that finding beautiful photogenic landscapes is the easiest part of the process. The world abounds in glorious views, both wide vistas and tiny details. The hard part is getting the right light with which to illuminate them. Putting light and landscape together and then capturing the best image possible, with the right lens and angle of view, on either film or pixel, is the art of the skilled landscape photographer. It rarely comes easily. Success often requires huge amounts of patience, an opportunistic streak that enables the photographer to move quickly when half an opportunity arises, and a readiness to leave the camera in the bag unused when the lighting works out other than as expected. But, by way of compensation, there is the thrill of the occasions when everything comes together and after even a fairly brief shoot you know you have managed to capture something really special.

rectly, it would be impossible to come away with anything less than stunning images. It happens to all of us from time to time and can be particularly important when travelling in unfamiliar territory with a limited amount of time available. But reliance on such random and accidental successes is hardly the best way to go about generating a portfolio of beautiful landscape images. A more methodical approach is needed. You have to be able to plan ahead, to spot possible good images long before they reveal themselves, to increase the likelihood of being in the right place at the right time. Much of this has little to do with being able to use a camera correctly, which in itself is almost a separate skill, and more to do with understanding the land, the sea, the weather, the seasons and, of course, the light.

PREPARATION

There will be occasions when even the most inexperienced landscape photographer will find themselves in the right place at the right time: turning up by chance at a location with a magnificent view, lit by exactly the right kind of light, shining from exactly the right angle. Provided the photographer manages to use the camera cor-

◄ Calm dusk light in the mountains above a sea of cloud, Yushan National Park, Taiwan. *Mamiya RB67, 250mm lens, tripod, 1/8 second, f/11, Fujichrome Velvia 50.*

23

CHECKLIST TO A LANDSCAPE PHOTOGRAPHER'S LIFE

The following is a checklist of some of the things a landscape photographer will need to think about, not just ahead of a particular shoot, but pretty much at all times as they go about their general life without a camera to hand but constantly on the lookout for good views worthy of consideration:

1 Identify likely beauty spots while moving around in a region or from a map before even visiting them.

2 Predict how the light is likely to illuminate those spots at different times of the day and year.

3 Make a judgment on what kind of light is most suited to landscapes that you want to photograph or at least to the mood you would like to portray in such a landscape.

4 Think about how the colours in a landscape will evolve during the year, how those colours will respond to different lighting conditions and so which season(s) will generate the best images for any given view.

5 Decide what type of lens(es) – wide-angle, standard or telephoto – will bring out the best in a particular landscape view under a particular type of light, or whether it is possible to produce a set of quite different images from a single landscape using different lenses under the same or a range of lighting conditions.

6 Learn, as a general way of life, how to understand weather forecasts and how to make predictions based on personal observations of both the sky and wind patterns. This knowledge can be crucial to an assessment of the kind(s) of light likely to be encountered during any landscape photo shoot, and may help determine not only what types of view you might want to photograph on any given day, but even whether you head out from home at all!

▼ Low side lighting in a view of rolling farmland and a plantation of larch trees in autumn colours. The low light has helped pick out the gentle folds in the hills and accentuated the golden colours of the larch trees. Haldon Hills, near Exeter, Devon, England. *Mamiya RZ67, 250mm lens with polarizing filter, tripod, 1/30 second, f/8, Fujichrome Provia 100F.*

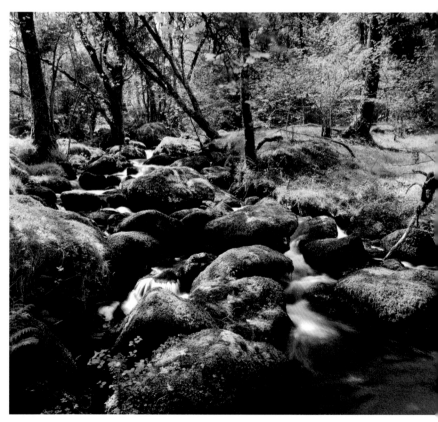

▲ Bright sunlight can make photography in woodland very difficult due to the tangle of shadow and highlight areas. In this instance, however, a soft sunlight has given just the right amount of brightness to create vibrant greens without there being too great a range of contrasts. Haytor Woods, Dartmoor National Park, Devon, England. *Mamiya RZ67, 50mm lens with polarizing filter, tripod, 1 second, f/22, Fujichrome Provia 100F.*

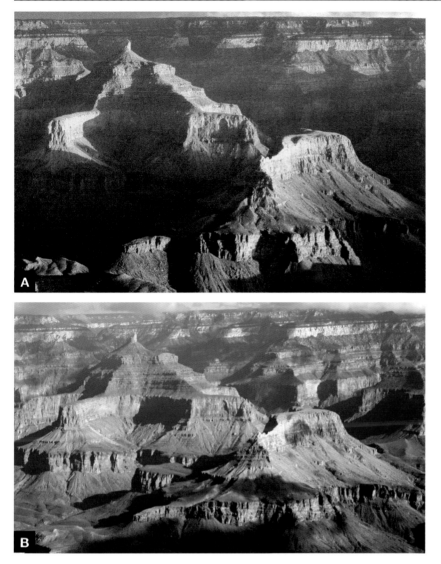

▲ A view from the South Rim of the Grand Canyon, photographed at two different times: (A) A sunrise view, in which the rich red light and the strong shadows combine to create an atmospheric, three-dimensional image; (B) The same view seen three hours after sunrise; the red hue is lost and the shadows are greatly reduced, resulting in a flat image. Although fewer areas are lost in dense shadow, details on the sunlit areas of rock are much less visible, reducing visual interest. *Canon EOS 5, Sigma EX 70–200 mm lens, tripod, Fujichrome Provia 100F. For (A) no filters, ¹/₃₀ second, f/11; (B) with polarizing filter, ¹/₉₀ second, f/9.5.*

As with so many things in life, one of the major keys to successful landscape photography lies in preparation, much of it conducted without a camera to hand and often at home. One of the first considerations is to understand how light can affect the landscape under a range of conditions.

THE SUN AND THE EARTH

Huge numbers of people whose lives revolve around office work and an urban lifestyle go through life barely aware of the movement of the sun relative to the Earth. They hardly notice the different qualities of light at different times of day, how light evolves with the changing seasons and how all this affects the colours in our landscape. For a landscape photographer, such knowledge is absolutely crucial to success, so it is vital for them to study the light whenever possible, to develop an innate understanding of the daily, annual and weather-dependent processes involved. The following sections will help with this process.

LIGHTING THE WORLD: LIMITATIONS AND OPPORTUNITIES

The sun is never stationary in the sky; it is always on the move from east to west and at a different height above the horizon, ensuring that our view of even the most rock-solid landscape is continually evolving. At the most obvious level, the height and angle of the sun relative to any view will affect shadow length. This, in a more subtle way, will affect our perception of the various elements within a view, changing the sense of roundness, steepness, dynamic energy, roughness or smoothness. The sun's height above the horizon will also affect the colour temperature of the light falling on a view and hence the colours we see reflected back to us. A view seen at midday when the sun is high overhead may appear to consist of a limited range of rather flat mid-tone colours. However, the same view seen a few hours later, shortly before sunset, may glow with a range of rich hues that totally transform what had been a rather uninteresting view into something quite stunning.

Not surprisingly, this constant dynamic state presents both opportunities and limitations. It presents opportunities because the same landscape may provide the photographer with a range of utterly different but equally stunning images courtesy of very

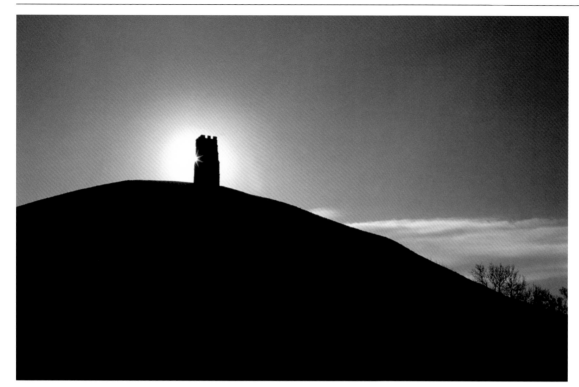

◄ The manmade hill of Glastonbury Tor, Somerset, England, with its hilltop tower silhouetted by a low winter sun. If the sun had not been right behind the tower, I would almost certainly have had flare in the lens. Its perfect alignment behind the tower, however, has given me a great silhouette without any flare, plus the bonus of a small starburst around the tower's walls. *Canon EOS 5, Sigma EX 28–70mm lens, 1/90 second, f/16, Fujichrome 100F.*

different lighting conditions at a variety of times of day and seasons of the year. It presents limitations because it is not possible to go out to shoot any given view at any time; the photographer will at the very least need to be able to predict what times of day will provide the best light for any given view and may often have to plan months in advance to wait for the right time of year.

THE QUALITY OF LIGHT, DAWN TO DUSK

The day starts with the first light of dawn, quite some time before sunrise. Because at this time the sun is still below the horizon, this light is wholly indirect, having come from the sun by being bounced around in the atmosphere. As a result, the light is very rich in blue and is not suitable to most forms of general photography without the use of at least a fill-in flash. It can work, however, in certain forms of landscape photography, where only simple outlines are required. Examples might include the outlines of distant mountains, rounded boulders on a shore, or a view of the sea or a lake. Such images are often very peaceful, exuding an extremely calm atmosphere.

As the sun comes closer to the horizon, so the eastern sky is likely to turn a variety of pink, red, orange or yellow hues, the result of direct sunlight reaching into the atmosphere further east. This is the classic dawn spectacle perfect for dramatic landscape silhouettes. Predicting accurately in advance how red a dawn is likely to be (and so whether or not to stay in bed!) seems to be virtually impossible. Obviously, weather forecasts, both official and your own predictions, are extremely helpful, but neither is foolproof. Apart from the most obvious limiting factors such as cloud cover, the intensity of colours in an apparently clear sky can still be greatly influenced by a number of factors, mostly linked to the amount of material suspended in the atmosphere, from water droplets, to dust, to pollutants. Too little or too much suspended junk will normally result in poor colours. Just the right amount will give perfect colours, but what constitutes 'just the right amount' is anyone's guess.

The time delay between the dawn and sunrise depends largely on latitude and time of year and is linked to the angle of the sun's arc relative to the horizon. In the tropics, where the sun comes up on a trajectory that is close to 90° to the horizon, the process is over very quickly, in as little as 15 minutes, but in the temperate latitudes, where the sun

▶ I was confident that these east-facing chalk cliffs would glow a beautiful pink colour at sunrise and I was absolutely right (A). Within less than an hour, the sun had climbed sufficiently high for most of that red light to be lost and the cliffs returned to their normal off-white colour (B). Studland, Dorset, England. *Canon EOS 5, Fujichrome Provia 100F, for (A) Sigma EX 28–70mm lens, tripod, 1/30 second, f/9.5; for (B) Sigma EX 17–35mm lens, polarizing filter, 1/60 second, f/11.*

▼ High sunlight may be good for producing picture-postcard images (the typical lighting used for such cards), but don't expect anything very atmospheric. Wayside Museum and church at Zennor, near Land's End, Cornwall, England. *Canon T90, 24mm lens with polarizing filter, 1/60 second, f/11, Fujichrome Velvia.*

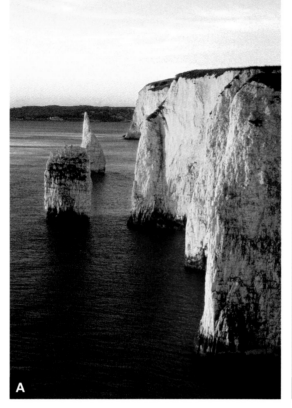

A

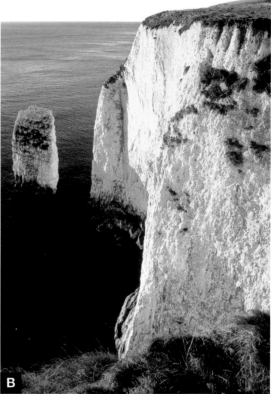

B

rises at a much shallower angle, the delay can easily be as long as an hour.

Once the sun is above the horizon, its low angle bathes the landscape in a light that is rich in warming red. Shadows are long and distinct, helping to maximize detail and emphasize shape and form. Gentle folds in a hill, tractor lines in a field of crops, the jumbled roof of a forest or the jagged peaks of a mountain range can often be picked out very clearly. Combined with the warm colour, this early morning light, which may last as little as ten minutes or as much as an hour after sunrise, is one of the best times of day for atmospheric landscape photography. The one drawback is the strength of the shadows that are commonly generated. They may be so deep that the huge contrast range between them and the sunlit areas (particularly of highly reflective objects such as white walls or sand) may simply be too great for either film or pixel to handle,

resulting in loss of detail at either or both ends of the range.

As with dawn, the strength of the sun at this time is modulated by the amount of water, dust or pollutants suspended in the atmosphere. Completely clear air will result in very strong colours and a huge contrast range between sunlit and shadow areas, while a small amount of suspended material will result in a convenient reduction in the contrast range without a serious impact on either general visibility or on the warming colours of the scene.

As the sun climbs higher, so the red-rich light will be replaced by white light with a colour temperature of 5500K, in summer occurring within an hour of sunrise. Once this point has been reached, the light intensity stays virtually constant until the final couple of hours before sunset, giving a camera exposure value in clear air of 1/125 second at f/16 for an ISO rating/film speed of 100 ASA. Suspended material will progressively reduce this value, by about half a stop for relatively small amounts and up to two stops on really hazy days.

If the air remains at least reasonably

▶ A beach image shot when the sun was high overhead and the air was free of haze. Images shot with such a high sun don't often work, but this one is effective in screaming out 'Hot!!!' And it really was. Northern Sierra Madre Natural Park, the Philippines. *Canon EOS 5, Sigma EX 28–70mm lens with polarizing filter, ⅟₉₀ second, f/11, Fujichrome Provia 100F.*

▼ In temperate latitudes in winter even at midday the light is still quite warm and never really reaches 5500K white light. This view of the Snowdon mountain range was taken at lunchtime in December. Snowdonia National Park, Wales. *Mamiya 645, 55mm lens with polarizing filter, tripod, ⅟₆₀ second, f/8, Fujichrome Provia 100F.*

clear, good landscape photography is still perfectly possible well into the morning, although the images will not be particularly atmospheric. Once the sun gets above about 45°, however, landscape photography becomes less and less worthwhile. This is because the shadows become shorter, making views appear increasingly flat and featureless. The amount of detail becomes seriously reduced and colours quite weak. This is the time to rest, recuperate and take stock of the morning's shoot.

On rare occasions when the air is very clear, it may be possible to shoot when the sun is high overhead. Success here, however, depends on the main subject being in the foreground. With lots of glare and through the judicious use of a polarizing filter (see page 37), the resulting images shout 'Heat!' It is pretty much the only atmosphere that they can portray!

During winter in the temperate latitudes, 5500K white light conditions may never be achieved, resulting in a relatively warm light lasting the entire day (despite the very low air temperatures!). Coupled with the constantly low sun angle, this can be a great time of year for landscape photography, provided there are any sunny days.

Once into the afternoon, the entire process is repeated in reverse, usually minus the attractive mist that is frequently present at dawn. A skilled landscape photographer should never make the mistake of packing away their camera the moment the sun has slipped below the horizon (a fault that many people have), as by far the best light show, that of the dusk glow, is yet to come. However, as with the dawn red glow, its level is almost impossible to predict in advance. As with dawn, in the tropics the delay between sunset and dusk is usually only about 15 minutes, whereas in temperate latitudes it can easily be an hour.

NATURAL FILTRATION OF SUNLIGHT

It has already been mentioned how a very small amount of haze can at times be useful in increasing the intensity of colours in the sky at dawn and dusk and in reducing the intensity of sunlight – and hence the depth of shadows – early and late in the day when the sun is low. When the sun is above the horizon, anything more than the smallest amount of haze can be a problem, not only reducing visibility and the sharpness of

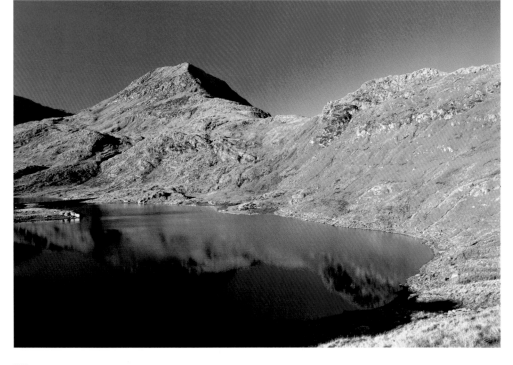

landscape elements, but also increasing the proportion of generally undesirable blue light and decreasing overall colour saturation.

Another form of filtration is by mist. A gentle early-morning mist, if not too thick and lit by the sun at just the right angle, can turn an interesting view into something quite magical. Details in the view will be greatly reduced, but the general atmosphere of the image will be hugely increased, producing something truly creative. Back lighting in particular can produce stunning results, with the sunlight often being broken up into rays pouring down through the mist and the mist sometimes shown up, as the sunlight bounces off it, as undulating or billowing thin sheets.

Very early in the morning in hilly country, it is often possible to climb above the layers of mist, which usually sit in the bottoms of the valleys, allowing the photographer to produce images showing a sea of mist or perhaps apparently a sea of cloud if the mist

THE SUN AS A RED DISC

One of the few occasions where a relatively large amount of haze is welcome is when photographing the sun itself just at sunrise or sunset. In clear air, the sun is far too bright for this to be possible, as the blazing light pours into the lens and completely overwhelms the image. In moderate haze, however, the sun may be reduced to a red ball that, with the use of a powerful telephoto lens, can make for a very dramatic image. Too much haze again ruins the view, either reducing the sun to a pale yellow disc or obscuring it altogether as it slips close to the horizon. At this point, I probably should insert a health warning. Don't photograph the sun too often, since looking at it definitely damages your eyesight.

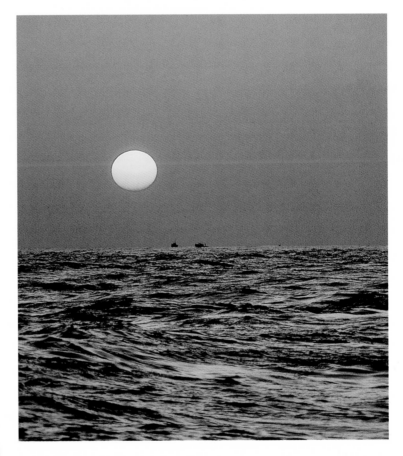

Just the right amount of haze in the air has made it possible to photograph the sun setting as a red-orange ball. Completely clear air would have made this image impossible, as the brightness of the sun would have totally overwhelmed the view. A little more haze would have rendered the sun too weak to be worth bothering with. Sunset at Kenting, Taiwan. *Canon T90, 100–300mm lens, tripod, ⅟₃₀ second, f/8, Fujichrome Velvia 50.*

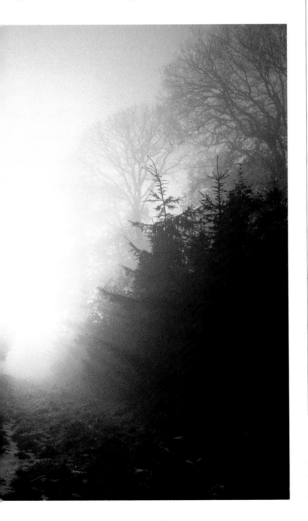

◄ On a cold winter's day, mist was hanging in this woodland, with the sun's rays pouring through dramatically. As a result, this strongly backlit image is very atmospheric, giving a touch of mystery to the forest. Staffordshire, England. *Canon T90, 24mm lens, ⅟₆₀ second, f/11, Fujichrome Velvia 50.*

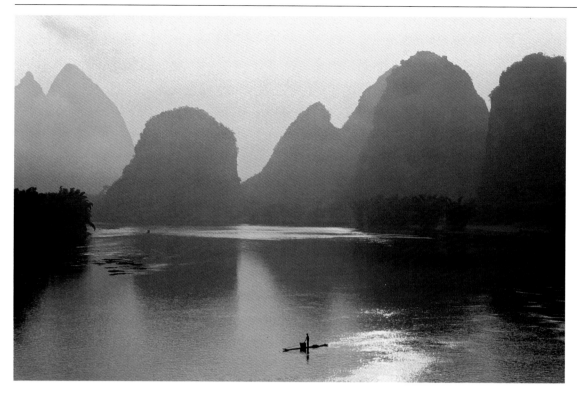

◄ The soft lighting created by early-morning mist can make for very delicate images, such as this backlit view of the Li River and its surrounding karst limestone peaks. Yangshuo, Guangxi province, southwest China. *Mamiya RB67, 127mm lens, tripod, 1/30 second, f/8, Fujichrome Velvia 50.*

is thick enough, with hills and forests protruding above it like islands floating on a fluffy sea. Again, back lighting produces the most dramatic effects on such a 'sea'.

Views Without Sunlight

The great majority of landscape images have sunlight somewhere in them, even if limited to just a narrow shaft of it, but there are times when it is desirable (indeed there may be no choice) to photograph without sunlight. Success here depends on choosing subjects with powerful shapes, textures or colours that are striking on their own without the help of sunlight or that might even be harmed by the complexity of shadows that sunlight can generate. This will often, although by no means always, imply photography of nearby landscape elements; details rather than wide-open vistas.

If the thin mist described earlier turns into a fog that sunlight is barely able to penetrate, the only images possible will be ones that reveal eerie silhouettes, with dark mournful shapes of rocks, trees and other nearby landscape elements appearing through the gloom. Success with these images will rely on powerful outlines and a strong mood, the fog and lack of light having almost certainly eliminated colour, detail and texture.

Landscape details that not only can be shot without sun but that actually benefit from not having any include rock formations and vegetation. Details of rocks, especially

▼ Soft lighting in a dawn view across a sea of cloud from the hill town of Erice in Sicily, Italy. *Canon EOS 5, Sigma EX 70–200mm lens with blue filter, tripod, 1/15 second, f/5.6, Fujichrome Provia 100F.*

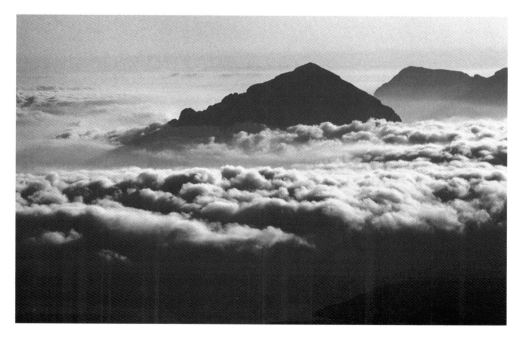

where patterns within them are the main components of an image, are often better shot without sunlight, as the multitude of shadows that would otherwise result can confuse the image, breaking up the rock's inherent pattern and producing quite an unsatisfactory result.

It is a similar story if photographing within a forest, the rather fuzzy point at which landscape and nature photography meet. Dappled sunlight under a canopy of trees can make it very difficult to produce meaningful images. The three-dimensional mixture of bright sunlight and dark shadow may look extremely attractive to the eye, but it is likely that neither digital nor film photography will be able to handle such a huge contrast range. The result will often be images consisting of a confusing two-dimensional mishmash of burned-out bright areas and overly dark patches in which any striking forest view that was visible to the eye is completely lost.

Quite dull light can often be the most successful in this environment, with shadows reduced to a minimum and greens showing up quite brightly, although, the low light level

◀ When shooting in foggy conditions, obtaining good images relies on strong shapes and outlines that work as atmospheric monochromatic compositions. Rocks and gnarled trees in thick fog, on the upper slopes of Mt Huangshan, Anhui province, China. *Canon T90, 28–70mm lens, tripod, 1/15 second, f/8, Fujichrome Provia 100.*

▲ Forest greens often become extremely vibrant just before, during, or after rain, when light levels are low and flat, and especially when seen through a polarizing filter. Here, the intense green of the moss gives a sense of lushness and the primeval nature of the forest. Dart Woods, Dartmoor National Park, Devon, England. *Mamiya RZ67, 110mm lens with polarizing filter, tripod, 4 seconds, f/11, Fujichrome Provia 100F.*

will make a tripod absolutely essential. Some of the best images, at least in terms of the intensities of the greens, can be obtained just before or after rain – or, indeed, during, if you can protect the camera.

Similarly, photography of waterfalls is often best under sunless conditions, partly due to the reduction in confusing shadows that might otherwise affect rock faces and vegetation surrounding a waterfall. The main reason, however, is so that, due to the lower light intensity, it becomes possible to use a very slow shutter speed, blurring the motion of the falling water into a continuous silken sheet. The one time when you might want to

be sure to photograph a waterfall in sunshine is when the sun is shining at an angle that it is likely to generate a rainbow in the spray.

Virtually the only occasions when wide vistas are photographed without sunlight are at dawn and dusk. At these times, successful photography towards the rising/falling sun generally relies on the presence of a subject that gives a dramatic silhouette; a beautifully shaped object to stand out against a violet sky streaked with red or orange clouds. This is usually some mid- or foreground element, such as a rock or tree, but a distant mountain range or island may also work well. Wherever the subject, the rule of thumb is that to be successful such images must have a strong main subject.

The other kind of image that can be taken at dawn or dusk is by looking away from the horizon below which the sun lies. As described earlier, these views are likely to be filled with a lot of blue light and so may not be suitable for many types of photography. This is especially true if vegetation is a significant component. However, water, rocks and mountain ranges may well look very beautiful in this light, resulting in some stunning images. If the sky has a lot of red in it, this might introduce sufficient red light into some of these views to help counter the excess blue. This makes it possible to shoot some very attractive images with a delicate pink wash across them, particularly across any significant fore- and mid-ground components.

THE SUN AND THE CAMERA

The previous sections aimed to develop an understanding of the properties of light in the landscape and what kinds of subject can be photographed under different lighting conditions. The next stage is to learn how to put the camera into the landscape and the lighting, where to point the camera relative to the light, how to make the most of the lighting to produce different kinds of image and how to generate a sense of mood and beauty in the images.

▲ A waterfall in shadow on a sunny day. Being in shadow allowed me to use a slow shutter speed to blur the falling water, but it also meant the image is bathed in blue light. In this instance, I felt the blue was quite acceptable as it enhanced the feeling of cold. Caihong Waterfall, Yushan National Park, Taiwan. *Mamiya RB67, 127mm lens, tripod, 3 seconds, f/11, Fujichrome Velvia 50.*

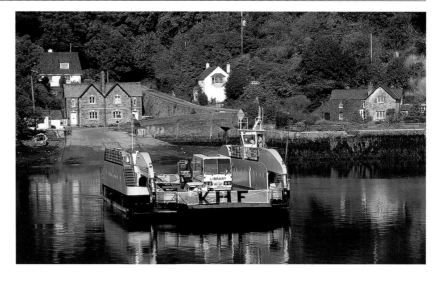

▶ Front lighting gives simple shots that are easily correctly exposed, though the results are rarely very atmospheric, especially when shot during the middle of the day when the sun is quite high. King Harry Ferry, near Truro, Cornwall, England. *Canon EOS 5, Sigma EX 70-200mm lens with polarizing filter, 1/180 second, f/5.6, Fujichrome Provia 100F.*

THE SUBJECT–CAMERA–SUN 'TRIANGLE'

As already described, the sun's angle relative to the horizon is one of the most critical factors in the lighting of a landscape view. Also of major importance is the sun's angle relative to the camera and hence not just the way the sun illuminates the view but also how the photographer sees that lighting.

The effects of four types of sun-to-camera angle need to be described: frontal, side, back and silhouette lighting.

Frontal lighting is the standard image lighting that most people use to obtain a simple shot that records a view but that generally does not produce anything very atmospheric. The sun shines onto the landscape from behind the photographer, generating a relatively flat view with shadow areas reduced to a minimum and, as a result, some details and subtle landscape features such as gentle hill folds are not always clearly visible. This is the easiest kind of landscape view to shoot, both in terms of composition and correct exposure. It is probably also the most common, although it is certainly not the most creative. One problem to watch out for when

▼ A glorious dawn silhouette, courtesy of Japan's most active volcano, Sakurajima, which obliged by smouldering right on cue. Kagoshima, Kyushu, Japan. *Mamiya RB67, 250mm lens, tripod, 1/8 second, f/8, Fujichrome Velvia 50.*

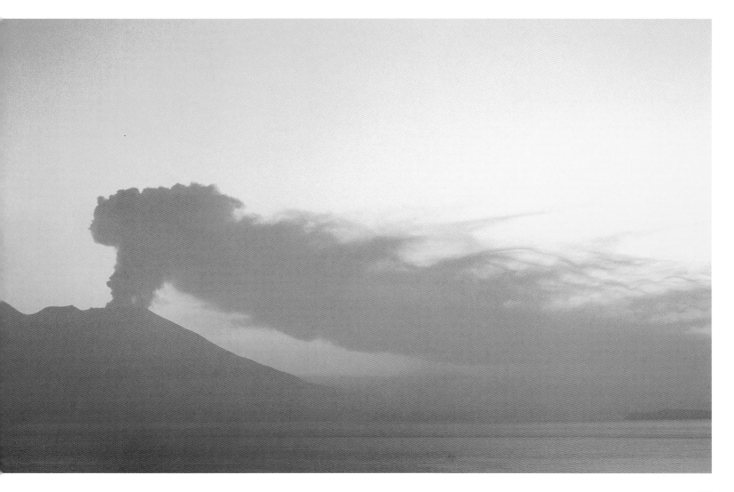

the sun is very low is the tendency for the photographer's own shadow to creep irritatingly into the image, no matter how much they try to hide.

Side lighting, with the sun shining towards the landscape view at about 90° to the camera, often generates considerably more dramatic images than is usual with frontal lighting. With the light at this angle, shadow areas are clearly visible. A low sun in particular maximizes surface texture and detail; each landscape element is sharply picked out by the shadows each creates, and the patterns of grasses, trees, rocks and the smallest contour variations are clearly visible. The one problem that can arise here, as mentioned already, is the huge contrast range that may develop between deep shadow areas and brightly reflective highlights lit by clear sunlight. A little haze can help to reduce the contrast range, but can be detrimental to the overall image quality if the landscape view being photographed is long-range or once the amount of haze passes an acceptable level.

Back lighting is one of the most creative techniques available to the landscape photographer, but it can also be one of the hardest to pull off successfully. Because the

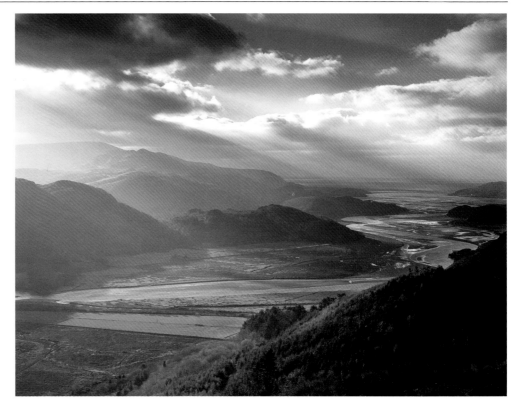

sun is at more than 90° to the camera, it is shining at the front of the lens and so has a tendency to spill into the lens's field of view, resulting in flare. To eliminate this, it is absolutely essential to use a lens hood. When used successfully, the results can be stunning. Detail in the image is reduced and many of a view's large components, such as hillsides, are likely to receive little direct sunlight. Instead, outlines are emphasized, often generating a halo around many of a view's elements, such as the outer edges of trees and grasses, and rippled water may sparkle beautifully.

The final lighting angle is the silhouette, which, strictly speaking, is simply an extreme form of back lighting. All detail is lost; the solid areas become completely black, and the strength of the image relies on the subject's dramatic outlines and density of the black areas. Overall, a good silhouette image becomes a powerful monochromatic view in which outline is everything. As with all forms of back light-

▲ A backlit image, with heavy clouds breaking the sunlight up into rays, showing a winter view across the valley of the Mawddach River towards the massif of Mt Cader Idris. Snowdonia National Park, Wales. *Mamiya 645, 55mm lens with polarizing filter, tripod, 1/30 second, f/11, Fujichrome Provia 100F.*

◀ Low side-on sunlight gives rich, warm colours and strong shadows, especially when a polarizing filter is used. A small lake in Little Langdale, Lake District National Park, Cumbria, England. *Mamiya RZ, 250mm lens with polarizing filter, tripod, 1/60 second, f/8, Fujichrome Velvia 50.*

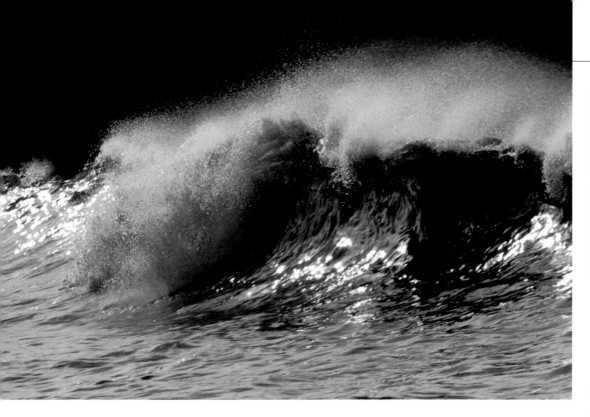

◀ Back lighting of surf highlights the spray flying off the wave's crest, as well as creating a gleaming highlight along its foot. Thurlestone, Devon, England. *Canon EOS 5, Sigma 70–200mm lens plus 2x converter, tripod, 1/250 second, f/5.6, Fujichrome Provia 100F.*

ing, problems may arise from flare in the lens, only more severely. Naturally, a lens hood is essential. One way to avoid flare is to shoot when the sun is still high, although this will reduce the strength of the silhouette, often reducing the blacks to wishy-washy grey and allowing a few distracting details to become visible.

The best silhouettes are obtained when the sun is low, but this then increases the risk of flare in the lens. This can be overcome by either shooting a silhouette that is a little off to one side of the sun's line or by waiting until after sunset and then shooting a dusk silhouette. The latter will not, of course, produce a monochromatic image, as there are likely to be red and orange hues in the sky. It is also possible to include the sun in the view, a ploy that, if successful, can be extremely dramatic. Using a very narrow aperture will reduce the sun to a spectacularly sharp starburst, whereas having a wide aperture will leave it as a diffuse white ball. If the sky is very clear, having the sun in the image will almost guarantee flare, although this can be eliminated if the sun's glare can

be reduced. This will either happen naturally if there is some haze; it can also be manipulated by waiting for the sun to drop behind, or partially behind, a very small thin cloud or aircraft vapour trail or by partially hiding it behind a building, rock outcrop or tree. Getting this right is quite difficult. Success depends on the photographer's being able to stand in just the right position, relative to the obstacle, to block exactly the right amount of sun. Block too much sun and its dramatic effect in the image will be reduced. Not block enough and the image will be filled with flare. Even a tiny adjustment, such as repositioning of a leg by a few inches, or a small cloud movement, can make or break the image.

▼ A silhouette view of O-Torii (the Great Gateway), an iconic symbol of Japan, shortly before sunset. The sun is almost in the middle of the field of view, but the risk of flare in the lens has been greatly reduced by hiding it behind a downward-pointing tree branch, a shape that adds an interesting element to the image. O-Torii, Miyajima Island, Hiroshima, Japan. *Mamiya RB67, 65mm lens, tripod, 1/125 second, f/11, Fujichrome Velvia 50.*

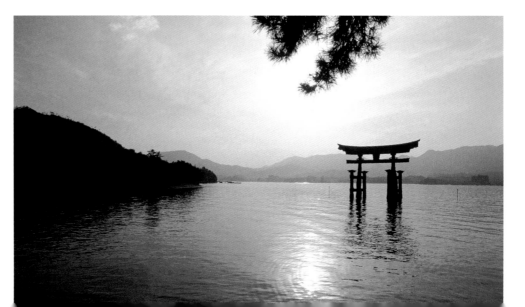

MATCHING LIGHT TO SUBJECT

It may seem blindingly obvious to say this (although it is amazing how often it is overlooked), but if a photographer intends to convey a certain mood in an image, it is essential to combine the relevant landscape view with the right light and camera-to-sun angle. It is no good trying to convey a peaceful, calming dusk scene if the sky is filled with angular scudding clouds lit by an angry pre-storm light, for example. And, of course, the reverse is also true.

Since we have absolutely no control over the weather and the light it delivers, it is important for the photographer to have in reserve a store of different landscape scenes – views that can be chosen on any given day according to the weather: for example, lovely tranquil dusk scenes for very calm, clear weather; woodlands or waterfalls for dull, cloudy days, turbulent seas and steep cliffs or rugged mountains with deep valleys for those wild and windy days. Knowing which to shoot on a given day (assuming all or at least a selection of these are within reasonable driving distance) will come down to knowing the weather forecast, combined with personal weather intuition and a feeling for what kind of photography will work as a result.

TECHNICAL ISSUES IN HANDLING THE CAMERA

So far, this chapter has concentrated on the ways in which the photographer should use nature to help produce good landscape images. There are also, of course, a number of technical issues surrounding the way the camera is used to make the best use of the light nature provides. These include:

1 An understanding of the different sensitivities of film and pixel to different types of light.
2 The correct use of filters and digital adjustments to both manip ulate these sensitivities and generally enhance a landscape view.
3 Correct metering to obtain the best exposures.

These are all covered in detail in the following sections.

CONTROLLING COLOUR BALANCE

As described in the previous chapter, daylight film is balanced to give the correct colours under sunlight at about midday, a time when the light contains a roughly equal mix of all the colours of the rainbow and so is truly white light. Such light has a colour temperature of about 5500K. If the light's colour temperature changes significantly from this level then the colours recorded by the film will change accordingly. Cloud cover will increase the balance of blue light and so will raise the colour temperature, whereas for short periods after sunrise and before sunset it will be below 5500K as it is rich in red light. We often do not register these changes as our minds compensate for what we know to be the correct colours. Film, however,

A **B**

▼ The same view of a river in the mountains of Taiwan, photographed on different days. The first (A) was taken in the middle of the day. The combination of white light and an 81B filter enabled the camera to record the vegetation as strongly green. The second image (B), however, was taken without any filtration and early one morning, before the sun had risen above the mountains, resulting in very blue vegetation. *Mamiya RB67, 65mm lens, tripod, Fujichrome Velvia 50, for (A) 1 second, f/22; (B) 3 seconds, f/22.*

will record the changes faithfully. The reds of dusk, for example, appear in an image much redder than they do to the eye simply because the light's colour temperature is well below that for which the film is balanced.

Years of photography with colour film have led to the development of a series of filters to help correct for these colour temperature changes (see Chapter 1, page 19), most often aimed at compensating for

excess blue light, a colour cast that is usually considered unwelcome due to its 'cold' feeling. An increase in red light in an image is generally considered desirable for its warm atmosphere, so photographers rarely bother to counter it. The pink 81 filters are a standard inclusion in the landscape photographer's kit, usually A and B, the latter being the stronger. There is also a C filter, but this is too strong for most uses. The A and B filters are frequently used to overcome excess blue light on overcast days and in shadow areas on bright sunny days, but they are rarely strong enough to fully counter the blue light of dawn or dusk.

As described in Chapter 1, digital cameras balance their sensitivity to colour temperature using a white balance mechanism (see page 21 for a description). For the landscape photographer, its most important settings are cloudy and sunny, although the custom white balance can be important on occasions for fine-tuning under awkward light. The automatic white balance (AWB) setting, which should automatically detect the lighting conditions and set the camera to overcome any excess blue or red light, in some camera models at least seems to favour excess blue in the final image, suggesting that it is not wholly to be trusted. It seems to be better to make use of the cloudy and sunny settings rather than the AWB and, if in doubt in any particular lighting situation, either shoot on both or use a custom white balance setting.

Correct use of the white balance system should make the 81 filters unnecessary, although they can always be added if necessary. Remember that if using the AWB setting, the 81 filters will be useless: once on the lens the camera will automatically compensate for their presence, putting extra blue into the image. In cameras where it is possible to enter an exact colour temperature, extremely fine tuning of the colour balance is possible, provided the photographer has a very firm grasp of the colour temperature scale and how to use it.

POLARIZING FILTERS

Penetration of haze, increase in colour saturation and removal of reflections: these are probably the most important jobs of the amazing polarizing filter. An absolute must in the landscape photographer's bag, regardless of whether they shoot on film or digitally, polarizers are used mostly during sunny weather, turning a pretty good view into a superb image, mostly due to the impact they have in increasing colour saturation. Consisting of two sheets of glass between which is sandwiched a polarizing foil, the front sheet can be rotated to change the angle of the foil, providing a variable degree of polarization from zero to whatever maximum is possible under the lighting conditions.

The polarizer's effectiveness varies according to conditions and it may be necessary to alter its use to match. I generally do not use a polarizer very much when shooting silhouette or backlit images, as the only effect it has here is to reduce reflections, particularly those coming off water. This may be useful, if only to reduce

▼ The effect of a polarizing filter can be clearly seen in this pair of images. The image that has been polarized (B) shows stronger greens, a richer blue sky and fewer reflections in the water.
Canon D30, Sigma EX 17–35mm lens with and without polarizing filter, ISO 100, for (A) $\frac{1}{125}$ second, f/16; (B) $\frac{1}{60}$ second, f/13.

the amount of glare, but it can also have the negative effect of reducing the general sparkle and vitality of the image.

The polarizer's main use is in side and front lighting, although it may have a fairly minimal effect on an image that is front lit. Polarization is at a maximum with side-lit images, where the increase in colour saturation can be huge. However, the contrast range can become too big for film or pixel to handle, creating excessively dense shadows. To limit this, it may be desirable to decrease the level of polarization a little by rotating the filter away from maximum.

In cloudy conditions, the polarizer is often best left off the camera, as it may produce slightly 'muddy' images. In images containing a lot of vegetation, however, especially if the vegetation is quite close, it can be beneficial if shooting on film to use both a polarizer and an 81 filter (or a 'warm' polarizer that contains pink colouring specifically for this use) to remove both the inevitable blue cast and reflections from the leaves. The eye often fails to see most reflections as they are such a normal part of vision, so the change that results when they are removed by a polarizer is quite startling. Colours are enriched and random patterns of white and grey, the usual colour of the reflections, are completely eliminated.

The polarizer can also be particularly useful when photographing vegetation in

gloomy conditions or when it is raining. It enhances the greens of the vegetation (which will probably be quite vivid anyway in these conditions) and removes reflections from the wet leaves.

It is also very useful in the photography of waterfalls, rivers and streams in any weather conditions, removing reflections from both wet rocks and the water surface. The normally annoying fact that polarizers reduce the light reaching the lens by 1½–2 stops can be beneficial with waterfalls, making it easier to have a shutter speed slow enough to blur the water, even on the sunniest of days. Be warned, however: a polarizer will totally erase a rainbow in both a waterfall's spray and in the sky, so it cannot be used in these situations.

GRADUATED NEUTRAL-DENSITY FILTERS

These are the only other 'must-have' filters in the landscape photographer's kitbag. They are commonly used, again in both film and digital photography, when a view consists of a relatively dark landscape and a bright sky. This is a common scenario under bright overcast conditions and at dawn or dusk, when the contrast range between sky and land is too great for film and pixel to accommodate. Without the use of a graduated neutral-density filter (called ND grad for short), an image of such a view would inevitably consist of either a correctly exposed landscape topped by a burned-out white sky, or a correctly exposed sky with a landscape lost in gloom. The ND grad reduces the contrast range, making it possible to produce an image in which both land and sky are correctly exposed.

The filter consists of two parts, one clear and the other dark. The aim is to place the darkened area over the bright part of the view. The trick is to ensure that the filter's transitional zone between clear and dark lines up with that in the view, something that

◀ Several different types of graduated neutral-density filter from Cokin and Singh Ray, cutting light by two and three stops, with soft and hard dark/light transitions.

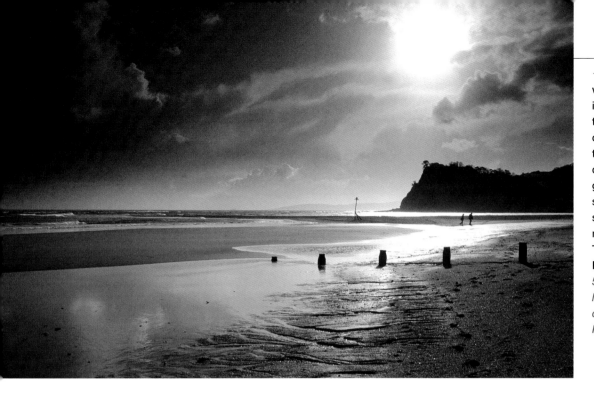

◀ On a stormy day, with a diffused sun visible through scudding thin cloud, the sky was quite bright, although the ground was rather dark. A three-stop graduated neutral density filter darkened the sky, producing this dramatic stormy image. Teignmouth, Devon, England. *Canon EOS 5, Sigma EX 17-35mm lens, tripod, 1/30 second, f/5.6, Fujichrome Provia 100F.*

takes practice. A complete set of ND grads generally consists of up to six filters: three different darkened densities, cutting the light by one stop (ND 0.3), two stops (ND 0.6) and three stops (ND 0.9), and two types of transition between the darkened and clear parts of the filter: hard and soft.

Hard filters have a sharp division between their clear and dark areas. They should only be used in situations where the view to be photographed has a clear, distinct horizon, such as the sea or relatively level ground. Aligning the division with the horizon is critical, as any error will be visible in the final image. It goes without saying that it is essential that the camera is mounted on a tripod to ensure the filter's light–dark transition stays in just the right place.

Soft filters have a gradual light-to-dark transition and can be used in most other situations, especially where the division between dark and light parts of the view is uncertain, such as in a forest where the lower areas are clearly very dark and the upper area towards the sky is clearly far too bright.

With most types of filter, the photographer has the choice of whether to use round filters that screw onto the front of the lens or square/rectangular ones that slide into a mount attached to the lens. With ND grads, however, the latter filter system is the only workable option, due to the need to slide the filter up and down to ensure that the clear/dark transition line is correctly aligned with the view.

SUCCESSFUL METERING

It will be obvious that the use of a meter to obtain correctly exposed images is critical to success, even in digital photography where post-photography processing is possible. For the vast majority of photographers, this means using the camera's own through-the-lens (TTL) meter, a piece of equipment that is not entirely foolproof.

The great majority of TTL meters have several settings. These include spot metering, covering as little as 1° at the centre of the viewfinder; centre-weighted, which meters about one-third of the image around the centre; and an overall metering, which measures the light right across the camera's viewfinder. Most often, the second or third of these is used for general photography, while the first is used for specialized images where only the lighting from a very limited part of the view is relevant to the final image.

HOW THE METERS WORK

The way these meters work is that they aim to expose everything correctly for a mid-tone. This means that light-coloured areas will tend to become underexposed (the meter wants to turn a white area to grey, for

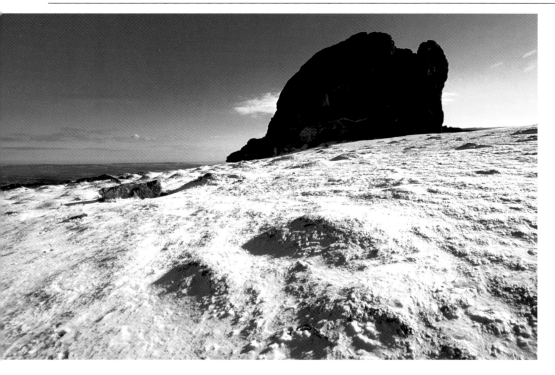

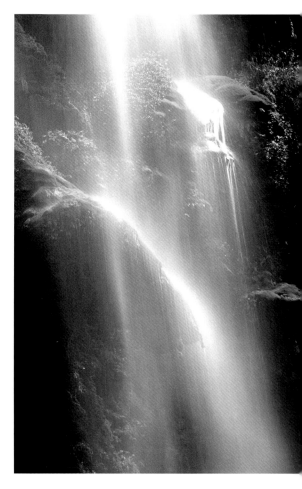

▲ Brilliant white snow can easily cause a camera's light meter to underexpose an image. This image had to be overexposed (according to the meter) by over a stop to get the correct exposure. The rock in the background is black largely due to its being backlit. Haytor, Dartmoor National Park, Devon, England. *Canon EOS 5, Sigma EX 17-35mm lens with polarizing filter, 1/90 second, f/11, Fujichrome Provia 100F.*

▶ Despite the water in this waterfall cascading down a vertical cliff, the high sun somehow still managed to provide back lighting, enabling the water to glow in the light. Maling Falls, Guizhou province, southwest China. *Canon EOS 5, Sigma 28–70mm lens, tripod, 2 seconds, f/22, Fujichrome Provia 100F.*

example), while dark areas will tend to be overexposed (the meter will want to expose a black section to make it grey). The result is that an image containing a lot of light colours, for example snow or sand, will tend to come out too dark, while an image containing many dark areas will come out too light. For this reason, photographers shooting on film almost always bracket their images, shooting a range of photographs that, according to the TTL meter, are both over- and under-exposed as well as correctly exposed, allowing the photographer to choose later which images have the best exposure. With digital photography, of course, this is less important, as an image that is too dark or too light will be immediately obvious on the camera's LCD screen and can be reshot with a different exposure if necessary.

Exposures are usually very accurate for evenly lit views, especially ones frontally lit. Problems can arise, however, with sidelit and most especially backlit views. The large shadow areas common in such lighting can fool the meter into believing that the image should be lighter than the photographer may actually want, so the meter's 'correct' exposure actually overexposes the image as a whole. From the photographer's point of view, the best image may be one that

is underexposed – i.e. darker than the meter calculated to be correct. Taking several bracketed exposures, especially if shooting on film, will avoid disappointment.

If shooting silhouettes, of course, most of the image is in shadow and should come out black, so the meter may well want to overexpose the image to convert these blacks to a mid-tone grey. However, this may be compensated by the sun's glare shining at the lens or reflecting off water and will certainly be the case if the sun is included in the view. This bright white ball will make the meter want to underexpose the image hugely. It may be difficult to decide which will have the greater impact on the meter's setting – the large black silhouettes in the view making the meter want to over-

expose, or the powerful white ball of sunlight making it want to underexpose the image. It is possible that the two will balance each other and the meter's 'correct' exposure will give the perfect silhouette image, but to be sure a photographer using film may want to do lots of exposure bracketing.

Some of the most advanced cameras can overcome many of these exposure problems through evaluative metering. This is a system that measures the light from a large number of squares across the viewfinder and then evaluates what the best exposure should be according to stored information. These meters are often very accurate, reducing the need to bracket exposures.

Metering When Using ND Grad Filters

One area where the photographer must be very careful with metering is when using ND grad filters. The filter will have a major impact on the meter's reading, so all metering must be done before putting the filter in place. Exposure settings can then be set manually once the filter is attached. The first step is to meter the bright and dark parts of the view.

This can be done by first pointing the camera at the dark area (usually the land) and then at the light area (usually the sky). When doing this, the viewfinder must contain only the bright or the dark zones, not a mixture of each. So, if intending to photograph the view with a wide-angle lens, it may be necessary temporarily to switch to a telephoto lens to take these initial meter readings. The different exposure readings for the light and dark areas will show which ND grad is needed. For example, if a correct exposure for the land is f/8 at 1/30 second and for the sky is f/16 at 1/30 second, that is a two-stop difference (f/8 to f/16), requiring the use of an ND 0.6 filter.

The correct exposure for the whole image once the ND grad is in place will be that obtained for the land, the image's dark area. Before taking the picture, this exposure should be entered manually. Leaving the camera on any of the automatic exposure settings may lead the meter to be fooled by the ND grad filter into providing an inaccurate exposure. As the usual precaution, photographers using film should take several bracketed exposures.

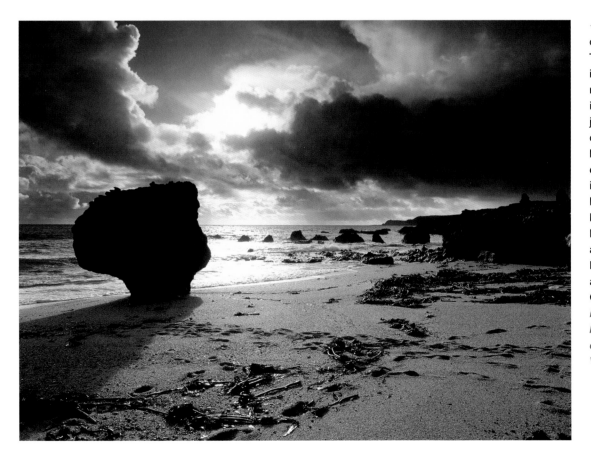

◀ A silhouette image of rocks on a beach. The risk of flare in the image has been greatly reduced by shooting when the sun was just behind the edge of a cloud. The timing had to be perfect: the cloud was fast-moving; a few seconds before, the view had been overwhelmed by too much sunlight, and a few seconds later there was no sun at all. Mattiscombe Cove, Devon, England. *Mamiya RZ67, 50mm lens, tripod, 1/125 second, f/11, Fujichrome Velvia 50.*

3 Nature

◀ Handheld fill-in flash photography of a black-and-white ruffed lemur at Singapore Zoo. Although the weather was sunny, the lemur was sitting in dense shade under a canopy of trees, so flash was needed both to provide enough light and to balance against the patches of bright light that were penetrating through the tree canopy. *Canon EOS 5, Sigma EX 70–200mm lens with flash, ⅟₆₀ second f/5.6, Fujichrome Provia 100F.*

▶ Beech leaves backlit against a blue sky. In early summer the beech hedge in my garden goes mad, producing long stems with beautifully green new leaves. The only way I could really capture their beauty was to cut a stem off and hold it up between the camera and the sky, getting this lovely backlit shot. *Mamiya RZ67, 110mm lens with polarizing filter, ⅟₆₀ second, f/11, Fujichrome Provia 100F.*

A hugely important and popular branch of imaging, nature photography covers everything from microscopic ephemeral algae to gigantic ancient trees, from minute zooplankton through insects to the mighty blue whale. It can also encompass, in its broader terms, environmental issues, especially wildlife and habitat destruction, as well as positive conservation projects. In other words, nature photography covers every aspect of the natural world, a world that includes us.

It is sometimes claimed that to be a good nature photographer you must be a biologist first and a photographer second. However, of greater importance is a general empathy with the subject, for example a sympathetic treatment of animals conscious of and sensitive to the photographer's presence, and a concern not to damage the habitat of a rare plant while in the process of trying to photograph it. Such empathy will go a long way towards enabling great nature photography.

While empathy may seem to be a rather separate issue from that of lighting, they are inextricably bound up together. The first will help in the making of a range of decisions, such as how far the photographer is prepared to go in ensuring that a subject is well lit. For example, such knowledge should help to limit the degree to which a photographer might be prepared to stalk around wild animals to get into a better position relative to the natural light; how much they might be prepared to 'persuade' captive animals into a position with a better lighting angle; or how much 'gardening' they can do to improve the composition and lighting around a plant to be photographed. Such issues make up a major part of the decision-making process prior to taking a photograph and should be based both on an ethical view of how much intrusion is acceptable and how much risk the photographer might be prepared to take when getting close to potentially dangerous animals!

Lighting techniques vary enormously according to the subject to be photographed – after all, plants are very different subjects from mammals, which, in turn, are very different from fish or corals. So, lighting for each aspect of nature photography will be described in turn, starting with plants.

▲ A soft, even lighting has allowed the complex arrangement of green stems and blue flowers in the bunch of bluebells to be clearly visible, something that would be much harder in bright sunlight due to the mix of shadows and highlights. Devon, England. *Canon EOS 5, Sigma EX 70–200mm lens plus 25mm extension tube, tripod, ⅟30 second, f/11, Fujichrome Provia 100F.*

LIGHTING FOR PLANTS

The great advantage of plant photography over that of animals is, of course, that plants are not going to run or fly away. That in itself naturally makes it much easier at least to obtain a photograph of a plant, but not necessarily to obtain a truly meaningful image that captures its essence, beauty or biological function. Their rather awkward shape, as well as their great diversity of shapes and sizes, in addition to the usually relatively limited range of colours (there can only be so many shades of green) can make it extremely difficult to obtain a truly great plant image. All too often, plant images turn into just a confusing mishmash of tangled, indistinguishable green, often the result of poor lighting technique. It is not surprising that many of the best plant images concentrate on just one part of the plant: its flower, fruits or a leaf, for example, images that at the very least capture a part of the plant's biological function and hopefully some aspect of its great beauty too. How to light those images, using either natural light or flash, with or without reflectors and diffusers is always open to discussion.

Lighting techniques in plant photography, while hopefully aimed at helping to produce attractive, creative images, mostly concentrate on simply overcoming two major problems:

1 Achieving sufficient depth of field, i.e. ensuring that parts of the plant nearest and furthest away from the camera are both in focus.
2 Freezing any movement.

► Frost-covered grass early on a cold sunny morning, when the sun was so low that this patch was still in shadow. As a result, the light is extremely blue and although the grass looked perfectly green to the eye, even with the help of a polarizer it has still come out blue in the final image. Dartmoor National Park, Devon, England. *Canon EOS 5, Sigma EX 28–70mm lens with polarizing filter, tripod, 2 seconds, f/16, Fujichrome Provia 100F.*

◄ Photographing in a forest in bright sunlight can be a real problem, as the images often come out as a confusing mass of shadows and highlights. This image is a typical example. Northern Negros Forest Reserve, Negros, the Philippines. *Canon EOS 5, Sigma EX 17–35mm lens with polarizing filter, ⅟30 second, f/8, Fujichrome Provia 100F.*

SUNLIGHT VERSUS OVERCAST CONDITIONS

Most of the time natural light will be the main, if not only, source of light for plant photography. The question remains as to whether sunlight or cloudy conditions provide the best quality of natural light. To some extent, it depends on the subject, but as has already been mentioned, strong sunlight often produces plant images that are a confusing tangle of highlights and shadows.

Another consideration is the quality of vegetation colours – mainly green, of course – possible under different lighting conditions. Sunlight clearly generates vibrant greens, whereas bright overcast conditions will render green vegetation quite blue, something that will be very noticeable in images shot on film. In very dull conditions, just before, during or after rain, the greens can be very vibrant, so this can be one of the best times to photograph plants. Light levels will be low of course, so such photography is only likely to be successful if there is no wind, making it possible to use very long shutter speeds. One set of dull lighting conditions a photographer should avoid when photographing plants is that prevalent before sunrise and after sunset. At these times, the light is very rich in blue wavelengths, a situation that will result in images with quite blue vegetation, whether shot on film or digitally (although with a digital camera it is sometimes possible to correct this blue cast using the white balance mechanism (see page 21).

▼ The deep rich greens of wet forest vegetation just after rain, enhanced by a polarizing filter. Mt Talinis, Negros, the Philippines. *Canon EOS 5, Sigma EX 17–35mm lens with polarizing filter, tripod, 1 second, f/16, Fujichrome Provia 100F.*

Securing both can be tricky, as taking steps to succeed with one makes it harder to succeed with the other. Using a narrow lens aperture (i.e. high f number) increases depth of field but will inevitably mean a slower shutter speed. Using a fast shutter speed will freeze movement, but mean using a wide-open lens aperture (i.e. low f number), reducing depth of field. Increasing the ISO rating (to say 400 or 800) will solve both those problems, but will result in a grainy image, whether shot digitally or on film.

Improving the lighting clearly ought to be the best way to solve the problem, but how to do it is a big question. It usually comes down to working out difficult balances and choices between the use of whatever natural ambient light is available and the application of flash lighting.

If long exposures are being used, not only is a tripod essential, of course, but also photographers using digital cameras should remember to take into account the possibility of noise creeping into the shadow areas of their images, as described in Chapter 4 (page 73). Those shooting on film will need to consider the problems of reciprocity failure, described in the same section in Chapter 4.

Autumnal tree colours are generally best shot in sunlight, as this will bring the reds and

yellows to sparkling life in a way that just does not happen in dull weather. This is one time when the problems of confusing light and shadow areas come secondary to the colour-enhancing effect of sunlight.

It is in photographing flowers in particular that sunlight can create the most awkward shadows. This renders it difficult to appreciate the flowers' structure and beauty, so these subjects are often best photographed under cloudy conditions. This is especially true of complex flowers that might create a multitude of shadows in sunlight. In addition, any white or pale-coloured flower can be difficult to correctly expose in sunlight, especially when they are set against dark green vegetation.

An attractive way to photograph taller herbaceous plants in sunny weather is to shoot them when backlit. This is often feasible when the sun is low. It works most effectively with a translucent part of a plant, such as the flowers, and can be used to show up hairy stems or leaves, creating an attractive halo of light along their edges.

When photographing dark greens, care may be needed to ensure the best exposure. As described in the last chapter, back lighting can confuse a camera meter. Also, the usually dark green of many forms of vegetation, combined with the deep shadows that are often present in bright sunlight, may cause a camera's TTL light meter to overexpose the

▼ **Pale-coloured flowers often do not photograph well in bright sunlight, but in soft lighting – just after rain in this case – this wild impatiens comes out perfectly, set against its very dark green vegetation. Mt Kitanglad Range Natural Park, Mindanao, the Philippines.** *Canon EOS 5, Sigma EX 28–70mm lens plus 25mm extension tube, tripod, ¹⁄₁₀ second, f/8, Fujichrome Provia 100F.*

images. Photographers shooting on film will almost certainly need to bracket their exposures, concentrating on those that appear to be a little underexposed (as measured by the TTL meter, that is).

FLASH AND AMBIENT LIGHTING

If photographing in a forest, the natural ambient light level is often quite low. If out in the open with lots of sunshine, the resulting complex mass of bright areas and shadows can make an image almost unintelligible, let alone actually striking. In poor light and with wind causing the plants to move around, flash lighting (always using a detachable flashgun, not the flash built in to many cameras) is often the only practicable solution. There are basically two ways to use flash in this type of lighting:

1 As the main source of light, set to be much more powerful than the ambient lighting.
2 On a much lower power setting, as fill-in light balanced with the ambient light.

▶ **An example of a plant, the frond of a tree fern, backlit by sunlight. The result is stunningly vibrant, with both the colour and the leaf's structure shown off to their best. Mt Talinis, Negros, the Philippines.** *Canon EOS 5, Sigma EX 28–70mm lens with polarizing filter, ¹⁄₆₀ second, f/11, Fujichrome Provia 100F.*

◀ In this image of backlit ripe barley, all the ears and whiskers are brightly lit up by their own halo of light. Lüneburg Heath, Germany. *Canon EOS 5, Sigma EX 70–200mm lens, tripod, 1/60 second, f/16, Fujichrome Provia 100F.*

▶ An unidentified forest flower photographed under windy conditions. With the plant in constant motion due to the wind, the only way to get a useable image was to shoot with flash as the dominant lighting source, allowing the background to fall away into darkness. Danjugan Island, Negros, the Philippines. *Canon EOS 5, Sigma EX 28–70mm lens, tripod and flash, 1/60 second, f/8, Fujichrome Provia 100F.*

Using the flash as the main light source allows the photographer to shoot with both a fast shutter speed and a reasonably narrow aperture, freezing movement and usually providing the necessary depth of field. However, the background will be completely dark and, if using a single on-camera flashgun, there are likely to be hard shadows around at least some parts of the photographed plant. Leaves with waxy surfaces will also reflect the light from this flash, causing burned-out highlights. The dark background gives a rather unnatural feeling, but can make for a very striking image with the plant totally isolated from its environment. Never fire a flash directly at a white flower, as it will be quite difficult to obtain an image in which the flower is correctly exposed.

Harsh shadows on the plant can be reduced by heavily diffusing or bouncing the flash. Burned-out highlights, including white flowers, can be minimized or lost altogether by setting up the flash some distance to the side of the camera. The exact distance depends to some extent on the size of the plant. Using two flashguns (not always easy when working alone out in the field) set up some distance from either side of the camera will reduce both shadows and highlights.

Balancing the flash with the ambient lighting usually provides much more natural results, ensuring, for example, that the background remains correctly exposed, although it may not overcome the depth of field/freezing movement conflict. However, provided the shutter speed is no more than about

◄ Coming across a cluster of pitcher plants in a rainforest, in dismal light and rain threatening, the only way I could get a photograph was to use flash. Fortunately, since it was windless, I was able to use a long exposure to ensure it balanced with the background light. Although not entirely natural in appearance, this image is a lot more attractive than what would have resulted from just using the ambient light! Mt Halcon, Mindoro, the Philippines. *Canon EOS 5, Sigma EX 28–70mm lens, with flash and tripod. 4 seconds, f/8, Fujichrome Provia 100F.*

¼ second, the low-level flash is often enough to freeze a small amount of breeze-induced movement in the resulting image, allowing the photographer to set a reasonably narrow aperture to maximize depth of field.

In my opinion, if the goal is images with a natural appearance, it is better to stick as much as possible with the ambient light, using flash as a fill-in. Use of flash as the principal light source is reserved for dire situ-

we hardly notice them. Hold up and rotate a polarizing filter in front of the eye, however, and the change can be quite stunning; the entire view of vegetation is transformed. One of the reasons for the polarizer's colour-intensifying effects is the removal of reflections. The absence of the mass of dull grey and whitish patches – the seemingly random reflections of sky in wet or waxy leaf surfaces – allows the full colour of the vegetation to reveal itself.

The downside of the polarizer is that it reduces the light available by up to two stops, thus greatly exacerbating any prob-

▲ The strong greens of wet plants in dim light seen through a polarizing filter. Mt Batur, Bali, Indonesia. *Canon T90, 24mm lens with polarizing filter, tripod, ¹⁄₁₅ second, f/16, Fujichrome Provia 100.*

ations where an image of a plant is essential but where wind levels make a slow shutter speed impossible. It should never be used in windless situations where very slow shutter speeds are viable – that is what photographers have tripods for. However, where this flash method can be used to good effect is when aiming to produce images with a studio-like feel to them, with the plant isolated from its environment by virtue of the dark background.

USE OF FILTERS
POLARIZERS
Probably the most important filter for plant photography is the polarizer, as it is for landscapes. Essential in both film and digital photography, it is highly effective in enriching colours and in removing reflections from leaves. As such, it is useful in both sunshine and cloudy weather. The intensifying effect it has on sunlit greens is quite stunning, especially when set against a deep blue sky, although in deepening shadows and increasing contrast it may accentuate the problems of confusing patterns of light and shadow. A polarizing filter will also intensify other flower and foliage colours.

Its value in removing reflections is not immediately obvious for the simple reason that we are so used to seeing reflections that

BALANCING FLASH WITH AMBIENT LIGHT

If using a flashgun with automatic TTL metering, achieving balance between flash and ambient light is usually very easy. The flashgun will automatically set its output level to match the ambient level metered by the camera. However, if the camera's lens aperture/f number setting flashes when showing its widest setting, this usually means that the flash is too powerful and is unable to quench its power down low enough to match the ambient light. Solve this by reducing the shutter speed. This will have no effect on the flash itself, but it will decrease the lens aperture (i.e. increase the f number), retaining the correct exposure for the ambient light and matching the lens aperture to that needed to correctly expose for the flashgun's minimum output.

If both lens aperture and shutter speed settings flash, this usually means that the flash lighting is too weak, usually the result of the subject-to-flash distance being too great.

If using a flashgun that does not have automatic TTL, ambient-to-flash lighting balance will have to be set manually. First, measure the flashgun's distance from the subject and then, using its guide number, calculate the lens aperture needed for correct exposure (see the calculation in the following section on flashguns on page 50). Set the camera lens's f number accordingly. Then meter the ambient light and set the shutter speed needed to give correct exposure at this lens aperture. The camera and flashgun are now balanced and ready to fire. Flashguns that do not have automatic TTL metering usually come with a table giving correct apertures for a variety of distances and ISO ratings. To speed up the calculations, this should be stuck to a prominent part of the flashgun.

If handholding the camera, be sure not to reduce the shutter speed to levels where camera shake will become a problem. If the lens aperture setting still flashes when the shutter speed is reduced to the minimum that is safe for sharp handheld photography, the flash will become the dominant light source; the subject will be correctly exposed, but the background will fall away into darkness. Of course, if the camera is mounted on a tripod, then the shutter speed can be reduced as far as is necessary for balance to be achieved, provided that subject motion is not a problem.

lems the photographer might already be having getting both a fast enough shutter speed and a large enough depth of field.

The 81 Series

The second most important filter for photographers using film, again as with landscape photography, is the 81 series of pink filters, used to remove blue casts from leaves

on bright overcast days. In many such situations, it may need to be combined with the polarizer to achieve complete removal of both the excess blue and reflections. Photographers using a digital camera can manage without the 81 filters provided they correctly use the sunny and cloudy settings on the white balance feature.

Red Enhancer

A third filter that may sometimes be of use is the red enhancer. Doing exactly as its name suggests, it strengthens colours at the red end of the spectrum, so in plant photography it is particularly useful in the autumn. At this time of year, it can be used to strengthen the reds and yellows of dying tree leaves, particularly if the leaves are past their best or if being photographed on a dull day when their colours would otherwise be rather muted. However, because a red-enhancing filter is a magenta colour, it will usually weaken greens (magenta being opposite green on the colour hexagon) and introduce a colour cast to whites and pale colours. Consequently, in views where these colours are prominent, the red enhancer may not be a workable option.

Diffusers and Reflectors

Clearly, sunlight can be a mixed blessing in plant photography, but the use of diffusers and reflectors can help to manipulate it into being wholly beneficial, at least for shooting small subjects.

Bright side-on sunlight will in many cases create an image in which the plant is brightly lit on one side but lost in shadow on the other, particularly in areas shaded by large leaves. This strongly uneven lighting can be reduced by using either a diffuser or a reflector, or both. Inevitably, their practicality in the field will be limited by the size of what can be carried and so will only be useful with relatively small plants.

A sheet of card that can be folded up when being carried, either white or covered with aluminium foil, makes for a very good and easily carried reflector. Since smooth aluminium foil tends to reflect light in a rather

The Flashgun

The detachable flashgun is an immensely versatile lighting tool for the location photographer. Powered by batteries or a small power pack, it can be used to provide light in a number of situations.

The light from all flashguns has a colour temperature of 5500K, balancing it with both midday sunlight and the colour sensitivity of daylight film. Most flashguns these days have automatic TTL metering, which means they automatically measure and control the light they produce, relieving the photographer of some complex calculations.

Maximum flashgun power varies greatly from one model to another, but few are able to provide light beyond about 15 metres (48ft). This is an important factor in choosing a flashgun. As an aid, all flashguns come with a guide number (GN), an indication of its maximum power and the result of the following calculation:

GN = f number x flash-to-subject distance (in metres)

The GN will also depend on the ISO rating and focal length of the lens used, so these need to be clearly stated, usually given by manufacturers for an ISO rating of 100 and a 50mm lens. The GN number makes it possible to work out how far a flashgun can throw its light for a given lens aperture and focal length. Clearly, the higher the GN, the more powerful a flashgun is.

Of vital importance is a rotating flash head – the top part that actually contains the lamp. A fixed flash head is of limited use, as it will deliver only direct flash lighting. Although it will still be possible to diffuse light from a fixed head, it will not be possible to bounce it off a reflector.

◄ One way to give indirect flash is by bouncing it off a reflector. With this one, the flash head is pointed straight up and the reflector attached to the top with Velcro.

THE FLASHGUN IN USE

Here are a few basic tips on how to use a flashgun successfully:

1 A flashgun's light can be diffused by stretching a piece of translucent material over the lamp lens or by using a purpose-made translucent plastic cap. Some flashguns have a diffuser plate built into the top of the flashgun, which can be slid out and then hinged down over the lamp lens. This also works to broaden the flashgun's beam, making it possible to use with a wider angle lens than would otherwise be possible.

2 To bounce the flash, the rotating head should be pointed directly upwards and a reflector attached. Diffusers and reflectors should not in any way impede the sensor cell (usually near the base of the flash), which is vital to the TTL metering. Diffusing or bouncing the flash will inevitably reduce the distance over which it will effectively fire light.

3 The duration of a flashgun is much shorter than the shutter speed, typically only about 1/1000 second. This means that altering the camera's shutter speed will have no impact on the correct flash exposure, provided the shutter speed is kept below the maximum at which it will synchronize with the flash.

4 Altering the aperture will affect the correct flash exposure. The narrower the aperture, the higher the flashgun's output will need to be to provide the correct amount of light.

harsh way that results in unnatural-looking bright highlights on the plant, the foil should be crumpled before being laid over the card to ensure diffuse reflection and an even lighting across the plant. Placed on the opposite side of the plant from the sun and below it, a reflector will bounce sunlight into a plant's shadow areas, thereby greatly evening out the lighting.

A diffuser, a sheet of white translucent material placed between the sun and the plant subject, similarly evens out the lighting, this time by reducing the glare and intensity of the light falling on the plant. A problem here is that the diffuser may need to be quite large and so could be awkward to carry, although I have found that a white translucent studio umbrella works well. It is important to ensure that the whole background is either also covered by the diffuser or is at

▼ The effects of photographing flowers, in this case common self-heal, a wild herb frequently found in Britain, in sunlight with and without reflectors and diffusers: (A) photographed in bright sunlight (the sun high and coming from the left) with no reflector or diffuser; (B) bright sunlight, with a foil reflector to the right; (C) bright sunlight, with a diffuser shading the plant; (D) bright sunlight with both a reflector and diffuser in place. The first is attractive but has quite a few shadows. With the reflector in place, shadows on the right side and under the leaves have been removed, giving fairly even lighting. With a diffuser in place, the image becomes very similar to those obtained in bright overcast conditions, with very even lighting and few shadows. With both a diffuser and a reflector in place, there are even fewer shadows – the image is perhaps a little too shadow free. Devon, England. *Canon D30, Sigma EX 28–70mm lens with 25mm extension tube, tripod, 1/60 second, f/11, ISO 100.*

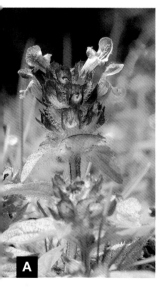
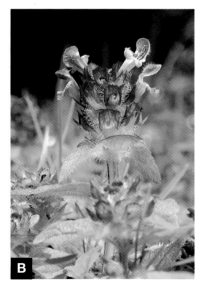

A

B

C

D

least out of the sun, otherwise the effect will be unnatural, with the subject softly lit and the background in hard sunlight.

LIGHTING FOR ANIMALS

Let's face it. Animals do not make great photographic models. They do not listen to instructions, they rarely pose properly and many are appallingly camera-shy. The most nervous are prone to scurry away at the mere sight of the photographer – let alone the camera – convinced that death is otherwise imminent. Why do photographers persist in trying to photograph them? Of course, because they are among the most beautiful, miraculous and often most charismatic of nature's creations. Any record of our magnificent planet would be utterly incomplete without images of the animal kingdom.

The trouble is, delivering the most effective lighting for the photography of such uncooperative models can be a truly nightmarish problem, often consisting of unsatisfactory balances and compromises between different kinds of natural light and, for some types of subject, flash lighting. This section describes the types of lighting available for photography of terrestrial animals that are large enough to be photographed without the use of a macro lens: what you might call the 'standard' kind of animal photography, if such a thing exists.

MAKING USE OF NATURAL LIGHT

It would be great to be able to use sunlight shining from just the right angle at all times for all subjects, but of course, even when it is the most appropriate light, it rarely shines on cue and almost always from the wrong angle. Because of sunlight's unreliability, at least in the world's cloudier temperate zones, it would be nice to be able to say that it is not really very important and that animal photography can be conducted just as successfully in cloudy weather. Alas, all too often, this simply is not true. It is quite amazing how both mammals and birds become almost

two-dimensional in dull weather. Even the most unlikely skin and feather colours manage to merge to perfection with the background, rendering it impossible to produce worthwhile images.

As a general rule of thumb, I find that photography of animals works under cloudy conditions only when they are at least reasonably close, so there is absolutely no danger of their becoming rather flat and merging with their background. Even then, I am cautious about shooting under these conditions, particularly with birds, and usually prefer to wait for some sunshine.

Only when the sun comes out do animals generally appear in all their three-dimensional, full-colour glory and even then, from the perspective of high-quality photography,

▲ A young red fox seen in evening light, which although not sunny was quite bright with a warm quality to it. The absence of sun means there are no awkward hard shadows or highlights, while the brightness ensures the fox is quite well lit and stands out from its background. Sussex, England. *Canon EOS 5, Sigma EX 70–200mm lens, tripod, 1/125 second, f/8, Fujichrome Provia 100F.*

only really when the sun is fairly low and rich in red light. Admittedly, a fairly soft sunlight is often the best. A bright harsh light, as with plants, sometimes leads to too great a contrast range and hence hard shadows and burned-out highlights. The low-level, red-rich sunlight of sunrise and sunset will usually add a lovely glow to most animals' colours and may well increase the three-dimensional feeling of many animal images. This is particularly important with animals that are well camouflaged against their background.

From the perspective of the subject–camera–sun triangle described in the last chapter, the lighting angle most commonly used is frontal. This is especially important if the animal species are to be clearly identifiable in the images. However, back lighting can produce stunning images, sometimes allowing species recognition to be possible, but often generating highly atmospheric images in which backlit hair, for example, can create a bright halo ring around an animal. Silhouettes are possible with animals on a high ridge when the sun is low.

LIGHTING ANIMALS WITH FLASH

With sunlight so unreliable and often rarely available anyway in the sorts of places where wildlife is found, such as woodlands, it would be highly beneficial to be able to substitute flash lighting whenever necessary. This is often quite possible with amphibians and reptiles, animals that frequently are not too sensitive to the human presence,

◀ A red deer stag photographed in golden evening sunshine. The low sun angle makes for very warm colours that complement the deer's coat, while not creating harsh shadows and highlights. Sussex, England. *Canon EOS 5, Sigma EX 70–200mm lens plus 2x converter, 1/250 second, f/8, Fujichrome Provia 100F.*

▼ This snake, a red-necked keelback was photographed with handheld camera and fill-in flash. Although it was quite dark under the tree cover, it was still possible to balance the flash with the ambient light. New Territories, Hong Kong. *Canon T90, 100mm macro lens with flash, 1/30 second, f/5.6, Fujichrome Provia 100.*

▲ One of those few occasions when the handheld camera, fill-in flash technique can be used with wild mammals, in this case a rhesus macaque. A large band of macaques live in the forests of Hong Kong's New Territories and (having become totally at ease with people) are easily approached for this kind of photograph. *Canon T90 100–300mm lens, with flash, 1/60 second, f/8, Fujichrome Provia 100.*

provided the human moves slowly and carefully. Sadly however, when photographing wild mammals and birds, it is usually not possible to get close enough for flash to be particularly effective, even when either concealed in a hide or when photographing animals that are conditioned to the human presence, such as the mammals of many African wildlife sanctuaries.

USE OF FLASH WITH CAPTIVE ANIMALS

Flash lighting can be of great use when photographing captive animals. Clearly, it is usually much easier to approach zoo animals openly than it is their wild cousins, making it possible to come within the reach of a flashgun. Even so, there will be many occasions when the distance is still too great for most standard equipment. Few flashes are able to fire more than about 15 metres (48ft) effectively, and this can be even less if the light is being bounced or diffused. However, the range can be greatly extended by the addition of a flash extender, a lens that fits in front of the flash. Several models are available; it is important to use the correct extender for the particular make of flashgun.

The flashgun will provide that bit of badly needed artificial sunlight in places where the natural stuff is blocked out by trees, lifting colours and showing off skin or feather markings to their best. Flash will also often put a bright sparkle of light into eyes, which are otherwise usually extremely dark, adding life and personality to the final image. The flash can also be extremely useful in situations where the subject simply will not stay still and where having the camera mounted on a tripod will not allow the photographer to respond quickly enough. This can be particularly important in photography of aviary birds. The flash will make it possible to hand-hold the camera and still use a relatively slow shutter speed (down to about 1/30 second), even with a telephoto lens in use.

Diffuse or bounce the flash's light whenever possible, resorting to direct flash only when the flash-to-subject distance is right at the flash's limit. In addition, try to ensure that the flash remains balanced with the back-

▲ A white-crested laughingthrush. Although this was an aviary bird, it was still hard work photographing such a restless animal and would have been quite impossible without the use of the handheld camera with fill-in flash technique. Despite the dense foliage, it was possible to balance the flash with the background ambient light. *Canon EOS 5, Sigma EX 70–200mm lens, with flash, 1/60 second, f/5.6, Fujichrome Provia 100F.*

ground ambient light, allowing the background to fall into darkness only when the natural light levels are very low or when the background is naturally quite dark. As with plants, having the flash more powerful than the ambient lighting may generate quite dramatic images of the subject, but they will usually look unnatural, appearing to have been shot in a studio.

▼ An angle-head lizard photographed (A) with flash balanced for the background and (B) with the flash as the dominant light source, with the background greatly underexposed. Mt Makiling, the Philippines. *Canon EOS 5, Sigma EX 70–200mm lens, tripod, Fujichrome Provia 100F.*

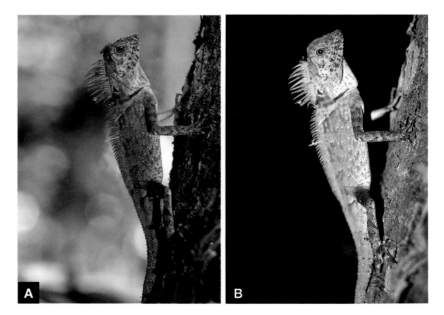

Most of the time, these images will be shot with the flashgun mounted on the camera. This works well in most situations, but there is always the danger of redeye should the animal be looking directly at the camera.

If photographing a zoo animal through glass, it is essential to remove the flash from the camera and set it up a little way to one side, otherwise the light is likely to bounce back off the glass into the camera lens.

If the background is naturally quite dark, the camera's TTL meter may be fooled into overexposing the image. Correct for this by underexposing (as measured by the meter) by increasing the shutter speed by a half to one stop.

For rapidly moving animals, it may also be possible to use the flashgun to create deliberate motion blur, something that creates dramatic and dynamic images in which movement and energy are more important than a clear image identifying the species. This really only works with an animal that is moving in fairly predictable ways across the camera's field of view. A very slow shutter speed is essential – probably less than about $\frac{1}{10}$ second – with the camera mounted on a tripod.

The rights and wrongs associated with how flash lighting affects animals are difficult to assess. While its use in the wild does seem to cause alarm to some sensitive species, others remain unaffected. In captivity, most animals seem to barely even notice a flash being fired and, in the case of primates, it may even help to make the photographer the centre of their attention, at least for a few minutes.

USE OF FILTERS

As a general rule, filters are only lightly used in animal photography. The 81 series may be used to correct for excessive blue light, but other filters, including the polarizer, are little used because they greatly reduce the amount of precious light while adding little to

▼ When photographing zoo animals through glass, it is important to angle the flash so that it will not be bounced off the glass back into the camera lens. For this shot of a penguin swimming, the flashgun was removed from the camera and held just to the left, angled so its reflection would bounce away from the camera. Marwell Zoo, Hampshire, England. *Canon EOS 5, Sigma EX 28–70mm lens, with flash, $\frac{1}{125}$ second, f/5.6, Fujichrome Provia 100F.*

This is a similar problem as that incurred when photographing plants, only more challenging. Depth of field often extends to just a few millimetres, while even the slightest movement becomes truly enormous in the viewfinder. This means that apertures usually have to be quite narrow (at least f/11), tripods become even more essential for most subjects and shutter speeds at least reasonably fast unless subject movement can be eliminated. The obvious solution would be to shoot using only either sunlight or flash, but even here there can be problems. Hard-edged shadows caused by strong sunlight or wrongly used flash can ruin a macrophotograph and so both must be used with care. The following sections outline how to do this.

USING NATURAL LIGHT

In macrophotography, I usually rely on natural light purely for plants and plant parts – subjects that are not going to run away, and for which I can take my time to get everything just right. The techniques here are essentially the same as described earlier for general plant photography, although there are a few additional considerations. Macrophotography with extension tubes or bellows, as opposed to a macro or close-up lens, will increase the exposure needed by 1–2 stops, thus increasing the problems of obtaining enough light. For this reason, if no other, the macro lens is a highly worthwhile investment.

To maximize the amount of light, it is tempting to shoot only in bright sunlight, but the hard-edged shadows that can be created in such tiny subjects are likely to disrupt the images, at the very least reducing the detail visible. This can be overcome by using a softer, diffused light, which for natural light means either overcast conditions or the use of diffusers and reflectors. This

▲ A large (and unidentified) caterpillar, photographed in dim light, with fill-in flash balanced for the background. To balance the flash with the ambient light and have sufficient depth of field to get the caterpillar in focus required such a slow shutter speed that it was not possible to handhold the camera, so a tripod was used. Tai Po Kan Nature Reserve, Hong Kong. *Canon T90, 100mm macro lens, tripod and flash, ½ second, f/8, Fujichrome Velvia 50.*

the overall animal image. Moreover, fiddling with these inevitably slows a photographer's reactions down, a critical factor in animal photography. However, a polarizer is often used in long-distance views of animals or herds of animals, where the animals basically become part of a landscape view.

MACROPHOTOGRAPHY

This technique involves the photography of animals and plants, or detailed photography of parts of them, too small to be adequately photographed using ordinary lenses. This is the world of insect and worm, flower stamen and leaf bud. This is where macro lenses, extension tubes and close-up lenses take over to shorten the minimum focusing distance and/or increase magnification. With such small subjects, lighting can be tricky and is often seen as a specialism within nature photography. Macrophotography does not cover the photography of microscopic organisms – those that are invisible or only just visible to the naked eye. This is microphotography and is beyond the scope of this book.

obviously has the serious drawback of greatly increasing exposure times, but reflectors and diffusers have the added benefit of acting as very effective windbreaks, greatly reducing subject movement.

When light levels become really poor and the resultant exposure times impossibly long, then it is time for flash lighting to take over.

POTENTIAL FLASH PITFALLS

To use flash in macrophotography there are a number of considerations to take into account, as follows:

1 Some of the larger flashguns used in general photography may be too powerful for macro work.

2 Some flashguns may be rather cumbersome in macrophotography.

3 Mounting the flashgun on the camera's hot shoe may cause a shadow from the lens to fall across the subject.

4 Mounting the flashgun on the camera's hot shoe may result in hard shadows being created on the subject.

USING FLASH LIGHTING

Flash is used not just as a reserve for when natural light levels become too low to be useful in photography of static subjects, but also as the standard lighting method when shooting tiny animals that are in almost constant motion, such as insects.

In the box above I have used the word 'may' several times because many of the latest top-end flashguns have such a wide range of controls over their power output that they can overcome just about all the above problems. This is especially if a reflector is added, making it perfectly possible to use them in the normal way mounted on the hot shoe. Before you invest in new flash equipment specifically for use in macro work, carry out some tests on your standard flashgun to see whether it can be used. If it is not appropriate, buy a smaller flashgun with a much lower guide number.

The best lighting for a macro nature subject is a single flashgun, positioned above the subject. With larger flashguns this can be achieved even with it mounted on the hot shoe, but it is often better, and certainly necessary for smaller flashguns, to position it directly above the end of the lens. One way to achieve this is by handholding the flashgun, with the camera mounted on a tripod. This works well for photography of plants and other immobile subjects, but when handholding the camera and attempting to photograph mobile creatures, the flash needs to be mounted on a bracket that attaches to the camera.

A second flash can be used to illuminate the background. This is particularly useful if the background is darker than the subject, but it only works if the background is reasonably close.

▲ A freshly moulted cicada clinging to the old skin it has just left while its wings dry out. This shot was taken with handheld flash at dusk. It was far too gloomy, especially under the trees where this cicada was, to balance the flash and ambient light. Therefore the background has been left to slip into darkness while the flash has correctly exposed the subject. *Canon T90, 100mm macro lens and flash, 1/30 second, f/5.6, Fujichrome Velvia 50.*

A ring flash, a circular light surrounding the end of the lens, is often used for some forms of macrophotography, but I do not recommend it for nature macrophotography. This is because it casts very unnatural shadows, which might be fine for the photography of inanimate objects, but which are rather jarring when used in the photography of nature.

HANDHELD PHOTOGRAPHY OF MOVING SUBJECTS

When photographing animals that rarely stay still for very long, the tripod normally has to be dispensed with. The photographer will then need to follow the animals around carefully, handholding the camera for maximum speed of response. In this situation, the flashgun is used not just to provide the main source of lighting but also to freeze any movement, mainly from the photographer's own unsteady hand. As a result this makes it possible to use shutter speeds as low as $1/15$ second. It is important to remember that both the flash's and the camera's automatic TTL metering systems can be confused by the background and subject.

A variety of combinations of dark or bright backgrounds with dark/dull or bright/pale subjects can have a variety of effects on both the overall exposure of the whole image and the accuracy of the flash lighting falling on the subject. It may be necessary to do some experiments with your camera's flash system to be sure of exactly how your combination works or bracket exposures while shooting. As a general rule of thumb, dark backgrounds, for example, will tend to cause the whole image to be overexposed, unless compensated for by underexposing. Bright or white subjects (for example, white butterflies) will either be burned out if the flash is unable to quench its output to a very low level or will result in the background coming out quite dark.

In the interests of speed of use, I would always use the flash in its automatic TTL mode, freeing me from having to make rapid exposure calculations. I usually aim to balance the flash with the ambient light whenever possible, keeping the aperture constant and changing the shutter speed to match flash output and ambient light. Doing this ensures that both the subject and its background are more or less equally exposed. However, in situations where the ambient light is really quite poor, such as in cloudy conditions or among trees, this may be impossible, so then I simply concentrate on ensuring that the shutter speed is fast enough to overcome hand shake and that the flash correctly exposes the subject, leaving the background to disappear into darkness.

UNDERWATER PHOTOGRAPHY

A detailed description of this highly specialized branch of nature photography is well beyond the scope of this book, but a general introduction is certainly worthwhile. The first point to note is that, of course, cameras and water do not mix well. Therefore, all equipment has to be specially designed to be not only waterproofed but also resistant to high pressures, usually to at least six times

A

B

◄ Handheld macrophotography of constantly moving insects, with and without flash. Without the flash (B) the whole image is blurred due to camera shake, in addition to which the colours are rather dull. When the flash is used (A), in this case balanced with background light, the image is sharp and the colours of the bee vibrant, a much more satisfying image. *Canon D30, Sigma EX 28–70mm lens with 25mm extension tube, plus a single flashgun mounted on the camera hot shoe. $1/45$ second, f/8, ISO 100.*

► It is a blue world under the sea. A pristine coral reef about 10 metres (33ft) below the surface is bathed in blue light. Photography with a 16mm lens has given at least the appearance of a wide view, while flash lighting (mounted to the image's left) has put colour into the foreground elements. Pescador Island, Cebu, the Philippines. *Nikonos V, Sea&Sea 16mm lens, Sea&Sea flash, $1/60$ second, f/8. Fujichrome Provia 100.*

▲ A silver-washed fritillary butterfly photographed in bright sunlight with handheld camera and fill-in flash, the best method of photographing animals that are constantly on the move. Jingbo Lake Nature Reserve, Jilin province, northeast China. *Canon T90, 100mm macro lens with flash, 1/60 second, f/11, Fujichrome Provia 100.*

atmospheric pressure. In other words, anyone thinking of taking up underwater photography is faced with some serious investment – taking a standard terrestrial camera in a sealed bag below the water will not be of much use.

The second point, and of more immediate importance to lighting, is the fact that all colours of light with the exception of blue are absorbed in the first few metres of water. This means that underwater photography is conducted in a blue world – or one that can often be blue-green if the water contains a sufficiently high algal count, something that is not conducive to great photography. As a result, almost all underwater photography, with the exception of silhouettes, utilizes flash.

FLASH PHOTOGRAPHY UNDER WATER

The first complication to underwater flash photography – apart from the incompatibility of water and electricity – is the fact that even the clearest water is filled with suspended particles that will reflect light and reduce visibility. This has two main consequences for photography:

1 Using a flashgun mounted directly on top of the camera results in large amounts of light being reflected straight back to the camera by the suspended particles, producing images filled with a scattering of bright white specks, hugely distracting from the main subject. The solution is to set the flashgun up on a long arm out to one side of the camera, so that bounced light – and hence, particles – is much less likely to be visible to the camera.

2 To overcome the limitations of visibility and further minimize the risk of suspended particles being visible in an image, underwater photography is usually carried out over very short distances and is limited to just two styles: macro and very short-distance extreme wide-angle views.

The latter type of photography uses lenses with focal lengths as short as 15mm, giving an angle of coverage as much as 100°. The flashguns must match this wide-angle coverage, although they usually do not need to throw their light very far. The resultant images may look like fairly broad 'landscapes', but the subjects are rarely more than two metres (6ft) away and usually much less.

Macrophotography is conducted pretty much as for handheld flash macrophotography on land. The flashgun is held much closer to the camera than for the underwater wide-angle photography, but still off to one side to minimize reflection of light back into the lens. It might appear that much less light would be needed for this than for the wide-angle photography. However, the difference is not so great because, while many wide-angle images are shot using a fairly wide aperture, say f/5.6 or f/8, macrophotography is normally shot with very narrow apertures,

at least f/16, in order to maximize depth of field, a setting that will require a higher output from the flash.

One inevitable consequence of having the flashgun set up well to one side of the view is that the light will be clearly directional, with one side of the subject well lit, and the other in shadow. This is not a problem for

▼ An underwater image of a large gorgonian sea-fan, a type of hard coral, taken at a depth of about 35 metres (115ft). The coral was about a metre across and was photographed with a 16mm wide-angle lens, with a single flash held out to the left. Boracay, the Philippines. *Nikonos V underwater camera, with Sea&Sea 16mm lens, Sea&Sea flashgun, 1/60 second, f/5.6, Fujichrome Provia 100.*

◄ An example of underwater macro-photography, showing a soft tree coral just a few centimetres high. Photographed using spacers to align lens and subject, a single flashgun was used, just to the left of the view. El Nido, Palawan, the Philippines. *Nikonos V camera, 35mm lens with macro kit, Sea&Sea flash gun, 1/60 second, f/16, Fujichrome Provia 100.*

many types of underwater images, but many can be hugely improved by the addition of a secondary light on the other side of the camera, usually of lower power than the primary light and fired by a slave cell that reacts to the firing of the primary. This secondary light is also set up on an arm well to one side of the camera, although usually closer in than the primary light. The whole set-up can become quite cumbersome, especially when out of the water, but this is the standard set-up for high-quality underwater photography.

4 Architecture and the Urban Scene

Photography of the urban landscape is one of the most important aspects of travel photography. Many an urban skyline is high on the list of must-see, must-photograph views for vast numbers of tourists. For most of these people, this photography is just a matter of point and click, but for photographers intending to produce a truly meaningful and attractive – dare I say stunning – set of urban images vastly more is involved.

This branch of imaging covers a wide range of topics, from entire city skylines, to individual buildings, to architectural details, to active street scenes. Not surprisingly, a wide range of photographic skills is needed, from landscape through to informal portraiture, not to mention the skills that are unique to architectural photography.

Illumination relies mostly on natural light, although flash lighting will be used for some street scenes, and from dusk onwards the main light source will be the ambient man-made light, whether fluorescent tubes inside office buildings, huge neon advertisements, floodlighting or traffic head- and taillights. In putting all this together into a coherent urban lighting skill, this chapter divides the subject into architectural and street scene subjects, in daylight and at night. While not a perfect division, as there are bound to be overlapping areas, this at least provides a workable way to introduce and develop the skills.

Daytime Architectural Lighting

The reflective properties of wood, brick, stone, concrete, steel and glass, our main construction materials, vary enormously. This diversity is not just in terms of the materials' own natural properties but also varies with any coatings such as paint that have been applied, how much grime covers them and last, but by no means

◀ **Nightlights reflected in a rain-soaked street, Taipei, Taiwan.** Downtown Taipei is a mass of action and bright lights, but on this particular evening I was frustrated by my inability to sort out dramatic images from all the jumble. I resorted to seeking out patterns in the details and in the aftermath of a brief downpour stumbled across this scene in the middle of one of the main streets. *Canon T90, 100–300mm lens, tripod, 4 seconds, f/8, Fujichrome Provia 100.*

▼ **Modern architecture: Rotterdam's famous cube houses,** photographed in mid-afternoon sunlight, when the sun is still quite high but is low enough to give interesting shadows and little glare. Rotterdam, the Netherlands. *Mamiya RZ67, 110mm lens with polarizing filter, tripod, 1/30 second, f/16, Fujichrome Provia 100.*

least, the intensity, angle and height of the sun striking them. The result is the surprising variety of colours and shades found across the walls of our towns and cities, something that can set the mood not only of the town concerned but also of any images a photographer may catch. Of course, these moods are not constant, but are likely to vary as the sun's intensity and angle change, altering the brightness and hues of buildings reflecting its rays.

As a result, the photographer can to some extent manipulate the mood they convey in the images of a town or city, for example turning a place normally believed to be dismal and depressing into an apparently colourful and vibrant city. The reverse can also be true, provided the dullest light and shabbiest buildings are chosen. So, whatever a photographer's reason for photographing the urban scene, they may need to think before shooting about what kind of atmosphere they might like to portray in the final images and so choose their lighting accordingly.

SKYLINE VIEWS

For a photographer to produce great images of urban skyline views there first has to be not only a good skyline but also some vantage point from which a good view is possible, unimpeded by wires, rubbish dumps and all the other detritus of urban life. Towns and cities with such skyline views are lucky indeed and they contribute in no small part to these places' world image. Some urban skylines are among the world's most famous views, hugely over-photographed, more often than not rather badly. You might say that it is the duty of the serious photographer to get it right and that invariably means getting the lighting right.

As with landscape photography, many of the best urban skyline views are photographed early and late in

> ### TYPES OF URBAN ARCHITECTURAL PHOTOGRAPHY
>
> **Urban architectural photography can best be divided into three areas, covering:**
>
> - Skyline views, wide images showing a significant slice of a town's or city's buildings, giving an overall impression of what at least one important part of this urban environment looks like.
> - A single or a very limited number of buildings, often photographed either to convey the building's historic or civic importance or to highlight its architectural style and atmosphere.
> - Architectural details, concentrating on relatively small decorative, structural or quirky features, such as statues or window shapes.

the day, when the light is rich in red wavelengths. In this light, concrete, brick and stone all glow warmly, the windows reflecting the sunlight in a mass of brilliant highlights, every building and many details standing out clearly from each other, separated by clear shadows. Such light often makes even the ugliest of cities look attractive and enticing! For the photographer to be able to use this

▼ A view of the Greek town of Agios Nikolaos, on the island of Crete, shows a great evening skyline, in many ways a classic Mediterranean view. *Canon EOS 5, Sigma EX 28-70mm lens with polarizing filter, ¹/₆₀ second, f/5.6, Fujichrome Provia 100F.*

▶ What haze can do to a city skyline: (A) mid-morning sunlight with little or no haze gives an attractive view of Frankfurt; (B) a similar view of Frankfurt, but taken in hazy conditions; the image is lifeless, the colours quite 'muddy'. Frankfurt, Germany. *Canon EOS 5, Sigma EX 28–70mm lens with polarizing filter, 1/125 second, f/8–11, Fujichrome Provia 100F.*

A

B

light inevitably means finding a view that faces either east or west. If they are lucky enough to get both, they must be sure to head to the right one at the relevant time of day!

Further into the day, when the sun is higher and has a greater proportion of blue wavelengths, this attractiveness diminishes. The scene appears flatter, many of the details become less prominent or disappear altogether, and white or pale concrete often has a blue cast to it. Again, as with landscape photography, do not bother trying to photograph skylines when the sun is high overhead or has moved around so far that the sun is no longer shining on the front of the buildings. Unlike landscape photography, back lighting and silhouettes rarely work on such a solid object as an urban skyline, although individual buildings may make great silhouette images.

Daytime skyline views rarely work well in any kind of overcast weather. Buildings, particularly grey concrete, will look rather dull and shabby, and the whole view rather downcast. So unless the aim is to make an urban skyline look rather down at heel, in these conditions put the camera away and think of something else to photograph.

HAZE

Haze is an especially serious problem for architectural photography. Even the smallest amount often disrupts skyline views. The golden rule of thumb with haze is that skyline views are a waste of time if anything more than the tiniest amount is present.

Unfortunately, haze is becoming an increasingly common problem, but this does not alter the golden rule. The photographer simply has to wait for a clear day to obtain the best possible image. Predicting in advance when haze will clear is very difficult, but shortly after heavy rain is usually a good time, as the rain will almost literally 'wash'

the air clean. Do not wait too long after the weather has cleared, however: it may be a matter of only hours before the haze gets sucked in again.

If the haze is natural, perhaps due to water vapour in the build-up to a thunderstorm, or due to agriculture, caused by dust particles stirred up out in the countryside, it may have a seasonal pattern that can be predicted and planned for from month to month. If the haze is the result of traffic fumes or industrial pollution, the air may clear on Sundays or during public holidays, so be prepared to work when everyone else has fled the city.

▶ An afternoon view of the Waikiki skyline, Honolulu, Hawaii. While the sun has not yet dropped sufficiently low to give a warm light, it is producing good shadows that enable almost every detail to be picked out. *Canon EOS 5, Sigma EX 28-70mm lens with polarizing filter, tripod, 1/15 second, f/22, Fujichrome Provia 100F.*

USE OF FILTERS

Once again, as with landscape photography, when it comes to filters the most important is the polarizer. It is vital for strengthening colours, particularly of a blue sky, cutting through haze and for reducing reflections off glass and water. Neutral-density graduated filters (ND grads) may well be of use in situations where an urban skyline is being photographed across an expanse of dark water, with a bright sky above. The darkened part of the filter will reduce the exposure of the sky and buildings to a level closer to that of the water, evening out the lighting right across the view. A red-enhancing filter might prove useful in enhancing the red glow in buildings just before sunset or after sunrise, but beware of the warning given in Chapter 3 (page 50) about a magenta cast being put into pale subjects – in this case, including light-col-oured walls and clouds. Since it is inadvisable to shoot skyline views in cloudy weather, it is unlikely that the 81 series of filters will be needed.

INDIVIDUAL BUILDINGS

Photography of individual buildings is surprisingly different from that of entire skylines. For one thing, although photography early and late when the light is rich in red wavelengths would be ideal, often it is not practicable: with the sun so low it is quite likely that the building to be photographed will be in the shadow of other buildings.

Photographing a building that is in shadow is still possible, of course, but it will be bathed in blue light, necessitating the use of 81 filters (or the cloudy setting on a digital camera), which may still be insufficient to remove all the blue cast. A tall building may also be half in shadow, half in sunlight, making it pretty much impossible to take a meaningful photograph of the entire building: it may be better simply to opt to photograph the sunlit half.

HAZE AND GLARE

In sunny weather most urban architectural photography will have to be done when the sun is relatively high, to be sure that the full height of the building is bathed in sunlight. The rule about not photographing when the sun is very high overhead still applies, however. Thankfully, with the subject normally very close, haze becomes less of a problem, except with really tall buildings, and it can even be useful in reducing the contrast between sunlit and shadow areas. Strong, clear sunshine can create a huge contrast range between sunlight and shadow, especially on white buildings – often too great a contrast range for both film and digital cameras to record details in either. The results can be very stark images. This is inappropriate for many kinds of buildings, but often apt for some modern minimalist buildings, provided the loss of detail is unimportant.

To avoid this problem in strong sunlight, compose the image so that either only sunlit

▼ The spires of King's College Chapel, Cambridge, are bathed in late-afternoon sunlight. Since the bottom half of the building was already in shadow created by other buildings, I concentrated on photographing only the top, sunlit, half. Cambridge, England. *Canon EOS 5, Sigma 70–200mm lens with polarizing filter, 1/180 second, f/5.6, Fujichrome Provia 100.*

▲ Bright sunlight reflecting off a white wall can cause other parts of an image to come out rather underexposed. It is important to overexpose large white areas to overcome this. The Sloop Inn, St Ives, Cornwall, England. *Canon EOS 5, Sigma EX 17–35mm lens with polarizing filter, 1/60 second, f/11, Fujichrome Provia 100F.*

walls or only shadow walls are visible in the image. With the former, the glare from the walls is likely to be quite strong, causing the camera's TTL meter to underexpose the image. You should compensate by overexposing. If photographing shaded walls, the light will be very blue so some red compensation will be needed. Furthermore, it is likely that what is being photographed is actually a backlit building, meaning that the sun is shining towards the lens and the sky is extremely bright.

Unless the building's relatively dark wall fills a very large proportion of the viewfinder, the sun and bright sky will again cause the camera's meter to underexpose the image. Again overexpose to compensate. However, if the building's shaded wall fills perhaps at least three-quarters of the camera viewfinder, this will dominate the metering and the image may be correctly exposed or possibly even somewhat overexposed. As ever, if in doubt, bracket the exposures.

RESEARCH

From what we have said so far, it should be apparent that successful architectural photography depends heavily on doing some research well ahead of actually attempting to photograph a building. It is important to study it from as many angles as possible, establishing the best viewpoints and working out at what times of day certain parts of the building will be in the sun and at what times in shadow. Only once that is done can the photographer be sure of photographing a building in the best possible ways. Of course, there will be many times when a building is stumbled on by chance at just the right time of day, but random chance is not a good way to produce consistently high-quality images.

▼ Beautiful buildings that are illuminated under conditions of very low morning or evening light are a joy to photograph. Here, the Taj Mahal, seen from the banks of the Jamuna River, northeast of the Taj, provides an excellent viewpoint from which to see the Taj being turned a lovely pink colour by the rising sun. Agra, India. *Canon T90, 28–70mm lens, tripod, 1/15 second, f/8, Fujichrome Provia 100.*

USE OF FILTERS

Polarizing filters are commonly used in photography of buildings in sunshine, strengthening colours and removing distracting reflections from windows. They will, however, also increase the already stark contrast between sunlit and shadow areas.

SILHOUETTES

Buildings do not often make great silhouettes, but any with an unusual or striking outline should be considered suitable candidates. All the rules described for silhouettes in landscape photography apply here too, including ways to create a great starburst from the sun as a fraction of it shines around one corner or edge of it.

CLOUDY CONDITIONS

Unlike skyline photography, individual buildings can often be photographed successfully in cloudy weather. It is arguable that they may even be best photographed in these conditions, as the problems of stark divisions between sunlight and shadow areas will be avoided, softening any contours and

increasing the amount of detail visible. It may work especially well with older, rather elaborate buildings, or somethng built using a colourful stone or that is white. It is likely that 81 filters or the cloudy setting on a digital camera will be needed to counter excess blue light.

Anything that is built using grey concrete or with glass walls is best avoided in overcast conditions. The former often look rather shabby, and the latter reflect the cloudy sky with a rather depressing greyness. Skyscrapers are often built of one or both of these materials, so they really need sunshine for successful daytime photography. Moreover, the fact that the camera usually needs to be tilted back to show the

▲ An old house photographed on a cloudy day. Some kinds of buildings are best photographed without sunlight. Lavenham, Suffolk, England. *Canon EOS 5, Sigma EX 70–200mm lens,* $^1/_{180}$ *second, f/4, Fujichrome Provia 100.*

▲ Smeeton's Tower, one of the world's first lighthouses, is of great historical importance, although it is rather dull photographically. Here it was possible to produce a stunning image – a silhouette of the tower with the sun as a starburst right at the top of the tower. To create the starburst, I lined myself up perfectly, to have exactly the right amount of sun shining around the top of the tower. Smeeton's Tower, Plymouth, Devon, England. *Canon EOS 5, Sigma EX 17–35mm lens,* $^1/_{250}$ *second, f/19, Fujichrome Provia 100F.*

whole building, which inevitably puts a lot of depressing grey sky into the shot, further compounds the problems of photographing skyscrapers in overcast weather. The one exception might be with a building that is so tall that it actually penetrates a layer of low cloud, something that might add a surreal edge to an image.

◄ The tent-like roof of the new Sony Centre in the middle of Berlin – built right where the Wall used to run – is a spectacular creation that allows the public concourse below to be flooded with light. It is itself a superb architectural feature, here lit by mid-morning sunlight. Berlin, Germany. *Canon EOS 5, Sigma EX 28–70mm lens with polarizing filter, 1/90 second, f/5.6, Fujichrome Provia 100F.*

◀ A building detail showing its blue glass curtain walling, all reflections removed by a polarizing filter. Hong Kong. *Canon EOS 5, Sigma 70–200mm lens with polarizing filter, tripod, ¹/₁₂₅ second, f/11, Fujichrome Provia 100.*

ARCHITECTURAL DETAILS

Down the years, most architects have embellished their buildings with details that range from statues, to elegant window frames, inscribed text, clocks, elegant pillars and rooftop towers. These can make for some great detail photography, all adding to any set of images aiming to capture the nature of the urban scene. It is likely that a telephoto lens will be needed for many details, thus impacting on shutter speeds, apertures and depth of field in whatever types of light may be available. A tripod is, therefore, frequently needed.

It is hard to say that details are universally best photographed in this or that type of light. Some will be suited to photography in sunlight, others in shadow or overcast weather. For still others, great images will be possible in all conditions; different types of light will just generate very different images. Clearly, details that are very elaborate three-dimensionally, such as statues and many other carvings, may have problems in bright sunlight, parts being brightly lit and other areas lost in shadow, so these may well be better photographed in softer light. Similarly, highly reflective surfaces such as steel or glass might cause problematic burned-out highlights if photographed in sunshine. If uncertain, photograph the same detail(s) several times, in different lighting conditions, and then choose the best. If photographing in sunlight, as usual the most attractive light is the red-rich stuff just before sunset or soon after sunrise. Sunlight at other times of day can be used, but a high sun is likely to cause more glare and a slight blue cast.

◀ A backlit fountain, set against buildings lost in shadow, creates a very dramatic image that really highlights the tumbling water and the bright sunlight. Trafalgar Square, London. *Canon EOS 5, Sigma EX 70–200mm lens, ¹/₂₅₀ second, f/4.5, Fujichrome Provia 100F.*

USE OF FILTERS

Polarizing filters may be useful when photographing details in sunlight, as usual strengthening colours and also removing blue casts from pale-coloured or white walls. However, they will also increase the contrast between sunlit and shadow areas. The 81 filters (or the cloudy setting on a digital camera) will be useful to remove blue casts when photographing either in shadow areas on sunny days or during overcast weather.

AFTER THE SUN GOES DOWN

Once the sun has sunk below the horizon, many urban landscapes are transformed into a fairytale land of multicoloured light that just begs to be photographed. Gone, hidden in the darkness, is the clutter of mismatching architectural styles, hideous air-conditioning vents and grimy walls, replaced instead by the enticing bright sparkle and warm glow of halogen, tungsten and neon lighting. In some cities,

entire skylines become transformed in this way, enabling the photographer to generate spectacular cityscape images that flatter the city far more than it deserves. As with daytime, evening architectural photography may consist of skylines, individual buildings or details, mixed in with street scenes such as traffic and advertising lighting.

EVENING SKYLINES

The number of towns and cities that are sufficiently well lit to allow worthwhile after-dark photography of an entire skyline is quite limited and very often will be determined by such factors as the city's architecture, whether office workers are likely to be still at work when it gets dark, and the day of the week. Architecturally, the most photogenic cities (when it comes to post-sunset lighting, at least) are those with a lot of tall office buildings constructed in what is known as the 'glass curtain wall' style. These are essentially glass buildings that often have floor-to-ceiling windows, allowing masses of internal artificial light to flood to the outside

▼ A superb dusk skyline, showing an evening shot of Hong Kong. The evening has become dark enough for all the lighting in the office tower blocks to become clearly visible, while at the same time there is still enough natural light both to show up the contour of the mountain behind and the outlines of the crowded buildings. Hong Kong Island, Hong Kong. *Canon EOS 5, Sigma EX 70-200mm lens, tripod, 4 seconds, f/5.6, Fujichrome Provia 100F.*

world. Cities consisting of stone or brick buildings with smaller windows are inevitably going to shed much less light and so will

PREPARING FOR AN EVENING'S VIEW

When preparing to shoot a skyline, it is important to scout out the best viewpoints in daylight. If necessary, carry a compass to work out where the sun will set. They may turn out to be the same viewpoints established for daytime skylines. Turn up at the chosen spot before sunset, for the following reasons:

1 If shooting a famous skyline view, there may be competition for space from tourists and other photographers.

2 It is helpful to be able to prepare in good light.

3 It will be possible to photograph the view repeatedly as it evolves with the growing darkness.

generate a far less well-lit skyline.

As for working hours, if dusk falls before about 7pm there are likely to be a lot of lights still on in office buildings. After that time the photographer is dependent on the presence of cleaners or maintenance staff to keep the lights burning. And then there is the day of the week. Skylines are definitely dimmer at weekends and during holidays, so anyone intending to get the best after-dark urban skyline images would be well advised to turn up on a normal weekday.

Urban skylines are almost always better photographed at dusk, while there is still some light in the sky, rather than once it is completely dark. The deep pink or violet colouration in the dusk sky will greatly add to the splendour of the view, while the additional light will help to keep the outlines of the buildings clearly visible and lit with a relatively natural colouration, something that may not occur once it is completely dark and the only lighting is from artificial sources.

Despite what is said in the above box, if short of time it is just possible in temperate zones, where dusk can be quite prolonged, to fit in two or even three different skyline viewpoints in the same evening, provided they are reasonably close together (and there is not too much need to jostle for position with other photographers). In the tropics, however, where dusk often only lasts 15 minutes, it is never possible to fit in more than the one viewpoint.

This photography will inevitably entail long exposures – anything from one second up to a minute – so a tripod is an absolute must. For such long exposures, digital photographers will need to be aware of the possibility of noise creeping into the images, while those using film will need to think about reciprocity failure (see box, opposite).

◀ **The London Eye seen at dusk. Although the Eye is not illuminated, by using a very long exposure the lights on each of the Eye's gondolas have eventually blurred into a continuous ring of light that has brought the image to life, and along with the blur of the wheel itself has given a sense of motion. London.** *Mamiya 645, 35mm lens, tripod, 20 seconds, f/22, Fujichrome Provia 100F.*

NOISE AND RECIPROCITY FAILURE

Using very slow shutter speeds can have some unexpected consequences for the final images, which need to be taken into account. If shooting digitally, it will be necessary to consider the possibility of noise creeping into the shadow areas of images taken using such long exposures. Many digital cameras have a noise reduction feature that may be useful in this situation. Both the need for and effectiveness of this facility may vary from one make of camera to another, however, and tests should be done in advance to see how well the camera handles long exposures.

Photographers using film will need to consider the film's reciprocity failure. This is a problem associated with daylight films subject to exposure times greater than about one second. Normally, when using shutter speeds at which it is possible to handhold the camera, the relationship between shutter speed and aperture is wholly reciprocal, i.e. halving the shutter speed will mean halving the aperture required for the same amount of light to reach the film (e.g. going from a shutter speed of 1/125 second to 1/60 second will halve the aperture from, say, f/8 to f/11). However, with shutter speeds of one second or more, this relationship is no longer reciprocal: halving the shutter speed will reduce the aperture needed by much less than the expected half. As a result, it will become necessary to over-expose the images, relative to the camera's meter readings, to ensure correct exposure. However, that said, nighttime skyline views often include a fairly large amount of empty darkness, usually the sky, which will tend to make the camera's meter want to overexpose the image, thus sometimes compensating for the film's reciprocity failure.

USE OF FLASH

Remember too, that for an entire skyline view a flash is going to be of *absolutely no use*. Can anyone really believe that a little flashgun attached to the top of a camera could possibly light up an entire city? I cannot count the number of times I have looked on in dismay as visitors have wasted huge amounts of film or disk space shooting off nighttime skyline views with a little pocket camera, handheld and with a tiny flash. They must have been so disappointed with the blank results, perhaps with the occasional speck of light scattered here and there on the images.

HAZE AND CLOUD

As with daytime photography, do not bother shooting evening skylines when there is haze about. Admittedly, with dusk and nighttime shots it is possible to get away with a little bit of haze, but as a general rule haze is a view killer.

It is possible, however, to do evening photography in cloudy weather, provided the cloud is not coming in too low to the buildings. If photographing at dusk, the cloud will often turn a fairly attractive bluish or violet colour. Once darkness has completely fallen, the cloud will either be almost invisible or will reflect the colours of the city's lights in a quite attractive way.

Filters are generally unnecessary for this kind of photography.

▼ A classic dusk shot of a modern city building, office lighting pouring out through the glass curtain walling, floodlighting adding some frontal illumination, and the red glow of dusk clearly visible behind. Exchange Square Towers, Hong Kong. *Canon EOS 5, Sigma EX 17–35mm lens, tripod, 1 second, f/8, Fujichrome Provia 100.*

INDIVIDUAL BUILDINGS AND DETAILS

Photography of individual buildings at night is done not so much for their architectural attractiveness as for the overall spectacle of the lighting on and around them. The lighting becomes more important than the buildings themselves, and a decision on whether or not to take any photographs will depend largely on such considerations as the way any internal office lighting reaches the outside, the quality of floodlighting, or the impact and attractiveness of advertising lights.

As with skyline photography, shutter speeds may be long, necessitating a tripod

▶ An enormous tower block, floodlit with light that fortunately gives only a little colour cast on daylight film, penetrates a layer of low cloud, causing some eerie lighting around the tower. Hong Kong. *Canon EOS 5, Sigma EX 28–70mm lens, tripod, 2 seconds, f/8, Fujichrome Provia 100F.*

and considerations of digital noise and film reciprocity failure. Haze, of course, is much less of a consideration due to the much shorter shooting distances, and cloud is usually not a consideration. The only situation where cloud might become an issue is when photographing very tall buildings. Low cloud in such situations may make or break an image, some very eerie results being possible if the building manages to penetrate the cloud, with floodlighting reflecting off that cloud.

COLOUR BALANCE

Of huge importance is the colour balance of the lighting. Most forms of artificial light do not have the same colour temperature as daylight, inevitably resulting in a colour shift in the final images, whether shot on film or digitally, no matter how much the lighting might have looked fine to the eye. Fluorescent lighting will come out in the

images with a green cast, as will some other forms of discharge lighting, while tungsten lights will be strongly orange.

Neon, another form of discharge lighting, is widely used in advertising lighting, produces red light, yet it reproduces perfectly in images, which is just as well as these lights make up a very large proportion of the lighting in nighttime photography! Floodlights are usually some form of discharge lighting, but the colour they emit varies immensely depending on what sort of discharge light they are. Buildings photographed with some types of what to the eye appears to be white light come out horribly green in the final images, while others retain a brilliant white. Finally, some films suffering reciprocity failure during long exposures can introduce a green colour cast, although this varies from one brand to another and is less of an issue than it used to be.

How the photographer deals with colour imbalances will depend very much on the individual and the situation. Clearly, the green of fluorescent lighting, generally the ugliest and least desirable of colour casts, can be dealt with if shooting on film by putting magenta filters in front of the lens or on a digital camera by selecting the fluorescent setting on the white balance feature. However, this is only really effective if fluorescent lighting makes up most or all of the lighting in the image. Any other lighting, or the remains of dusk light in the sky, will of course themselves be altered by such measures. However, a slight magenta cast in a few parts of an image is usually more acceptable than a lot of green lighting.

USE OF FILTERS AND FLASH

The orange cast of tungsten lights can similarly be removed by placing a blue filter (usually called 80A) over the lens on a film camera or by selecting the tungsten setting on a digital camera. Again, this will introduce a blue cast to other parts of an image not lit by tungsten lamps.

Lighting-induced colour casts that occupy just a small part of an image are generally not worth worrying about and may in some

▲ A dusk shot of an old pub, with a mixture of different lighting and consequent colour casts, but each of them occupying just a small part of the image and so not worth worrying about. They all work together to make this an attractive evening scene. Polperro, Cornwall, England. *Canon EOS 5, Sigma EX 17–35mm lens, tripod, 4 seconds, f/5.6, Fujichrome Provia 100F.*

◄ Old and new buildings in the heart of London; vapour discharge floodlights have put an unpleasant green cast across much of the image. This can be a big problem and is difficult to predict in advance. Once a problem with a particular view is known, however, it is possible to filter for it (or put a digital camera's white point to the required setting). *Canon EOS 5, Sigma EX 28–70mm lens, tripod, 4 seconds, f/ 11, Fujichrome Provia 100F.*

way actually add to the range of colours visible in the night lighting.

If photographing building details that are either illuminated patchily or that include some lighting that will introduce a colour cast in the images, it can be useful to use fill-in flash, balanced with the artificial lighting. This will often fill in some of the shadow areas not lit by the artificial light, help to reduce the artificial lighting colour cast, and add some general sparkle to the image, particularly if some of the surfaces in view are moderately reflective. The techniques of fill-in flash used in such situations are the same as those described in Chapter 3 (page 49).

STREET SCENES DAY AND NIGHT

Once the buildings of a town or city have been photographed, there is then all the life going on in its streets to look at. Images of individual people going about their business could also be included here, but it is at this point that the urban scene meets informal portraiture, something that will be covered in the next chapter.

DAYTIME SCENES

If shooting during the daytime, sunlight would ideally be the best lighting for almost all these subjects, but on urban streets awkward shadows cast by buildings of different heights and angles can be problematic. Issues such as having half the subject, or half the background, in sunlight and the other half in shadow will really mess up any otherwise potentially great shot. Waiting for the sun to climb high enough to ensure short shadows and even sunlight across a street will often result in too much glare coming off white walls or an asphalt road. Waiting for the sun to be low enough for those red-rich wavelengths means limiting the photography to subjects that are wide open – without any obstructions to cast long shadows across them – to either the east or west.

Therefore, it is not uncommon to shoot such scenes on overcast days or in areas

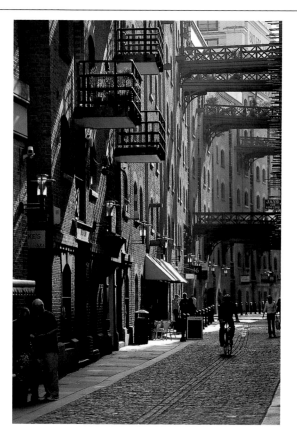

that are completely in some kind of large shadow. In both situations, but especially the latter, the light will be rich in blue wavelengths, so the usual red corrections already described need to be invoked.

Markets are a classic example of the kind of place where photography in sunlight can be very problematic. It is not at all uncommon for the customers to be out in bright sunlight, the vendors lost in shadow under heavy canopies. Try to photograph this and the results will be a mass of bright light and dense shadows, often with the customers overexposed, and the vendors just barely visible outlines in the shady gloom. Add a polarizer to the mix and the results will be even worse, with the shadow areas inky black. Some restoration is possible using fill-in flash, but often the difference between the sunlit and shadow areas is too great for most flashguns to provide sufficient output to balance the two.

It is far better to shoot such scenes in overcast conditions, when the contrast range is much less. It may still be quite dark under the canopies, but this time fill-in flash will be able to provide enough light to compensate.

◄ An early morning view of a narrow street, backlit, with heavy shadows and sunny areas making for an atmospheric image. Butler's Wharf, London. *Canon EOS 5, Sigma EX 70–200mm lens, ¹⁄₁₈₀ second, f/5.6, Fujichrome Provia 100F.*

► The bright lights of Hong Kong, showing neon advertising lights and the blur of moving traffic. Fortunately, neon lighting reproduces quite accurately, without colour casts, on both film and in digital cameras. Kowloon, Hong Kong. *Canon EOS 5, Sigma 70–200mm lens, tripod, 2 seconds, f/8, Fujichrome Provia 100F.*

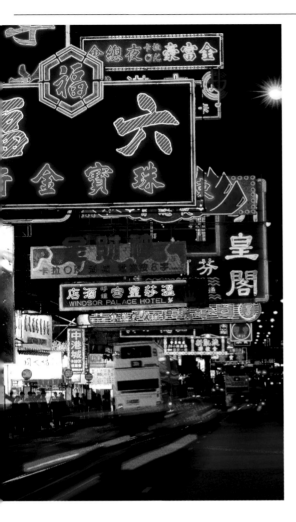

just the scene but also of movement, noise and smells, a photograph portrays only the scene. This has to be exaggerated in the final image in order to compensate for the absence of the other stimuli.

Such images will often be photographed using telephoto lenses in order to crowd all the lights along a street together, since wide-angle lenses will exaggerate the spaces between the lights and so diminish the sense of dynamism and vibrancy. There may also be a certain amount of overexposure to maximize the lights' brilliance and ensure that every light is visible. A very narrow aperture (and hence a very slow shutter speed) will cause points of light to come out as stunningly beautiful starbursts, the size of which will usually depend on the light's brightness. This can be greatly enhanced using a starburst filter, but to my mind this usually grossly overdoes it, masking the overall image behind a mass of star-like

▼ A slow shutter speed was needed to expose this view of Temple Street night market in Hong Kong correctly. It was just enough to give a dynamic blur to the movement of the crowds. Using a longer exposure would have resulted in the crowds becoming so blurred as to make them almost invisible. Hong Kong. *Mamiya RB67, 127mm lens, tripod, ¼ second, f/5.6, Fujichrome Provia 100.*

THE STREETS AT NIGHT

For urban areas that do not close down at dusk, the evening is often one of the best times to photograph city life. Usually, such photography concentrates on individual streets in the city centre or entertainment districts, where lighting from traffic, shops, nightclubs and advertising are likely to be in their most spectacular combinations. At the smallest scale, photography may also concentrate on details such as reflections and individual lighting patterns.

CREATING ATMOSPHERE

The best nighttime street photography manages to exaggerate both the action and the vibrancy of the lighting, producing images with a greater dynamic feel to them than might have been apparent to someone actually at the scene. This is not so much a case of deception as simply trying to compensate for the fact that, while the excitement and energy of the city consists of not

lights and decreasing the sharpness of other parts of the image.

Slow shutter speeds will help to blur the movement of people and traffic, adding to the feeling of dynamic energy. Don't use too long an exposure, however, (no more than about ½ second) for moving crowds or they will just turn into a continuous unidentifiable blur or may even become completely invisible! Add a bit of fill-in flash to images covering a fairly short range view. Not only is a little bit of extra sparkle added, but also some of the moving people will be partially frozen, decreasing the level of blur while retaining enough to maintain the dynamic feeling.

▶ One way to make nightlights visually more exciting is to move the camera during a long exposure. In this image, nightclub lights were given the blur treatment by moving the camera in a downward arc during the exposure. Kowloon, Hong Kong. *Mamiya RB67, 127mm lens, tripod, 8 seconds, f/11, Fujichrome Provia 100.*

▼ A nightclub light in Hong Kong is turned into something quite dramatic by photographing it with a zoom lens which is turned through its entire zoom range during a long exposure. *Canon T90, 28–70mm lens, tripod, 6 seconds, f/16, Fujichrome Provia 100.*

▲ The red streaks of the rear lights of vehicles, photographed with a long exposure, adds a feeling of dynamic energy to a city view. The dynamic traffic and the advertising lights combine to produce a sense of urban excitement and fun. Piccadilly Circus, London. *Canon EOS 5, Sigma EX 17–35mm lens, tripod, 8 seconds, f/5.6, Fujichrome Provia 100F.*

Another ploy to increase the dynamic energy of an image is to move the camera while taking a long exposure of a scene. The final picture is likely to show moving light patterns in which the original subject is no longer really recognizable, but the dynamic feeling is very strong. Similarly, a zoom lens can be carefully turned through its focal length range during a long exposure, producing an image akin to multiple exposures of the same subject but at different sizes.

STREAMING TRAFFIC

Perhaps the most well-known method for generating dynamic nighttime city shots is to take long exposures of moving traffic, preferably from their rear. Lines of moving traffic exposed for several seconds will produce images containing continuous streams of red light, with the vehicles themselves completely invisible. Do the same with traffic moving towards the camera and the streams will be white. This often does not work quite so well as the headlights can pour too much light into the camera's lens.

Getting such images right is generally not difficult, but can take some patience. Evening traffic in many city centres is not as dense or as continuous as might be imagined. It will often be necessary to open the shutter in time to the nearest set of traffic lights as it releases a batch of cars, a group that will provide one or two images' worth of streaming taillights, before the lights turn back to red and store up another batch of vehicles for release a couple of minutes later.

The greater the space between cars passing the camera, the longer the exposure time will have to be. Generally, just one vehicle passing by does not generate a very impressive red streak – at least three or four seem to be needed.

As for colour balance and the need for filters, there is no need to worry. Car head- and taillights come out just perfectly on both film and in digital photography.

5 Outdoor Portraits

◀ A woman dressed as a medieval Japanese courtesan waits for the start of Jidai Matsuri, the Festival of Ages, an annual event in Kyoto to celebrate the city's long history. It was a sunny day, and the woman was sitting in dappled shade under a tree, making for an awkward light that put the woman mainly in shadow but with some patches of sunlight across her. To even out the lighting and reduce the risk of camera shake, fill-in flash was used, balanced with the ambient light. *Canon EOS 5 with flashgun, Sigma EX 70-200mm lens, 1/90 second, f/5.6, Fujichrome Provia 100F.*

All the world's a stage', wrote Shakespeare, referring to the drama of human life continually being played out all around us. For anyone with a camera, determined to capture at least a few pieces of the action, that can mean a huge range of human activity, with subjects as diverse as happy snaps of the family or friends out with a picnic or on a beach, special events such as a wedding, formal business portraits, fashion shots and people at work or engaged in sports.

Good lighting is, as ever, critical to successfully creating great images of the human face, whether shot indoors or outside. There is a vast range of techniques associated with achieving that and this chapter looks at those techniques necessary for success outdoors. Inevitably, that means largely making good use of natural light, combined on occasions with use of reflectors and fill-in flash, techniques already described to some extent in the context of nature photography (Chapter 3).

USING NATURAL DAYLIGHT

As with every form of outdoor photography, while the *quantity* of light can sometimes cause problems in creating good images, more often than not the issue is its *quality*. Is the sun too high or too low, too blue or too red, too harsh or too soft? Is it best to have the light shining in the subject's face, coming from the side, shining straight down from above or coming in from behind? Can the light be diffused in some way? Could a reflector help? As usual, a host of decisions have to be made, with no control over the lighting provided, all in the name of creating images that are both technically good and that put over the right kind of atmosphere. Here 'right' is defined as something appropriate both for the subject and for any intended end use for the images, whether for a family photo album, a job resumé or a magazine feature article.

▼ A close-up of a young bridesmaid, photographed in the shade of a translucent canopy, where the light was soft and evenly diffused. *Canon EOS 3, 28-70mm L lens, 1/60 second, f/4, Fujicolor NHP 400.*

▼ In this image of a man practising tai chi on a beach, it is not so much the person that is important as the location. The image aims to show what people get up to on this beach. As a result, he is fairly distant, but the image tells us a lot about his environment. St Ives, Cornwall, England. *Canon EOS 5, Sigma EX 70–200mm lens with polarizing filter, 1/180 second, f/8, Fujichrome Provia 100F.*

PROBLEM SOLVING

The technical problems all those questions just posed aim to solve, of course, include such matters as getting skin colour and texture correct (or at least flattering in some way), minimizing the visibility of skin blemishes and minimizing shadows in awkward places (such as under the nose or around the eyes).

There is also the issue of what kind of image is needed and how to go about getting it with the lighting, subjects and environment to hand.

If the subject is the most important component of an image, then presumably the aim is to create something that

DIFFUSED VERSUS BRIGHT SUNLIGHT

As an almost universal rule of thumb for portrait photography, soft lighting is much better than hard. The latter, created by strong sunlight, leads to shadows under noses, around the eyes and under jawbones. It may also produce burned-out highlights in areas of pale, reflective skin, will emphasize skin texture, wrinkles and blemishes and exaggerate certain facial features such as angular noses and jaws. In other words, it is not a very flattering kind of light. Soft lighting, on the other hand, overcomes all those problems, as well as reducing the risk of the subject squinting against the light or perspiring in the possible heat.

The ideal kind of natural light is a fairly bright white sky, a day in which the sky is covered with a white gauze of cloud or haze, through which the sun can perhaps be felt but not clearly seen: the kind of day that landscape photographers hate! Under these conditions, there is guaranteed to be plenty of light available with the white covering acting as a huge diffuser that generates a soft, very even lighting.

With this kind of light, however, during much of the day the light is likely to be quite rich in blue wavelengths, which may well result in a bluish cast across fair skin and pale-coloured clothes. It will also give a bluish cast to any background vegetation.

▶ A baker displaying his products outside his shop on the harbourside in Looe, Cornwall. Photographed on a bright overcast day, the subject is lit only by natural daylight. Heavy diffusion of the sunlight by the cloud cover has created a soft, even lighting, resulting in an attractive portrait. *Mamiya RZ67, 110mm lens, 1/125 second, f/8, Fujichrome Provia 100F.*

captures their personality and/or good looks. If, however, the location or event is the main feature to be captured, then the final images may need to convey their atmosphere, a sense of place and what is going on, with the subject playing a supporting role.

All these questions will impact directly both on the images' composition and the way in which the natural light is used. Needless to say, the photographer will have to make do with whatever light nature provides, adapting methods and style accordingly in order to produce the desired kinds of image.

pose the image (according to the camera's meter). Overexpose even if using a digital camera, as it is better to obtain a correctly exposed image in-camera than to have to manipulate an underexposed image later on the computer. Use the camera's LCD screen to determine which exposure is correct.

If the sun is not clearly visible through the haze or white cloud when it is high in the sky, it certainly will not be able to penetrate when it is low. This is for the simple reason that at the ends of the day its low angle means it has to penetrate through even more atmosphere than it does when high. The result will simply be a very dull light, which although still usable – and, of course, quite shadow-free – may not be very attractive.

Rather thinner haze or cloud that allows the sun to penetrate when it is low results in a soft lighting that is rich in red wavelengths; something that can put a very attractive and highly atmospheric warm glow across both subject and background, making for some excellent portrait lighting.

A second best lighting situation after the bright white sky is the generally overcast

◀ Standing on the summit of Mt Snowdon in thick fog, these two boys are enveloped in a huge natural white diffuser. The light was quite bright, and to get the faces correctly exposed against the wall of white behind the boys, I had to overexpose by half a stop. Mt Snowdon, Wales, Great Britain. *Canon EOS 5, Sigma EX 17–35mm lens with 81A filter,* 1/60 *second, f/9.5, Fujichrome Provia 100F.*

As usual, if shooting on film, this can be corrected by using the 81 series of filters or, with a digital camera, by selecting the cloudy setting on the white balance feature.

The problem with a bright white sky is its tendency to fool a camera's meter into underexposing the image. This will be a particular problem if the image is not a close-up of the subject but instead shows plenty of background and sky around them. It may also be an issue if the subject is dressed in pale-coloured clothing. If shooting on film, it will certainly be necessary to bracket the exposures, favouring those that overex-

▶ Lit by the soft warm glow of evening sunlight, this portrait tells us about the working environment of a lighthouse guide. Start Point, Devon, Great Britain. *Canon EOS 5, Sigma EX 17–35mm lens,* 1/90 *second, f/11, Fujichrome Provia 100F.*

day. The soft light of such weather is good for photography of faces free from shadows, generally softening features. However, backgrounds may be rather dull and the sky will certainly be fairly unattractive, so portraits taken in this kind of light might be best quite close up, minimizing the inclusion of background and sky.

USING BRIGHT SUNLIGHT

If sunlight is anathema to portrait photography, what is a portrait photographer to do when the sun insists on shining? The simple answer is to do everything possible in order to soften that light.

The most obvious way to achieve this is to move the subject out of the sunlight into some kind of shaded area, such as under a tree or in the shadow of a building. Instantly, the lighting is similar to that of a bright hazy day, giving soft shadows and facial features.

▲ A wedding portrait shot on a beach during an overcast day. Reflection of light from the sand and sea has thrown light onto the subjects, while the rather dull background has been kept largely out of view. *Canon 10D, 28–70mm lens, ISO 100.*

◄ A group of Chinese sailors pose proudly in front of a statue of Lin Zexu, a national hero of the Opium Wars, lit by a low evening sun, softened by haze. Dongguan, Guangdong province, southern China. *Canon T90, 24mm lens, 1/60 second, f/11, Fujichrome Provia 100.*

Care should be taken to minimize, or preferably completely do away with, sunlight in the background, as this will distract from the main subject and may cause the camera's meter to underexpose the image.

Also remember that in such shadow areas, the light will be very rich in blue wavelengths, which will need some considerable correction with either the pink 81 (or possibly even the amber 85) series filters or selection of the cloudy setting in a digital camera's white balance system.

An age-old trick that can make it possible to photograph a subject frontally lit by bright sunlight is to stretch stocking across the front of the lens. This greatly softens not

only the light but also the entire image, generating a strongly soft-focus, almost painting-like, image that I personally do not like very much. Alternatives include putting a diffusing filter across the front of the lens or using a soft-focus lens. These two methods generally have a less extreme effect than the stocking, generating a gently blurred image in which fine details and sharp shadows are greatly reduced. The overall result is quite atmospheric and, depending on the subject and environment, can convey such feelings as romance or lazy, hazy summer days.

Another method to soften direct bright sunlight is for the subject to hold a parasol, an instant and portable diffuser and source of shade. Only likely to be of interest when the subject is a woman, this trick definitely helps to generate a feeling of delicate feminine beauty linked inextricably with warm summer sunshine. To produce good results, the parasol needs to be a light colour and ought to be translucent. A black umbrella will definitely not do the trick!

BACK LIGHTING

A wholly different way to use sunlight is as back lighting. In its most extreme form, often

◄ A woman photographed in warm evening sunshine. Although the reddish colour of the light has put a pleasant colour cast across her face, it was quite a strong light that put some hard shadows and highlights across her skin. This was countered by place a diffusing filter across the lens, something that has softened the light, thereby decreasing highlights and having a smoothing effect on the skin. *Canon EOS 5, Sigma EX 28–70mm lens, ¹⁄₆₀ second, f/8, Fujichrome Provia 100F.*

◄ Photographing this woman in high, bright sunlight has left a mix of shadows and highlights across her face (A). Moving her into the shade (B) has greatly softened the light, resulting in a far more pleasing view of her face. *Canon 10D, 28–70mm L lens, ISO 100.*

the subject's features fully visible but softly lit, the result of the subject's face being in their own shadow. The back lighting may generate a rim of bright light around the subject, particularly in their hair and most especially if that hair is blonde, where bright highlights can be created.

If the subject fills almost the whole of the image then the camera's meter, calculating the exposure from their shadowed body, might manage to expose correctly. However, if a considerable part of the image consists of the inevitably very bright background, the meter will almost certainly underexpose. It will be necessary to compensate for this by overexposing by at least one stop, possibly

▲ A strong silhouette of a hiker standing atop a rock, this image is not about this particular person at all, but instead sends out a strong message about outdoor leisure, fitness and health. Dartmoor National Park, Devon, Great Britain. *Canon EOS 5, Sigma EX 17–35mm lens, ¹⁄₁₂₅ second, f/16, Fujichrome Provia 100F.*

with the sun directly behind the subject, it can be used to make silhouettes, a very useful technique provided the subject takes on a pose that gives a dramatic, clearly discernible outline. Clearly, such an image is not about the subject itself, but is intended to convey a message, something that has to be put across perfectly in that single silhouette.

Less stark than this, with the sun either still directly behind the subject or a little out of the image (but still providing back lighting), very attractive images can be created with

▲ In this image of Emma Richards, one of Britain's leading yachtswomen, the danger of unpleasant shadows across the face as a result of the high sun was overcome by ensuring that she was backlit, the sunlight just coming in over her right shoulder. There is a slight highlight on her forehead, but overall the lighting on her face is quite soft and the shadows reasonably gentle. *Canon EOS 5, Sigma EX 70–200mm lens, ¹⁄₁₂₅ second, f/11, Fujichrome Provia 100F.*

more. If in doubt, bracket the exposures.

Instead of overexposing the image, another way to ensure that the face is correctly exposed is to use either fill-in flash or a reflector. Both these methods are described in the following sections.

DIFFUSERS AND REFLECTORS

Techniques described so far have concentrated mostly on simply how to make the most of whatever natural light is available, shooting with just the camera and few other aids. However, no description of outdoor

◀ Photographed under a high sun, the problem of high-contrast areas of shadow and highlights across this yachtsman was overcome by photographing him with back lighting. His face and body are in shadow, but by over-exposing the image a little (half to one stop) he is perfectly exposed. This image would also have worked well with fill-in flash, although I didn't use any on this occasion. Conrad Humphreys, one of Britain's top yachtsmen. *Canon EOS 5, Sigma EX 17–35mm lens, 1/125 second, f/11, Fujichrome Provia 100F.*

portrait photography with natural light would be complete without mention of the use of diffusers and reflectors.

Used with the same principles in mind as described for close-up plant photography, the main difference here is that the diffusers and reflectors must be bigger to cope with the larger subject. That in itself may cause problems, as their use will probably require a team of helpers. They will also greatly increase the contrived nature of each image, being only applicable to static portraits and clearly of no use in a reportage style of photography in which moving subjects are the photographer's quarry. Not surprisingly,

◄ The concept here was to produce a gothic-style image with a fashionable feel to the lighting. An overcast day was chosen to ensure a soft and diffused light. The matt white surface of a large (2m/6ft across) reflector was used in the horizontal position to bounce soft lighting into the model, with the camera positioned just behind the middle of the reflector. *Canon 10D, 28–70mm L lens,* $^1/_{125}$ *second f/5,6, ISO 100.*

▼ Photographed beside a lake on a sunny day, the lighting across the model was softened using a large diffuser held above her. A large gold reflector was also used, placed horizontally beneath her to reflect strong, warm light into her face. *Canon EOS 3, 28-70mm L lens,* $^1/_{250}$ *second, f/4, Kodacolor 400.*

they are frequently used in advertising and fashion photography, where perfect lighting is more crucial than an ability to move and shoot quickly and spontaneously.

DIFFUSERS

Despite the restrictions, any photographer aiming to get the best possible natural lighting for his or her subjects would do well to consider using diffusers and reflectors, particularly the latter. Diffusers are difficult to use if only due to the huge size of the light source, namely the sun. If shooting in overcast or bright and hazy conditions, a diffuser will not be necessary as the cloud and/or haze will perform the diffuser's function, and so they will only be a consideration in bright sunlight. In these conditions, the diffuser would serve the same function as just described for the parasol, only held above the highest point visible in the image and so out of shot. It thus needs to be quite large and very light, held quite some way above the subject on a long pole: not an easy solution, although it is sometimes employed in advertising and fashion shoots.

Of course, if the sun is very low and shining into the subject's face, a diffuser will

be immensely useful and quite easily used, held up between the sun and the subject, softening the light, retaining the red warmth usual for such low sunlight and overcoming the subject's having to squint.

REFLECTORS

Of far wider use is the reflector. Two simple reflectors could consist simply of boards, one white, the other covered with crumpled aluminium foil. Not surprisingly, the foil-covered board is a more powerful reflector, but in bright sunny conditions the white board may provide sufficient reflection to soften many shadows. Crumpling the foil ensures that light is reflected diffusely, instead of the hard beam that would result from using smooth foil. Standard silver-coloured foil will reflect light with the same colour as that shone onto it, whereas the use of a gold-coloured foil will reflect light with a warm golden tint, to some extent mimicking the light of a low sun, thus putting warm tones into the subject.

It should be borne in mind that the choice between using a white reflector and a foil-covered one is not necessarily down to the amount of light that needs to be reflected, but also the quality of that light. Foil will reflect a much harsher light than a white surface, which might result in burned-out hotspots on someone with shiny, oily skin. In this case, a matt white surface is infinitely preferable for its softer lighting.

Reflector boards, unless they can be folded, are likely to be quite cumbersome to carry to any photo location. More convenient (but of course also more expensive) are the purpose-made reflectors produced by such companies as Lastolite, which are extremely light, circular and can be folded down to a very small size.

Such reflectors can be used in a whole range of lighting situations, under both natural and artificial light, outdoors and in. In the bright hazy conditions described earlier in this chapter, if the sun is high overhead or slightly behind the subject, even though essentially invisible behind the white gauze of haze, it may still put shadows into the

subject's face, particularly under the nose, below the chin and around the eyes. Putting a reflector low down and angled upwards so as to reflect the sky's light back into the subject's face should greatly ease (if not totally remove) those shadows. Use of a gold-coloured reflector here may also remove any blue cast resulting from the high energy of the light on such a day.

In fairly dull overcast conditions, a reflector used in much the same way as described for bright hazy conditions can make a crucial difference, not only removing the few shadows present in the subject's face but also

▲ This couple was backlit by dappled sunlight, and then photographed using the silver surface of a reflector angled to high-light the shiny lustre of the bride's dress. The reflector was deliberately angled so as not to bounce light into the couple's faces, thus retaining some of the silhouette. *Canon 10D, 28–70mm L lens, ¹⁄₁₂₅ second, f/4, ISO 100.*

throwing a vital bit of extra light into the face, brightening it up and lifting it clear from the almost inevitably dull background.

In bright sunlight, if the sun is reasonably high it is possible to remove some of the hard shadows by putting a reflector close to and below the subject, keeping it out of shot by placing it below the lowest point of the image, enabling it to reflect sunlight back upwards into the face. Similarly, side lighting can be softened, not only by the diffuser, but also by the use of a reflector to one side of the subject bouncing light back into the shadowy side of the subject's face.

Finally, the reflector is of enormous importance with a backlit subject. Sunlight shining from behind the subject can be bounced by a reflector placed close to the camera directly back at them. This provides a much-increased level of soft lighting in their face and decreases (but probably not eliminating) the need for the image to be overexposed.

ARTIFICIAL LIGHTING

Although the great majority of outdoor portrait photography is undertaken using just natural light, there are times when artificial lighting plays an important part. Its uses vary from throwing a bit of light at a subject's face to remove unsightly shadows (this is especially the case on bright sunny days) to providing a bit of extra light on particularly gloomy days, to becoming the main lighting source after dusk.

More often than not, artificial lighting comes in the form of fill-in flash, but just occasionally some other form of continuous artificial light might be used.

CONTINUOUS LIGHTING
This is most likely to be of use in an urban setting in poor light or after dusk, where

▶ A lone pianist in St Mark's Square, Venice, Italy. Shot at twilight, illumination of the pianist came from localized tungsten lights, while natural lighting was just sufficient to put some details in the pillars. *Canon EOS 3, 28–70mm L lens*, ¼ *second, f/2.8, Fujicolor Neopan 1600.*

◄ Backlit by the sun, this little girl was illuminated using a large white reflector placed in front of her, to bounce some of the sunlight back into her face and clothes. Using a silver reflector would undoubtedly have been too efficient, resulting in an overly harsh light on the girl's face. The image here is pleasingly soft, with a very summery feel, and the girl's blonde hair is beautifully lit by a halo of sunlight. *Canon 10D, 28–70mm L lens, ¹⁄₁₂₅ second, f/5.6, ISO 100.*

the lights of the city might sometimes provide a convenient, although not ideal, lighting source. Floodlighting, neon advertising lights or the glow from shops may, however, provide sufficient light to illuminate a subject.

Although a reasonable way of using available light for a reportage style of portraiture, perhaps more like documentary photography, showing someone or a group of people going about town at night, there are a number of limitations to using continuous light sources. The first is whether they will be able to provide enough light. Unless the subject is standing very close to the lights, it is likely that light levels will be relatively low, resulting in wide open apertures and slow shutter speeds.

Second, such lighting is likely to be very

directional, creating strongly lit areas and deep shadows. If the subject is facing the light source they may well be quite evenly lit, with surprisingly few shadows in their face. However, turning side-on to the light will result in one side of their body being brightly illuminated and the other side being lost in darkness. Putting a reflector on the subject's dark side could reduce this, but as described earlier this affects the mobility and spontaneity of the photography.

Third, as described in Chapter 4, most sources of continuous artificial light have colour temperatures well away from the 5500K of daylight and so give colour casts on standard daylight film or on a digital camera set to a daylight white balance. If only one type of artificial light source is present in a view then measures can be taken to correct for the colour imbalance. On a digital camera, this is done by selecting for the appropriate white balance setting. If shooting with film, this is done by using the appropriate filters on the camera lens: magenta to correct for fluorescent lighting or a blue 80A filter for tungsten, for example. However, if both are present, as is usually the case in an urban night scene, probably also mixed with some daylight-balanced lighting, it can be difficult to know which source to correct for – it is only really possible to correct for one source at a time. The worst that can happen in this situation is that your subject comes out with a ghastly green face – something that will not earn the photographer many friends!

For these reasons, it is unusual to use continuous lighting as the only source of artificial light for outdoor portraiture. Instead, they are usually combined with fill-in flash, a technique that helps to overcome all three problems and at the same time adds its own bright, dynamic dimension.

◄ Lit only by stagelights during a dusk performance, this woman is bathed in an attractive warm light. Because she is facing the lights, she is quite evenly lit. Were she to turn side-on to them, one side of her body would probably fall away into shadow. Maui, Hawaii, USA. *Canon EOS 5, Sigma EX 70–200mm lens, tripod, ¹⁄₃₀ second, f/4, Fujichrome Provia 100F.*

FLASH LIGHTING

Flash is the most common way to use artificial light with an outdoor portrait. It is usually used to fill the same sort of role as the reflector – bouncing a bit of light into the subject's face to remove unpleasant shadows. In most instances, flash is used to provide some fill-in lighting, its output balanced with the ambient natural light and playing a supporting, secondary role to the sun.

The techniques used are pretty much as described for nature photography (Chapter 3, page 49), with the added advantage that human subjects will usually allow the photographer to approach much closer and, it is to be hoped, will cooperate with his needs!

USE OF FLASH IN BRIGHT SUNLIGHT

The idea of using flash in bright sunlight initially seems a little hard to grasp. Surely flash is used to provide light when there is not enough of the natural stuff? Well, of course, that is one of its uses. But the importance of its role in removing shadows from a face in bright sunlight cannot be overstated. The method has great advantages over the use of a battery of reflectors in the sense that it allows both subject and photographer to keep moving and shooting simultaneously. In other words, it is ideal for reportage photography.

Unfortunately, even if the flash is fired through a diffuser or via a reflector the lighting often gives an unnatural effect and may be a little hard. Skin texture and blemishes may become visible, as will any perspiration, and there may be a burned-out hotspot on any area of shiny skin. On a flash where the power output is manually adjustable, these problems can be minimized by reducing its power, under-powering the flash (according to its own TTL metering) by up to a couple of stops. Provided it is not overdone, this can reduce the visible impact of the flash while still removing the shadow areas. Nevertheless, in reportage photography, where obtaining images of the subject's actions, or perhaps their presence at an event or location, is more important than securing perfect lighting, fill-in flash provides the ideal solution.

◀ Two boys aboard a yacht, one working the winch backlit by a low evening sun that is coming in from the right of the image. Fill-in flash balanced with the background light has illuminated the front of the boy perfectly. Dartmouth, Devon, Great Britain. *Canon EOS 5, Sigma EX 17–35mm lens with flash, 1/45 second, f/11, Fujichrome Provia 100F.*

◀ Strongly backlit by a setting sun, the only way to grab this image of my son tying up his shoelaces was to use some powerful fill-in flash. The result, while not at all natural, is quite dramatic. *Canon EOS 5, Sigma EX 17–35mm lens, flash balanced with the sunlight behind, 1/125 second, f/11, Fujichrome Provia 100F.*

◀ This bride was backlit by diffused sunlight, so to put light into her face she was photographed using fill-in flash, balanced to expose at two stops below that of the sunlight. *Canon 10D, 28–70mm L lens with flash, 1/125 second, f/5.6, ISO 100.*

▶ Elinchrom's Free Style portable lighting system is ideal for outdoor photography where more power than a flashgun can deliver is needed.

FLASHGUN LIMITATIONS

Usually, the versatile flashgun, mounted on or close to the camera, provides the flash lighting. Although it is hugely useful, there are limitations, principally its recycling time and maximum output. The latter is usually quite adequate for most situations, particularly on overcast days when the fill-in flash only has to balance with quite a low ambient light level, probably shot with the lens aperture quite wide open. The real problem comes in bright sunlight, when its output needs to be much higher to balance with the sunlight and when the lens aperture is likely to be stopped right down. Even in this light, most flashguns will cope reasonably well, but where they can let the photographer down is in trying to illuminate a strongly backlit subject. In this situation, a flashgun is often unable to produce enough power to balance the sunlight (after all, it is being asked to produce a light with the same intensity as the sun).

Linked to the flashgun's maximum output is the question of recycling time, the downtime between flashes when the gun is recharging and cannot fire. The great majority of flashguns rely on

AA batteries for their power, a source that is generally fine when they are fully charged or when shooting fill-in flash in overcast lighting. Under these conditions, it is possible to more or less keep shooting continuously, with little or no recycling time. However, once the batteries start to run down, or when the flash's output needs to be greatly increased, such as when shooting in bright sunlight or when the lens aperture is stopped down (say to f/11 or smaller), then the recycling time starts to become an issue. Even if it stays as brief as just a couple of seconds, when shooting reportage images the downtime can mean losing some valuable action shots. Once the recycling period gets to be ten seconds or more, the photographer may find himself with an increasingly impatient subject.

One solution is to change the batteries very frequently – something that can become very expensive unless rechargeables are being used.

Another idea is to use a small rechargeable power pack that can either be clamped to the bottom of the camera body or clipped to the photographer's clothing. Be sure to choose a pack that is compatible with the flashgun, or the latter can suffer damage.

A third solution is to use a battery-powered flash system that operates separately from the camera, similar to the mains-operated monobloc flashes used for studio photography (described in Chapter 6, page 101). Equipped with powerful, long-lasting batteries, several systems are on the market, such as the Free Style, produced by Swiss lighting manufacturer Elinchrom. These will overcome both

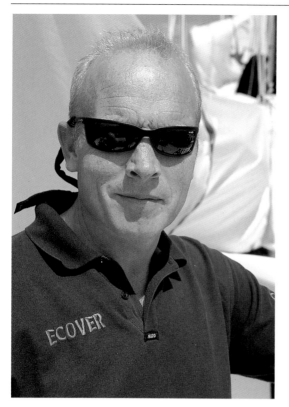

▲ Unavoidably shot in bright sunlight, this image of Mike Golding, one of Britain's most successful competitive yachtsmen, conveys a sense of the man's strength and experience. Although the sunglasses are in danger of making him appear somewhat anonymous, they have overcome the danger of him having to squint at the camera. *Canon EOS 5, Sigma EX 28-70mm lens, 1/125 second, f/13, Fujichrome Provia 100F.*

▲ Dressed in white, this woman walking around on stilts during a festival made a tricky subject against the dusk sky. Using flash as the main lighting, partially balanced against the background natural light, has caught her nicely. *Canon EOS 5, Sigma EX 28–70mm lens with flash, 1/15 second, f/2.8, Fujichrome Provia 100F.*

maximum power output and recycling time problems, although they are generally rather less portable than the flashgun and so will reduce mobility.

NIGHTTIME FLASH PHOTOGRAPHY

For outdoor photography after dusk, the flashgun is truly invaluable. The principal or only light source, the lighting is not usually very flattering even if diffused or bounced rather than being fired directly. However, for reportage photography it is vital for recording outdoor nightlife and can produce particularly dramatic results in urban nighttime photography. Using a handheld camera with a slow shutter speed, the flashgun not only overcomes any camera shake that may result from the slow shutter speed, but also helps to freeze some of the subject move-

ment. The result is brightly lit images with the subject clearly visible and well lit, but nevertheless blurred; an image that conveys a sense of dynamism, energy and excitement: perfect reportage material.

LIGHTING AND MOOD

I have already alluded several times in this chapter to the steps that can match the type of lighting to the kind of image wanted. As the final part to this chapter, it is worthwhile bringing those points together in a summary of ways in which, even using just natural light, different methods of using it can generate different types of images.

Perhaps the most obvious example is that of the parasol, used to provide shade

and hence softer light on a face otherwise lit by bright sunshine. Clearly a very feminine prop that can be used to emphasize feminine beauty in summer weather, one could hardly expect a man to agree to use a parasol, although a golfing umbrella could create a more masculine image. Similarly, strong back lighting with bright highlights in the hair, a lighting halo around the body's rim and an overexposed background has a feminine feel to it and so is, perhaps, more appropriate to women or young children than it is to men.

This does not mean to say that such feminine lighting methods should always be used for women. They might be fine for portraits aiming to emphasize a woman's beauty or to convey a romantic or sexy atmosphere, but they will not be of much use to a woman who needs a photograph for a business resumé or a newspaper article. The lighting needs to match the end use and for business, with both men and women, that usually means soft frontal lighting that shows up a true likeness of the person.

For images that emphasize masculine features, such as a strong jaw, strong sunlight can be useful. However, even here the lighting needs to be diffused, as otherwise the subject will not only be forced to squint but will also end up with ugly shadows under the nose and chin and around the eyes.

One of the biggest divisions in portrait photography is that between the more or less static posed composition, in which the subject usually looks at the camera, and reportage photography, in which both subject and photographer may be on the move, the subject perhaps completely ignoring the camera. As already mentioned, this will have major implications for the choice of lighting style, particularly when it comes to the choice between reflectors and flash for fill-in lighting. Static, composed portraiture is more likely to use reflectors for the soft, subtle way in which bounced light removes unwanted shadows, whereas reportage photography is more likely to go with the fill-in flash due to its great mobility and ease of use.

▼ Reportage-style photography at a wedding. This couple were backlit by dappled sunlight, so to correctly expose them fill-in flash was used, balanced to expose at two stops below that of the ambient sunlight. The result is even illumination, reduced contrast range and visible detail in the shadow areas. *Canon 10D, 28-70mm L lens with flash,* ¹⁄₁₂₅ *second, f/5.6.*

6

Indoor Portraits

◀ This model was photographed in a conservatory using natural daylight; a soft white lighting has been achieved by diffusing the light through a large diffuser held above her, and by placing a white reflector below her face. This has eliminated all shadows and kept the lighting white. *Canon EOS 3, 70–200mm L lens, ¹/₂₅₀ second, f/4, Kodacolor 400.*

▲ Indoor photography using only natural light. In this image the baby's toes were placed close to a heavily diffused window, ensuring that she was bathed in gentle, soft light. *Canon 10D, 28–70mm L lens, ¹/₆₀ second, f/5.6, ISO 100.*

While an awful lot of portrait photography happens in the great outdoors, it is inside that much of the most creative portraiture is achieved, mostly as the stylized, posed form rather than reportage style. Business, family, fashion, advertising, editorial, model portfolios and many aspects of weddings are all subjects for indoor portraiture, mostly taking advantage of the ability to make and control every aspect of the lighting. In the majority of occasions that lighting is artificial, usually delivered as flash, but there are times when natural light may be used.

TYPES OF LIGHT AND LIGHTING EQUIPMENT

NATURAL LIGHT

It is unusual for there to be enough natural light indoors for it to be useable in portrait photography without at least some input from artificial lighting. When there is enough, however, it can make for a very pleasant kind of light, often being rather soft and so quite gentle on the facial features. This normally happens in such places as conservatories or large buildings that have an entire glass wall or ceiling, buildings that in many ways are little more than covered open spaces. Although pleasantly soft, the lighting in these buildings is often also a little blue, due to the increased proportion of reflected light, which will need to be corrected.

Another way to use natural light indoors is close to a window, where plenty of natural light will be flooding in. A window bay can be a very attractive setting for a portrait, adding to the allure of this kind of shot. A profile view of the subject as they look out through the window will often be quite evenly lit, the background of the room behind at

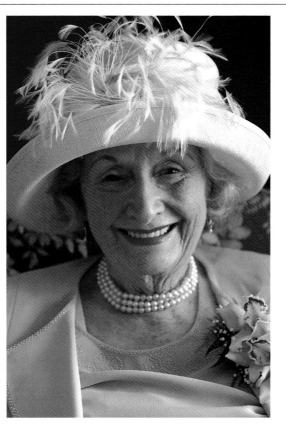

▶ Natural lighting from a window. This elegant lady was placed in the soft, diffused light coming through a large window. A matt white reflector was placed vertically on her shadow side and at a distance from the subject that gave two stops less lighting on her shadow side compared to that on her window-lit side. The result is a softly lit portrait, with just the right amount of shadow to provide a natural feel. *Canon 10D, 28–70mm L lens. ¹/₆₀ second, f/2.8, ISO 100.*

least partially lost in darkness. Since the light is so directional, however, if the subject is facing the camera and angled side on to the

incoming light, the side that is towards the room will be lost in shadow unless a reflector is used to bounce some of the daylight back at the subject.

Apart from these two instances, natural daylight is rarely sufficient for indoor portraiture, the vast majority relying on artificial lighting and that will almost entirely be flash lighting.

ARTIFICIAL LIGHTING

Like natural light, artificial lighting in the form of tungsten or fluorescent lamps is rarely sufficiently bright to allow the photographer to both freeze any movement with a fast shutter speed and obtain a large depth of field with a narrow lens aperture. In addition, there are the colour casts both of these light sources create, although provided the subject is lit by only one or the other, these are reasonably easy to overcome on a digital camera by selecting the appropriate white balance.

By far the most commonly used source of artificial lighting is flash, dominant in portrait photography for its reliability as a source of 5500K white light, sufficiently powerful

LIGHTING	
	CAMERA
	FLASH MONOBLOC WITH UMBRELLA (REFLECTOR OR DIFFUSER)
	SUBJECT
	FLASH MONOBLOC WITH SOFT BOX
	FLASH MONOBLOC WITH SNOOT
	FLASH MONOBLOC WITH BARNDOORS
	FLASH MONOBLOC WITH STANDARD REFLECTOR
	FLASH MONOBLOC FITTED WITH HONEYCOMB GRID
	FLASH GUN
	FLASHGUN FITTED WITH A REFLECTOR
	A THREE-PART FOLDING REFLECTOR (TRIFLECTOR)

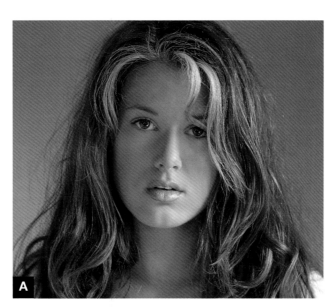

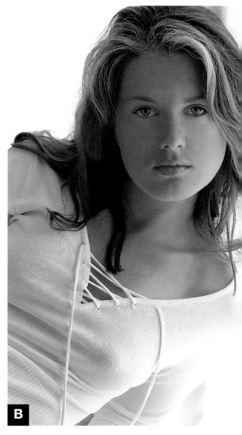

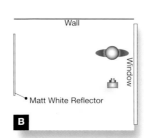

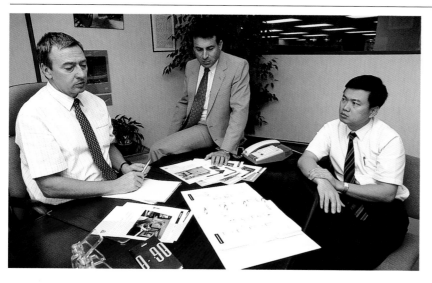

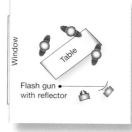

to allow both fast shutter speeds and large depth of field, as well as being hugely versatile and easily controlled.

Flashguns can be used for indoor portraiture, but these will generally be only the most powerful ones, with the highest guide numbers and shortest recycling times. They are of greatest use in editorial or reportage photography, where perhaps the subject is frequently on the move and where just obtaining images in which the subject is adequately lit is more important than lighting perfection.

For posed images, flashguns are still just useable, particularly if used off camera and with two or three working together to provide main and fill-in lighting. However, their power limitations, the fact that their small size almost inevitably leads to hard shadows and the normally limited range of diffusers and reflectors that can be fitted to them greatly restrict their usefulness in this field.

◄ Two portraits shot indoors using natural daylight only. In both, the subject sat close to a north-facing window, which provided a soft, diffused light, while a matt white reflector was set up below and on her shadow side. In (A) the reflector was set up sufficiently close to the subject to provide a fill-in light that was only one stop below that of the exposure from the window. The background was the existing colour of the interior wall. In (B) the subject sat much closer to the window, resulting in a stronger main lighting, while the reflector provided a fill-in lighting that was two stops below that of the window, resulting in deeper shadows. *Canon 10D, 28–70mm L lens, 1/30 second, f/4 for (A), 1/125 second, f/5.6 for (B).*

► A chef in a hotel oyster bar. The room was large and quite dark, so even with a cluster of monobloc flash units I could not have fully exposed the entire room. So I just left the background to fall into darkness, photographing the chef simply with an ordinary flash gun, bounced off a reflector. There are a few shadows, particularly of his arm across his white uniform, but apart from this he is well exposed. *Canon EOS 5, Sigma EX 17–35mm lens, flash, 1/20 second, f/5.6, Fujichrome Provia 100F.*

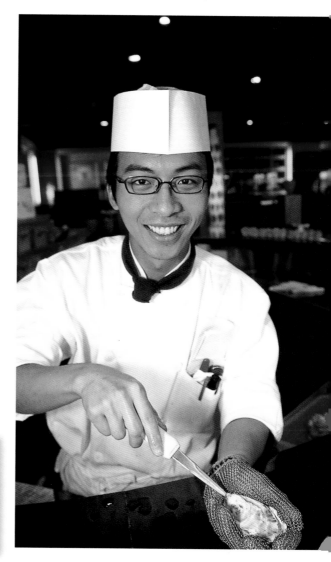

Flash monoblocs and console units dominate the lighting of portrait photography; both are much larger light sources and vastly more powerful than a flashgun and able to work with an array of reflectors and diffusers.

▲ A typical monobloc flash system, with both an umbrella reflector and softbox diffuser.

Monoblocs and Flash Console Units

Any photographer intending to undertake any amount of indoor photography, whether portraiture, interior design or still life, will need to invest in one of these flash units. With a wide variety of models on the market, power ratings vary enormously, so each photographer will need to consider their needs closely before deciding which system is for them.

The light output of both monoblocs and flash console systems is measured by the energy of the lamp's discharge, measured in Joules or Watt seconds, with the smallest having a maximum output of about 125 Joules (J for short), a little less powerful than the best flashguns, and the most powerful going up to over 6000J. Monoblocs mostly have maximum energy ratings of 125–1500J, while flash console systems cover the range from 2000J upwards. On all monoblocs and flash consoles the flash output can be manually varied by usually between two and four or even more stops, depending on the model and its maximum energy rating.

A second principal difference between the two types of unit is the arrangement of the controls. Monoblocs are essentially self-contained units, with all the electronics and controls built into the body, the whole unit plugging directly into the mains electricity. Flash console systems, by way of contrast, consist of a power pack, which plugs into the mains, containing most of the circuitry and all the controls, with separate flash heads that plug into the power pack. With symmetric power packs the power is distributed to all the flash heads equally, but with asymmetric systems each head can be controlled separately.

Another type of flash unit, mentioned in the last chapter, is the battery-powered unit, such as Elinchrom's Freestyle. This consists essentially of a monobloc that plugs into a battery power pack, which can run two flash heads simultaneously. Since the controls are in the flash head, as with a standard monobloc, the output from each can be managed separately. This makes for a very compact and highly portable flash system that can be used both indoors and out, independently of any mains power source and free of trailing wires for people to trip over.

For the vast majority of portrait photography the monobloc flash units provide ample power, mainly in the 500–1000J range, either as the standard mains plug-in or the battery-run version. For this reason, along with its relative portability that allows its use both in a studio and on location (whether indoors or outside), all the flash photography described in this chapter assumes the use of a monobloc system.

Diffusers and Reflectors

It is important to note that a flash unit, whether a monobloc or console system, is rarely used as a direct, unfiltered lighting source. The lights will almost always be either bounced off reflectors, such as a white or silver umbrella, or filtered through a diffuser, usually either a translucent umbrella or a softbox. This not only greatly softens the light but will also reduce its intensity by 1–2 stops, an important consideration when deciding how powerful a system to buy.

An accessory that comes as standard with almost all monoblocs is a bowl-shaped reflector that has a roughened silver inner surface, which locks onto the front of the

DESCRIPTION OF A MONOBLOC

The lamp component of a monobloc consists of two bulbs: the flash-tube itself and a modelling lamp, usually a 100–200 Watt tungsten or halogen lamp. The latter is an extremely useful feature, providing a clear indication of lighting angle, positioning and pattern well before the flash is fired. As the modelling lamp's intensity is well below that of the flash it can be left switched on at all times, having no effect on the flash lighting. However, it does generate heat, which may be uncomfortable for the subject if quite close to it; it will, of course, also cause the monobloc to heat up.

CONTROLS

The controls, mounted either in the side or rear of the monobloc, generally consist of the following:

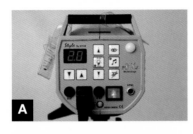

1 a mains lead socket

2 a flash sync socket that connects to the camera

3 separate on/off switches for the modelling lamp and flash element

4 controls to vary the outputs of the modelling lamp and flash element. These two should be independent but it must be possible to keep the modelling lamp's output proportional to that of the flash

The controls on the backs of two different designs of Elinchrom monobloc flash units (A and B). At the front end, the lighting consists of the central modelling lamp and a circular flash tube surrounding it (C).

5 a slave cell on/off switch, enabling secondary flashes to fire automatically when the main light is fired, without the need for interconnecting cables

6 a flash firing button, making it possible to fire the flash manually, for testing purposes, to dump excess power or for repeat manual firings during long exposures.

The front end of the monobloc also has fitting and locking mechanisms for a variety of reflectors and diffusers, while on the side is a locking system to mount the unit onto a light stand.

monobloc. Its main function is to ensure that all light emitted is directed forwards, ahead of the monobloc, rather than having some spilling back behind. It can also be used in conjunction with a range of umbrellas to ensure that all emitted light is bounced off or diffused through the umbrella before reaching the subject.

UMBRELLAS

Umbrella reflectors and diffusers literally are umbrella-like, resembling their rainy weather cousins in both shape and the way they fold up, usually about 1 metre (3ft) in diameter. The similarity ends there, since, if used as a reflector their lower side is covered with a white or roughened silver surface and, as a diffuser, is made of white translucent material.

Umbrellas have been standard equipment for a long time, but in recent years

▲ Different types of umbrella reflector (with white and silvered inner surfaces) and diffuser.

many professionals have come to prefer softboxes. Usually square, but occasionally octagonal, this consists of a huge box up to 2 metres (6ft) across that locks onto the front of the monobloc. The front part consists of a double layer of diffusing material, while the inner faces of the side walls have a roughened silver surface. Enormously effective diffusers, the light transmitted by a softbox is, as the name implies, extremely soft, giving a very even lighting that minimizes shadows and skin texture.

Different shaped soft-box diffusers, produced by Swiss flash lighting manufacturer Elinchrom.

OTHER TYPES OF REFLECTOR

Also commonly used are stand-alone reflectors, usually placed either to one side of the subject or in front of and below them. These are used to reflect light from the main flash back into shadow areas, further softening the lighting.

Finally, a cone-shaped hood called a snoot is sometimes fitted over a monobloc to direct a narrow beam of light – one of the few times a monobloc is fired directly and undiffused at a subject – usually to act as what is called a hair light, something that emphasizes and puts highlights into hair. A snoot should be used with caution as the narrow funnel traps heat and as a result can cause a monobloc to overheat and cut out.

FLASH TECHNIQUE

The aim of using flash in portrait photography is to mimic indoors the lighting of the sun, usually on a bright but overcast day, doing so in a wholly controlled way. In a sense, flash lighting is a kind of portable sunlight that is always available. However, its skilled use requires some practice and the understanding of a few basic principles if the problems of hard shadows, burned-out highlights and a generally very unflattering picture are to be avoided. The sections that follow are intended as a step-by-step guide, looking at how to set lights up, how to meter accurately before pressing the shutter and what the effects are of shooting with differing numbers of lights used in different ways.

PREPARING THE LIGHTS

Before you rush into taking any photographs, think about how the subject should be photographed. Will there be a screen behind the subject or an open room? If the latter, should the room be left to disappear into gloom behind the subject or does it need to be a well-lit integral part of the photograph, perhaps revealing something of the subject's home or work life? If there is to be a background screen, does that need to be lit and if so how many lights are needed for this?

LIGHTING THE SUBJECT

When it comes to lighting the subject, will one light be sufficient or will two be needed? If only one light is being used perhaps a reflector will be needed on the subject's side away from the light to fill in the shadows?

The most straightforward lighting methods use just one or two lights, usually with a screen behind that cuts out any background environment. This is the setup that will be described initially, later moving on to arrangements that involve more lights and a more complex background.

The first point to note in this kind of lighting is that ambient room light plays no part in the photography, as the flash lights are fired at a far higher output, completely overwhelming ambient light. Second, no matter how many lights are used, there is always one main light that is dominant, providing the main subject illumination. It should be set up quite close to the subject, less than a metre away, perhaps up to two metres if the subject is likely to move very much, aligned about 45° to the subject–camera line and raised so that its centre is just a little above eye level. This ensures that the lighting is angled downwards slightly, thus mimicking

out grey in the final image due to fall-off in the ambient light behind the subject. Provided the subject is some distance from the screen and the main light's softbox or umbrella is angled correctly, no subject shadow and no light should spill onto the background. If the latter were to happen a black screen would tend towards a grey that would almost certainly be uneven and hence probably unattractive.

◀ A typical studio lighting set up for a high-key portrait image: a diffused main light with a large soft-box and one or two lights to illuminate the white background.

A Second Light

If a second light is to illuminate the subject, this should be set up on the opposite side of the subject from the main light and should play only a secondary role to the main light, providing fill-in lighting on what is the subject's shadow side. Whether diffused through a softbox or translucent umbrella or bounced off an umbrella reflector, it must deliver less light to the subject than the main light does. This is best achieved by reducing the flash's output or, more simply, moved further away, although this would increase the lighting's harshness.

Alternatively, the role of this second light can often be taken by a reflector set up close to the subject either on their shadow side or, if the image is to be a head-and-shoulders shot only, in front of and below the subject. Whether to use the reflector's matt white or silver surface depends not so much on the amount of light that needs to be bounced back at the subject as the quality of that light. The matt white surface will tend to reflect a soft flat light, whereas the silver will reflect a much harsher, brighter light. Using the latter on someone with shiny, reflective skin would be a mistake as it would very likely result in white hot spots and the appearance of skin texture in the area exposed to the reflected light.

For a photographer with only two lights

the sun's angle and providing a relatively natural light that the human mind is used to seeing, while at the same time not generating harsh shadows under the eyebrows, nose, jaw or chin. The reason for putting the light so close to the subject is to ensure that it is as big a light source, relative to the subject, as possible. This will virtually flood the subject with light, making it extremely hard for shadows to form. Using a smaller light source, or moving a large source further away, would result in ugly harsh shadows that would not flatter the subject in any way.

Background

As for the background, the subject should be quite some distance (at least two metres) in front. This not only ensures that the background will be out of focus but also reduces the risk of any shadows from the subject or stray light from the main flash falling on it. If the background is not to be illuminated it should be a matt black screen, as an unilluminated white screen will tend to come

using a reflector would free up the second light with which to illuminate the background. In this case, the light should be set up close to the subject (although, of course, out of shot) and fired directly at the background without any diffusion or reflection. An illuminated background can be just about any colour (as long as it does not interfere with the subject) and the lighting is even right across that part of the background visible in the final image. A single light has sufficient coverage to illuminate the background behind at most two people. If the subject consists of a group, lighting the larger background will require two lights, set up at either end of the background sheet and fired at it at 45°.

At the two extremes of background colours, white backgrounds inevitably produce high-key images, in which the background is totally white, whereas black backgrounds generate dark low-key images. Interestingly, colours can be introduced into a black background by putting coloured gel filters over the background light. How to do this is described on page 107.

SETTING AND METERING FLASH OUTPUTS

Once the lighting has been decided and arranged there is then the matter of setting light outputs and of correctly metering everything. In a lighting setup where there is a background sheet, no need to balance the flash lighting with any ambient source and all the lighting is provided by controllable flash monoblocs, the main consideration becomes providing enough light to have a narrow lens aperture. The shutter speed is relatively unimportant since it will inevitably be much slower than the duration of the flash (typical duration of a monobloc flash is only about $\frac{1}{2000}$ of a second or 2 milliseconds) and so will not have any impact on flash exposure. All that is required of the shutter speed is that it be slower than the maximum speed at which its curtains will synchronize with the flash and fast enough to freeze any subject movement.

Lens aperture, on the other hand, is critically important, as it will be directly related to the flash output: halving the lens aperture

(for example going from f/11 to f/16) will double the amount of flash output required. Once the lens aperture has been selected, commonly f/16 in order to maximize depth of field, the next step is to produce and meter the flash output needed for a correct exposure at that aperture, starting with the main light. It is here that correct use of a light meter is crucial.

Unlike flashguns, the output from neither monoblocs nor console flash units can be controlled automatically via TTL metering. As a result, all the metering and the setting of flash output levels must be done manually, calculated using the light meter. The following is a step-by-step guide to how to do this:

1 Many light meters can read both flash and ambient light (often known as a flash meter) and this is what is needed in this work. The first step is to select the flash setting.

2 Plug the flash sync lead from the main light into the meter's flash socket.

3 Press the ambient light-metering button. This will bring up on the meter's LCD screen the shutter speed presently selected plus the letter 'F'.

4 The shutter speed reading on the meter is unimportant as it will have no influence on the flash reading that will follow, but if desired it can be altered at this point to match the one to be used by the camera (often about $\frac{1}{60}$ second). If so, repeat step 3.

5 Now measure the output from the flash. This must be an incident light reading, in other words one that measures the amount of light coming from the flash to the subject, not a reflected reading (the amount of light bouncing off the subject to the camera). The latter would be influenced by such factors as skin and clothing colour and so could give an incorrect exposure. An incident light reading is not affected by such factors.

6 To take an incident light reading, stand or sit where the subject will be and point the meter towards the main light. Make sure this meter reading measures only the

light coming from the main flash, not also that coming from secondary flashes being used. To do this, screen the meter's sensor with a hand. Press the flash button to fire the main light.

7 The meter's LCD will now show, in addition to the selected shutter speed, the lens aperture needed for a correct exposure with the light at its current output setting. If the output is too low for the desired lens aperture, say it comes out at f/11 when the image is to be photographed at f/16, turn up the power on the flash's controls and try again. Similarly, if the flash is too bright, giving a reading on the meter of, say, f/22, turn the light's power down and start again. Note that on many monoblocs turning the power down when it has already charged up will not lead

▲ This portrait illustrates the classic high-key studio technique. The main light was a monobloc fitted with a 2-metre (6 ft) diameter octagonal softbox set up just to the left of the camera. The result is a soft illumination, generating gentle skin tones. A large white reflector was placed on the floor in front of the subjects to provide fill-in. Two further lights were placed on either side of them, facing the white background, their power set to produce a pure white lighting. *Canon 10D, 28–70mm L lens, three Elinchrom 500J monoblocs, 1/125 second, f/11, ISO 100.*

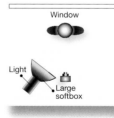

◄ An unusual high-key lighting technique, in which the white background is created by overexposure of light coming through a large window behind the subject, diffused using two layers of petticoat netting. Just one light was used, positioned just away from the camera-to-subject axis. Exposure readings were taken to determine the camera aperture for the main light, and then for the light coming through the window. The shutter speed was slowed to ensure overexposure of the window lighting, resulting in a pure white background. *Canon 10D, 28–70mm L lens Elinchrom Rotalux, 1/4 second, f/4, ISO 100.*

to the excess power being automatically dumped. It will be necessary to dump that power manually by firing the flash with the manual button, allowing the light to recharge to its new, lower setting.

8 Repeat the process with any secondary light in use, ensuring that the meter is shielded from the main light and so reads only the secondary light's output. This reading will enable the ratio between the outputs of the main and secondary lights to be set. The secondary light is usually fired with an output that gives a correct exposure 1–2 stops below that of the main light; i.e. at f/8 or f/11, if the main light's output is at f/16.

9 Any background light should be set up and metered to give an exposure on the background equal to that of the main light.

10 Repeat the process with the meter reading the output from all the lights simultaneously, to give a final exposure that may well be a little above that for either light alone (in other words, up to f/22). Check this not just in the position where the subject will be, but also on the background.

11 With the subject in position, take several flash meter readings around different parts of their body (put the flash meter up close to each part of the face, arms, clothing etc., but always facing the lights) to check the lighting distribution and so minimize the risk of strong shadows.

12 Finally, unplug the flash sync cord from the meter and plug it into the camera's flash socket. The lighting is reading to take some photographs.

As a final check on lighting and composition, professional photographers using film often take some instant print pictures, something that gives a clear idea of the lighting and shadow distribution. With digital now king, this role has been taken by the camera's LCD screen. Unbearably tiny though it is, the screen on professional level cameras at least has a zoom feature allowing the photographer to home in on certain parts of the picture, something that provides an adequate check on shadows.

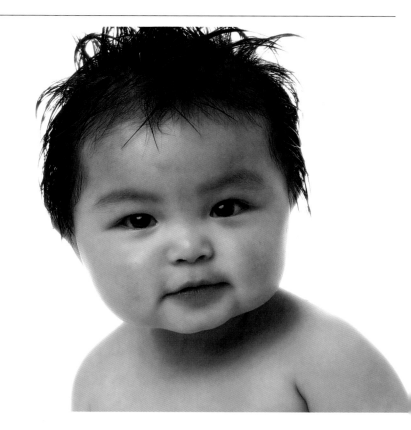

▲ A simple high-key portrait taken using two lights. The main, diffused, light was placed 45° away from the camera-to-subject axis, while the second illuminated the background to create pure white. *Canon 10D, 28-70mm L lens, Elinchrom Rotalux as main light, $1/125$ second, f/11, ISO 100.*

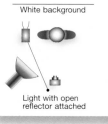

White background

Light with open reflector attached

ISSUES WITH BACKGROUND LIGHTING

It is important to note the correct way to light a background, particularly one that is white. It is frequently said that for a white background to come out white in the final image it is necessary to overexpose it: in other words, to set the background light to a higher output than the main light. This might be so for a photographer taking reflected light meter readings, in which a large, reflective white wall will tell the meter to underexpose the image. With incident light readings this is not an issue – only the light falling on the subject and background are measured, not the light being bounced back from them. So a wall that is white will come out white in the images if it is illuminated with the right amount of light as measured by an incident light reading.

Once it is white, overexposing will not increase its whiteness. What it will do, how-

White background

◄ A high-key portrait photographed using two lights. The main light, diffused through a large octagonal softbox, 2 metres (6ft) across, was placed in front of and at an angle of about 30° to the subject. The second light, placed next to the subject, was used to illuminate the background to give pure white. The huge octagonal diffuser has generated a very soft, even lighting across the subject. *Canon EOS 3, 70mm L lens, Elinchrom 500J monobloc flash, ¹⁄₁₂₅ second, f/11 Fujichrome Velvia 50.*

▼ This portrait demonstrates the use of a black background illuminated with a lamp covered with a coloured gel. The main light illuminates the right side of the subject's face, with fill-in provided by a white reflector on his left. The black background is illuminated by a blue gel-covered lamp set to overexpose, while a third light, fitted with a snoot, and set up above and behind the subject, pro-

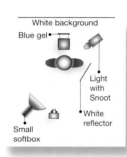

White background
Blue gel
Light with Snoot
White reflector
Small softbox

vides separation lighting, ensuring that the subject's black hair is distinguishable from the dark background. *Canon 10D, 28-70mm L lens, Elinchrom Rotalux and two Elinchrom 500J monoblocs, ¹⁄₁₂₅ second, f/8, ISO 100.*

ever, is cause the image to start to burn out, the excess white bleeding into adjacent non-white areas of film or microchip, turning them increasingly white and leading to an ugly burned-out 'halo' around the subject.

Conversely, a black background can be overexposed, as the background lighting's output is increased further and further above what the meter measured to be the correct exposure, the background turning increasingly grey, going all the way to white if the background light's output can be turned up high enough. Colours can even be introduced by placing filter gels over the background light, something that does not work well with a white background as the white will always dilute, if not totally swamp, the colours.

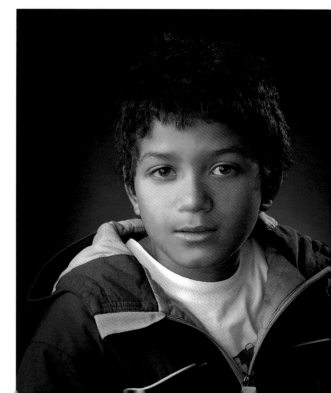

DESCRIPTION OF A TYPICAL FLASH METER

A typical combined flash and ambient light meter, the type needed for this kind of photography, consists of a sensor at one end (usually a white dome), an LCD screen, a number of control buttons, a socket for the flash sync lead and a body containing the electronics and space for batteries.

Selection buttons allow the user to scroll through a number of options displayed on the LCD, including at least ISO setting, shutter priority reading for ambient light, aperture priority for ambient light and flash metering. There may also be an option to build over- and underexposure corrections into meter readings. Separate buttons will activate the ambient and flash reading systems, although often in order to activate the flash system the ambient metering button has to be pressed first.

A typical flash-meter used for both ambient and flash light readings, incident and reflective.

The white dome on the meter's sensor is usually removable: leave it on for incident light readings (to measure the amount of light shining onto a subject) and take it off to make reflective light readings (to measure the amount of light being bounced back off a subject).

Note that the filters must be special photographic gels (produced by such companies as Lee Filters) due to the heat they have to withstand from the light. Use any ordinary coloured acetate sheeting and it will probably melt and may cause a fire.

USING MORE LIGHTS

The lighting arrangement described ear-

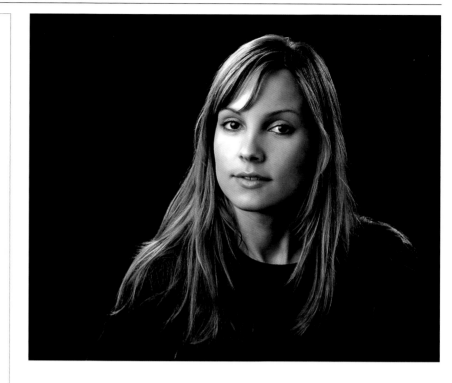

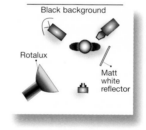

Black background · Rotalux · Matt white reflector

▲ This portrait demonstrates the use of hair-lighting to provide extra sheen in the hair and make a clear separation between the subject and a dark background. Three lights were used. The main light, set up at an angle of 45° to the subject, illuminates the right side of her face, while a matt white reflector provides fill-in on her left. A second light, fitted with a snoot, is set up above, behind and to the subject's left, while the third light, fitted with a reflective umbrella, is set up above, behind and to the subject's right. Together, this type of lighting accentuates the structure of the subject's face while also illuminating her hair and clearly separating it from the background. *Canon 10D, 28-70mm L lens, Elinchrom Rotalux and two Elinchrom 500J monoblocs, 1/125 second, f/11, ISO 100.*

lier used one or two lights, for main subject light plus either secondary or background lighting. Obviously, one can introduce more lights, but then, of course, the arrangements and metering become ever more complex.

The use of three or four lights would make both background lighting and a secondary subject light possible, while a further option is the introduction of a hair or separation light. This is used to put highlights into hair or ensure that the subject's outline is clearly separated from the background. It should be set up above and behind (although, naturally, out of camera shot) the subject, softened with an umbrella reflector if a broad light is needed to fall on the head and shoulders (to act as a separating light) or concentrated through a

snoot if it is to light up only the hair. As mentioned, care should be taken with a snoot as it may cause the light to overheat. The light's angle means there is a danger of it partially pointing at the camera, so care should be taken with its angling to ensure that no light from it spills into the camera lens. The risk of this is greater if the light is being softened and broadened with an umbrella than if it is being funnelled through a snoot.

The hair and separation light should be used sparingly, most especially if high-key lighting with a white background is being used and particularly if the subject is blond. In this situation, a hair light may simply cause the hair to glow excessively or to burn out altogether. A hair light does work well in combination with high-key lighting if the subject has dark hair and both hair and separation lights are valuable when a dark background is being used.

OTHER LIGHTING ANGLES AND INTENSITIES

The lighting description so far has concentrated on soft lighting that is heavily diffused and reasonably frontal. The benefit of this kind of lighting is that it is easy for the photographer to use and is generally flattering to the subject, softening many facial features such as nose and chin, and minimizing wrinkles, blemishes and facial hair.

Increasing the harshness of the lighting will all help to accentuate these features, revealing skin texture and facial hair and putting strong shadows into wrinkles and along the jaw, chin and nose lines. With shiny, reflective skin, it will also cause bright hotspots on the face, rarely an attractive feature. Not a very flattering lighting, it is nevertheless effective in emphasizing the sense of a strong, perhaps forceful character, something that is often appropriate in the photography of men.

This harsh lighting can be developed, first, by increasing the lighting angle, moving the light further round towards the subject's side. The second step is to increase the light's hardness by moving it further away from the subject (and so reducing the light's relative size), by removing one

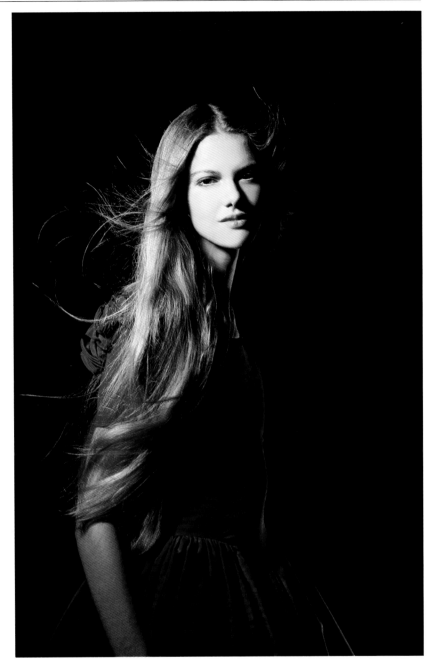

Black background

▲ An image shot with fairly hard light, created partly by increasing the lighting angle. The main flash light, set up almost side on to the subject, was fitted with a square honeycomb grid (the inside of which had a matt white surface), over which was stretched a white gauze. The result was lighting that was both directional and soft. A second light, fitted with barndoors, was placed at an angle of 45° behind the subject to create a rim and separation light. *Canon 10D, 28-70mm L lens, two Elinchrom 500J monoblocs, 1/125 second, f/11, ISO 100.*

Window
Diffuser umbrella
Table
DINING ROOM
Harpsichord
Reflector umbrella

▶ This image of a woman playing her harpsichord at home was photographed using three lights: A) a monobloc flash to the right to illuminate both the woman and the harpsichord; B) a small flash gun on the floor next to her left foot to throw some light under the harp-sichord; C) a second monobloc flash in the back-ground dining room to ensure that was not lost in a distracting darkness. *Mamiya RZ67, 65mm lens, tripod, Elinchrom 500J monobloc flash, ¹/₁₅ second, f/11, Fujichrome Provia 100F.*

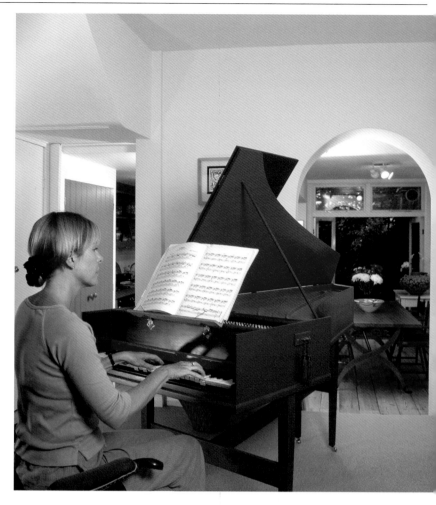

of the usual two diffuser screens from the softbox or by replacing the softbox with a much smaller umbrella. A highly effective, forceful light when used well, such hard lighting is, however, quite unforgiving both of any unattractive physical features inherent to the subject's face and of any tendency to overdo it by the photographer.

As a final note to all these lighting styles, there is always the risk of light spilling from one or more of the flashes directly into the camera lens instead of first going via the subject and background. At the very least, this will decrease colour saturation in the final images and, at worst, will cause flair across the images. To minimize this risk, the lens should always be fitted with a hood. In situations where lighting angles are particularly acute, especially with the separation light, a 'flag' may need to be set up between the light and lens, a small screen to block out any stray light.

ENVIRONMENTAL PORTRAITURE

Often used in editorial photography, this is the kind of portraiture that shows a person or people in their environment, whether at work, home or some other place. Gone is the background sheet, replaced by some appropriate surroundings, whether they be an office, factory, kitchen or shop, a three-dimensional

▶ Shot specifically for a magazine article on commercial espionage, this image was delib-erately set up to look as though it were shot on a CCTV camera. The lighting is deliber-ately harsh and from one side, to resemble an office light on in another room, although in fact it was a tung-sten photoflood. *Canon T90, 8mm fisheye lens, ¹/₂₀ second, f/11, Kodak Ektachrome 64 ASA tungsten film.*

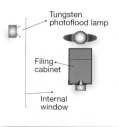

Tungsten photoflood lamp
Filing cabinet
Internal window

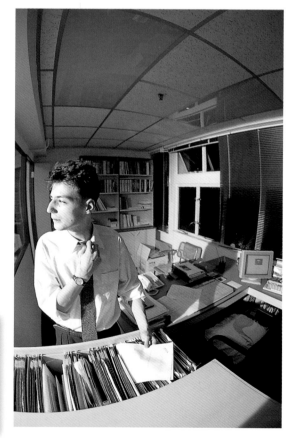

▼ The scientist James Lovelock (founder of the Gaia principle of Earth as a living organism), in his office in Cornwall, southwest England. As he was interviewed for a magazine at the age of 82 (and still an active scientist), I took this image using a combination of light from the window (coming in from the left) and a single monobloc flash with umbrella reflector on the right, the background his book shelves. *Mamiya RZ67, 110mm lens, Elinchrom 500J monobloc flash, ¹⁄₁₅ second, f/8, Fujichrome Provia 100F.*

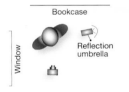

background that says something about the subject and their life.

Clearly, this kind of background cannot be lit in the same way that a flat sheet can and one of the first decisions that needs to be taken in photographing a subject is how important it is to keep that background well lit and clearly visible. If it is relatively unimportant it may well be perfectly acceptable to concentrate on exposing the subject with bright flash lighting, leaving the background to slip into at least a certain amount of gloom behind. However, if the background is an important or maybe even crucial part of the image, then it will be necessary to ensure that it is just as well lit as the main subject: the lighting for the subject and background will need to be balanced. If the background is simply a small room, this may be relatively simple, one or two monoblocs being sufficient to provide enough light to balance with the subject's main flash. However, with a larger room, things are much harder as it is difficult for monoblocs to light up a large space.

In this situation, the only way round may be to ensure that the subject's main flash balances with the background ambient lighting, something that in many indoor situations

will require a slow shutter speed and wide lens aperture. To correctly set the lights and meter for this, proceed as follows:

BALANCING PORTRAIT AND BACKGROUND ROOM LIGHTING

1 After deciding where the subject will pose and setting up the subject lighting, the next step is to take light meter readings for the background ambient lighting. Have the meter set to an ambient setting, preferably aperture priority, and take several incident light meter readings in different parts of the background. If metering near a window, be sure the meter reads the light levels inside, not those outdoors.

2 After establishing which shutter speed and lens aperture are needed to expose the background with ambient light correctly, switch to flash metering and, using the method just described, find the right flash output to give the same lens aperture as is needed for the ambiently lit background. This setting will give balanced subject and background lighting.

3 The required flash output will necessarily be quite low, in fact sometimes lower than the monobloc can manage. In this situation:

- select as slow a shutter speed as you dare in order to push up the ambient f number as close as possible to the monobloc's minimum setting, and

- put a neutral density filter gel across the monobloc (photographic gel only, not an ordinary acetate sheet) to further reduce the output.

4 Once the flash and ambient lighting are balanced, continue as described in the preceding flash technique section.

This method will provide ambient and flash lighting that is balanced in the intensity of light delivered to subject and background, but that says nothing about the colour of that light. If the background is lit naturally then clearly both it and the flash will have approximately the same colour temperature (although the background may be a little

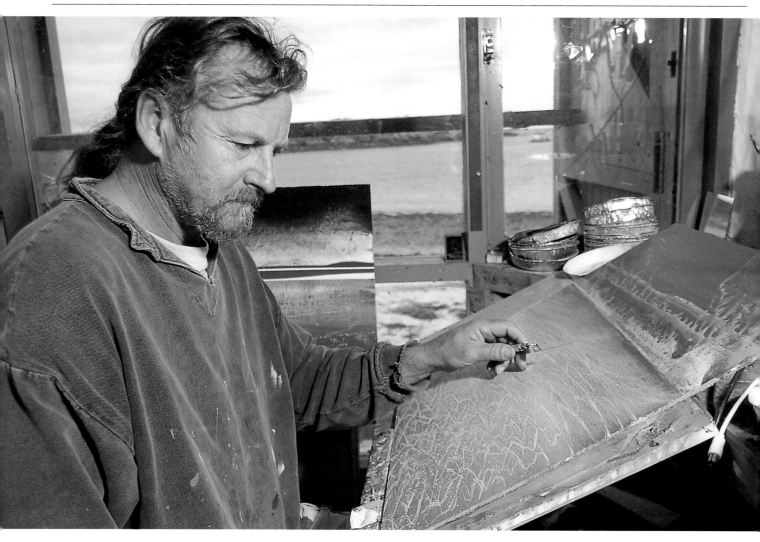

blue) and there will be no imbalance in the images. However, if the background is lit by fluorescent tubes or tungsten lights, while the main subject will come out in the final images correctly coloured having been lit by 5500K flash lighting, the background will have either a green or an orange cast or both if both types of lights are present.

This may not be important or bothersome, but if it is, the problem can be corrected, at least partially, by giving the flash lighting the same colour as the ambient lights and then correcting for both at the camera. Thus, to remove a fluorescent lighting-induced green background cast put green-coloured correction gels over the monoblocs. If shooting on film, put a magenta colour correction filter over the lens and, if using a digital camera, select for fluorescent lighting on the white balance feature. To remove an orange background cast caused by tungsten lights, put

▲ An artist at work in his studio, Bryher, Isles of Scilly, Cornwall, Great Britain. While exploring this tiny island off southwest England's Atlantic coast, I stumbled across this artist working in his studio, a converted boat shed right on a beach. Although there was a lot of natural light in the studio, the image was shot with one flashgun and reflector handheld a little to the right of the camera. *Canon EOS 5, Sigma EX 17–35mm lens, flash, 1/30 second, f/8, Fujichrome Provia 100F.*

orange 85B gels over the monoblocs and an 80A blue filter over the lens on a daylight film-using camera or, with the white balance of a digital camera, select for tungsten lighting. Colour balancing with filters will be covered in more detail in Chapter 7 (page 123).

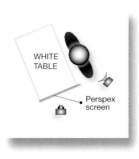

◄ This image of a botanist at a sterile workbench was extremely difficult to pull off as it had to be shot through a perspex screen, a flashgun held up high to the right. The man is almost backlit as a result, the side of his head illuminated, the front of his body lit only by light reflected off the white workbench. Note the light green cast on his white coat, a result of the workbench's fluorescent light, in an area the flash lighting could not reach. *Canon EOS 5, Sigma EX 17-35mm lens, flash, $\frac{1}{15}$ second, f/5.6, Fujichrome Provia 100F.*

PROBLEM SOLVING

Most people have specific features that might in some way be challenging to a portrait photographer, such as spectacles or a long jaw. In almost all situations, there are ways to solve or minimize the problems and a few of these are listed here.

BLACK OR VERY PALE WHITE SKIN

It is often believed that very dark or very pale skin will cause problems with obtaining correct exposure, the former tending to cause overexposure, the latter underexposure. This is only the case if reflective light meter readings have been taken: provided the lighting is measured using incident readings skin colour will have no impact on the exposure – they will always come out correctly exposed.

SHINY, OILY SKIN

Such skin will obviously have a greater tendency to reflect light than dry skin will, leading to the likelihood of burned-out hotspots on the skin. This can be minimized by using the softest light possible, including both large, dense diffusers on the lamp(s), and with reflectors by using only matt white surfaces. It can also be reduced by careful application of make-up to dull the skin's surface and, if the skin is actually damp, by drying it.

SPECTACLES

Big white reflections of the diffusers and reflectors in a subject's spectacles, making eyes almost invisible, are the bane of many a photographer's life. It can usually be solved by a small alteration in the angle of the subject's head, ensuring that the white reflections are bounced off elsewhere, not into the camera lens. In the case of a head-and-shoulders portrait in which a reflector is set up below the subject's face, if this shows up in the subject's spectacles and is not removable by moving the head (or if doing so then puts a reflection of the diffuser into the camera lens instead!), it can be removed by laying strips of black material on the offending sections of the reflector. This ensures that the reflection into the spectacles is now black and hence invisible. In the worst case scenario, the lenses can, assuming the subject agrees, be removed and the photograph taken with the subject wearing just the empty frames.

ROUNDED FACE

This can be reduced by de-emphasizing the cheeks. Do this by raising the main light to increase the lighting angle and by raising the camera position to increase emphasis on the

forehead. These two steps will together tend to make the top half of the head wider and the lower half narrower. The higher lighting angle will create stronger shadows along the jaw, emphasizing them, making them seem higher and hence reducing the apparent size of the cheeks.

Long Jaw and Nose

The effect of these can be reduced by using very soft lighting with the flash as close to the camera as possible, the centre of the lighting no higher than eye height, as well as a frontal camera angle. Soft reflectors should also fill in as many shadows as possible, in order to minimize any shadow forming along the bridge of the nose, as well as the jawline shadows.

Red eye

This is certainly a common problem with on-camera flashgun photography, light from the flashgun, or an in-built flash on a simpler camera, being bounced off the eye's retina straight back into the camera lens and making the pupil appear red. With off-camera monoblocs this should not be an issue. These lamps stand to one side of the camera, ensuring that the light hits the eyes at a greater angle than is the case with on-camera flash. As a result, the light is also reflected back at a greater angle, well away from the camera.

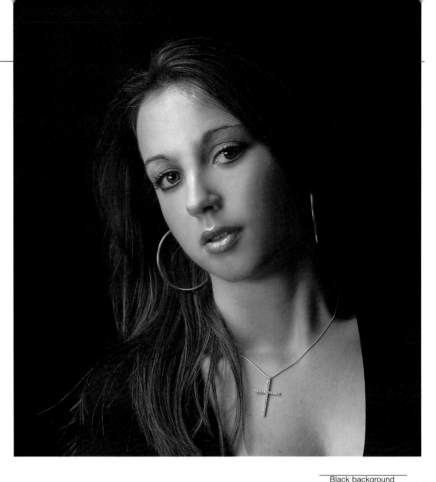

▲ An image taken to play down a rounded face. The subject was lit using a single light, positioned about 90° from the camera-to-subject axis, with her face angled towards the light to create a triangular-shaped catch-light on the nearest cheek. This creates the effect of a more angular shape to the face. *Canon 10D, 28-70mm L lens, Elinchrom Rotalux flash, 1/125 second, f/8, ISO 100.*

Black background

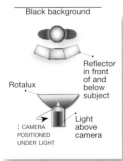

Black background

Rotalux

Reflector in front of and below subject

Light above camera

: CAMERA POSITIONED UNDER LIGHT

► A dramatic image that is lit using strong directional light to accentuate facial bone structure. A single flash was used, positioned in front of the subject and about 45° above her. A reflector positioned in front of her bounced more of the light back into her face, thus reducing contrast and shadow areas. *Canon 10D, 28–70mm L lens, Elinchrom Rotalux flash, 1/125 second, f/11, ISO 100.*

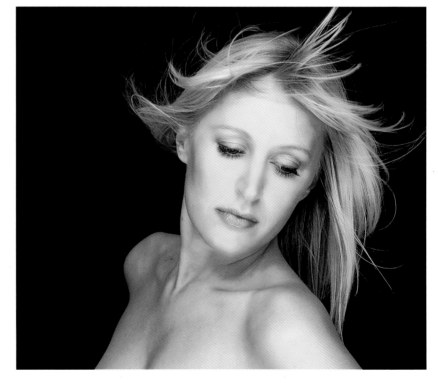

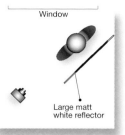

◄ An image that creates a romantic or sexy mood. The main lighting is natural via a window through which the light has been heavily diffused with three layers of fine netting. A 2-metre (6 ft) reflector was placed vertically behind and to one side of the model, using the matt white surface to lighten and soften the shadow areas. *Canon 10D, 28–70mm L lens, ¹⁄₃₀ second, f/4, ISO 100.*

MATCHING THE LIGHTING TO THE SUBJECT

Already alluded to on numerous occasions, it is vital to match the lighting style to the subject. While soft, shadow-free lighting is ideal to enhance a woman's beauty or to convey the sense of a kind, loving person in someone whose job it is to care for people, it is not likely to go down well with a man who wants a photograph that emphasizes his masculinity. For that type of image, it is necessary to employ rather harder lighting to highlight such features as a strong jaw, a certain ruggedness and worldly experience. That means a more acute lighting angle and a quality of light that is less diffused to show up greater bone structure and skin texture.

The moral from that, then, is that the photographer should always know a bit about their subject before setting up the lights, understanding what kind of life the subject leads and what sort of image they want to project of themselves. Once that is sorted, it is possible to decide on and set up the lighting required.

▲ A hard, directional light, with strong shadows to enhance masculinity. This boxer was illuminated with a single flash fitted with a small softbox from which the outer (but not the inner) diffusion panel had been removed. This, coupled with the softbox's silver interior created a harsh, crisp light with a strong directional quality. A silver reflector was positioned vertically at 45° in front of the boxer to ensure that details were visible in the shadows and to emphasize three-dimensional form. *Canon 10D, 28–70mm L lens, ¹⁄₁₂₅ second, f/11, ISO 100.*

7

Interiors

◄ Looking down through the open well in the centre of a well-known Hong Kong department store. This image was shot on tungsten film to balance with the store's predominant lighting. A couple of small patches of blue show up where there was some fluorescent lighting. *Canon EOS 5, Sigma EX 17-35mm lens, tripod, 8 seconds, f/22, Fujichrome 64 ASA tungsten film.*

► An attractive Spanish-era home in the town of Vigan, in the north of the Philippines. Note how rapidly the light falls off, moving away from the window: very bright close to the window and then deep shadows at the back of the room, a much greater-range than the eye is aware of due to the eye's greater ability to handle contrast, compared to film or digital. *Canon EOS 5, Sigma EX 17-35mm lens, tripod, 2 seconds, f/16, Fujichrome Provia 100F.*

Photography of interiors, whether they be a dining room at home, a restaurant, office, hotel lobby or factory, is a whole skill in itself. The number of photographers who have been frustrated by their early attempts hardly bears thinking about, their images a mix of strange green and orange colour casts that just were not visible to the eye. Each location has its own set of lighting characteristics, ranging from superb natural daylight, to dim tungsten bulbs, to flickering fluorescent tubes and sometimes a mixture of all three, all put there it seems to challenge the photographer to come up with correctly exposed, correctly coloured images. It is not surprising, then, that success requires some understanding of the colour properties of artificial lighting and the best ways to use filters and flash to reduce or remove those colour casts, techniques that, when used correctly, can produce some stunning results.

One general consideration is that with interiors photography, light levels are usually relatively low, much lower than those outdoors. However, because it is usually important to ensure that as much of an interior space as possible is in focus, depth of field must be maximized, inevitably meaning narrow lens apertures, slow shutter speeds and the need for a tripod. Lighting techniques are generally not affected by this, although photographers using film will have to look out for reciprocity failure when using exposures longer than about one second (see Chapter 4, page 73).

NATURAL DAYLIGHT IN INTERIORS

During the day, natural light is the dominant source of lighting in the majority of interiors, although, of course, it is often quite muted and usually with a strong fall-off in intensity from the windows towards the innermost, windowless interior. It is quite common to be able to photograph such rooms with little more than a tripod-mounted camera loaded with daylight film and a warming (81 series) filter over the lens or using a digital camera with the white balance set to cloudy. Flash lighting is often used to fill in shadow areas, but this is almost always used only in a supporting role to the natural light, not as the main source of lighting.

METERING INDOOR LIGHT
With the strongly directional light usually predominant in naturally lit interiors, it is

▶ A bedroom photographed using a combination of natural daylight and a fill-in flash (monobloc reflected off the ceiling) set to one stop below the intensity of the daylight. Note how the view beyond the window is

Monobloc Flash angled upwards to bounce off white ceiling

completely burned out. Although this is a pleasant image, the bright white area of the window is perhaps a little too dominant. *Canon D30, Sigma EX 17–35mm lens, with one Elinchrom 500J monobloc flash, 2 seconds, f/27, ISO 100.*

important to meter correctly to avoid the problem of areas away from the windows being completely lost in shadow. This is a particular danger in images where the window is included in the view, the strong light outside often overwhelming the camera's meter and causing it to greatly underexpose the interior.

To overcome this, meter several different areas within the room (but which will be within the image's frame), excluding any area where the windows are visible, and shoot using an average exposure. Remember that any readings taken with the camera's TTL meter will be reflective light readings, which will be affected by any dark or bright/reflective surfaces within the view. If the room is small enough to walk around before taking any photographs, the problems of reflective readings can be overcome by taking incident readings from a handheld meter (see Chapter 6, page 104–5). If doing this, be sure never to take incident readings of the light coming directly through the windows, as this will be far stronger than the light around the room. Also, if using a handheld light meter, it will be necessary to adjust the exposure value obtained to allow for any filters, such as a warming 81 series, that may be on the camera lens.

This metering method should give accurately exposed interior images, but if in doubt bracket the exposures, even if using a digital camera. Views outside any windows will be burned out, so to avoid having large white areas in an image make sure when choosing a viewpoint that windows will make up only a minor part of the image.

INTERIORS FLOODED WITH NATURAL LIGHT

There are occasions when natural daylight floods an interior area, often large public spaces with glass roofs. Such places are usually a joy to photograph, often generating great images whether lit by bright sunlight or cloudy skies. The former will shed shafts of light across the walls, floors and people, shadows often softened by the naturally reflective properties of internal walls. Cloudy skies will generate a lovely soft lighting that can have a very calming effect, especially when combined with the neutral greys common in large modern interior spaces.

In such a space it is commonly possible to photograph pretty much as for outdoor photography. Light levels will, however, still be somewhat lower than outdoors, so if it is impossible to meter without getting large areas of window in the view it may be necessary to overexpose a little on the meter reading in order to get the interior correctly exposed.

FLASH LIGHTING AS FILL-IN

In the great majority of interiors windows will be present in just one or two walls, resulting in a steep fall-off in lighting levels from the windows to the innermost parts of the room, with many areas, particularly

▶ The spectacular dome on the roof of the recently restored Reichstag, the German parliament, in Berlin. A fabulous study in glass, it was a simple matter to photograph inside using only the natural light. *Canon EOS 5, Sigma EX 17-35mm lens, 1/45 second, f/11, Fujichrome Provia 100F.*

film nor digital camera, however, has such a wide range of sensitivity. In a photograph exposed to ensure that details in the highlights are recorded, shadow areas will be completely lost in gloom, with no details visible even though they may have been perfectly clear to the eye.

The solution is to use a little fill-in flash to brighten up those dark areas. The lighting must be subtle and done in such a way that it appears as though no additional lighting has been

◄ Another modern building in which it was easy to take photographs using only the natural light: the museum at the Millennium Seed Bank, a unit run by Kew Gardens to store away the seeds of thousands of species of endangered plants. Wakehurst Place, Sussex, England. *Canon EOS 5, Sigma EX 17-35mm lens, $\frac{1}{30}$ second, f/11, Fujichrome Provia 100F.*

behind and beneath furniture, in shadow. The human eye is normally able to accommodate this great range in lighting level and contrast, able to see the details in both the brightly lit and shadow areas. Neither used: the flash should support the daylight not compete with it. An ordinary flashgun can sometimes be used for this, but due to the narrow lens apertures commonly needed they are usually not sufficiently powerful. For

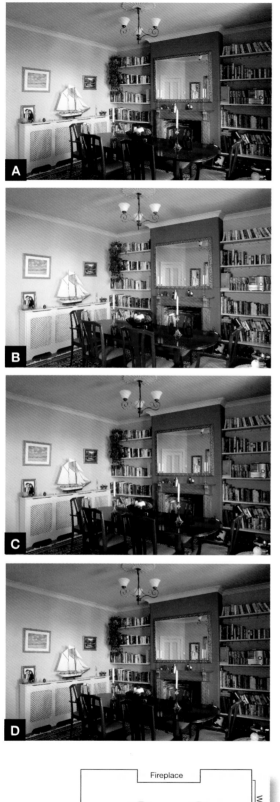

A

B

C

D

Fireplace

Table

Window

Monobloc flash with umbrella reflector

◀ A dining room photographed with a combination of daylight (coming through a window to the right) and a single monobloc flash bounced off an umbrella reflector: (A) the effect of daylight only; there are quite dark shadows around the table and chairs. Exposure 3 seconds, f/16; (B) daylight with flash balanced to the same lens aperture. The image is very bright, perhaps a little too bright, with no shadows in the areas where they would naturally be – it appears a little unnatural. Exposure 3 seconds, aperture f/16 for both ambient and flash light; (C) daylight with flash one stop below the intensity of the daylight. The image is a little less bright with shadows reappearing in areas you would expect to see them. This looks a lot more natural. Exposure 3 seconds, f/16, flash set to an output equal to f/11; (D) the flash is now two stops below the ambient daylight and the shadow areas are a little darker again, giving a natural appearance. Exposure 6 seconds, f/22, flash set to output equal to f/11. It may well come down to personal taste as to which of (C) and (D) is the more appealing, natural-looking image. *Canon D30, tripod, white balance setting at AWB, ISO 100, Elinchrom 500J monobloc flash.*

this reason, monobloc flash units are the usual solution (see Chapter 6, page 101 for a description).

To make the lighting appear as natural as possible, it is common to set the flash up between the camera and window at an angle that allows it to illuminate areas in shadow but not shining directly against the natural light. Moreover, although it is perfectly possible to completely balance the flash with the daylight, it is better to set the flash up at a half to one quarter (i.e. one to two stops below) the intensity of the daylight; thus

METERING FOR FLASH AND NATURAL LIGHT

The usual way to correctly balance flash and natural light is to start by taking reflective or incident light readings of the natural ambient light at various points around the room (as described earlier), being sure to have the monobloc's modelling lamp switched off. From this, the desired lens aperture (and hence the shutter speed needed) can be selected. The power of the flash can then be adjusted using incident flash meter readings (as described in Chapter 6, page 104–6), to provide output for an aperture one or two stops below that of the ambient natural light. In other words, if the room's natural light allows for an exposure of f/22 with a shutter speed of one second, for example, then the flash's output needs to be adjusted to give a reading on the flash meter of either f/16 or f/11.

Of course, the flash's intensity will diminish rapidly across the room, so this metering should be done at a point approximately one-third of the way from the flash to the furthest point of the room to give an accurately exposed fill-in.

If shooting on film, it is very useful if possible to take instant prints (see Chapter 6, page 106) to check for correct exposure and lighting distribution before shooting with negative or transparency films. If using a digital camera, carefully check the image in the camera's LCD screen to see whether any adjustments are needed.

preserving the natural appearance of the room. Obtaining an equal balance of flash and daylight would result in quite unnatural-looking almost shadowless lighting.

The flash should always be fired indirectly to ensure that it delivers a soft lighting. This can be achieved either by reflecting the light off a white umbrella or by bouncing it off the ceiling (provided this is white). It is important to set the light up not too close to any furniture as this may otherwise be overexposed or reflect a hotspot of light. It should also be set up at a height that will give an angle of illumination similar to that of the natural light pouring in through the window(s).

Finally, any localized shadow areas that cannot be filled in with a monobloc, can often be illuminated by a flash (often a small flashgun) hidden within the view and fitted with a slave cell that will fire it when the main flash fires.

CONTINUOUS ARTIFICIAL LIGHTING

It is not uncommon for a room to contain some artificial lighting even during the daytime, providing a complicated mix of natural and artificial light for the photographer to deal with. At night and in rooms with no windows artificial lighting is, of course, the only source of light, something that often simplifies things. Situations where artificial lighting is the only light source will be described here. As already described, few artificial light sources produce light with a colour temperature equal to that of daylight's 5500K, resulting in a colour cast on both film and digital images if they have not been correctly balanced.

REMOVING COLOUR CASTS

To remove, or at least minimize colour casts it is important to use a combination of the correct film or digital white balance setting, along with, where necessary, colour conversion, correction and compensation filters. The last of these will need to be fitted not only on the camera lens but also, if used, on the flash lighting.

Digital photographers can stick with using the automatic setting on the white balance feature, but they may need to do some tests to assess the accuracy of its colour correction. For more accurate work, it may well be better to make use of the camera's tungsten and fluorescent light balance settings, combined with either a custom white balance setting (see Chapter

▶ Vinopolis, a museum to wine in central London, is superbly lit with tungsten lamps. I photographed the entrance hall with tungsten film (it could also just as easily have been shot on a digital camera using the tungsten white balance setting) and no additional lighting. The images have come out with few awkward shadows and with good colour balance, although there is a slight warm tinge, providing a pleasant atmosphere. *Canon EOS 5, Sigma EX 17–35mm lens, tripod, 4 seconds, f/16, Fujichrome 64 ASA tungsten film.*

1, page 21) or filters when any fine tuning is needed.

As can be seen from the chart in Chapter 1 (page 17), the commonly used domestic light sources, including candles, tungsten and halogen bulbs, produce orange casts (having colour temperatures of about 1900K, 2800K and 3400K respectively) on daylight film or in a digital camera in which the white balance feature is set to daylight's 5500K. Fluorescent and other forms of discharge lighting generate ugly green or blue-green casts.

The easiest of all colour casts to remove is the orange caused by halogen bulbs.

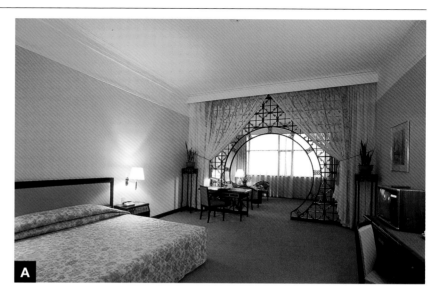

A

▶ A hotel bedroom with mixed tungsten lighting and daylight. I was unsure as to whether the daylight or tungsten would dominate the lighting in this room, so I shot on both daylight film (A) and tungsten film (B). When shot on daylight film (A), the colour balance was clearly too orange, but when shot on tungsten (B) (with the curtains pulled across to cut out all daylight) the colour balance is much more accurate. In (B), a tungsten light was hidden in the alcove to provide some extra fill-in light. *Canon T90, 17mm lens, tripod, 4 seconds, f/16, Fujichrome Provia 100 (A); and 8 seconds f/16, Kodak Ektachrome 64 ASA tungsten film (B).*

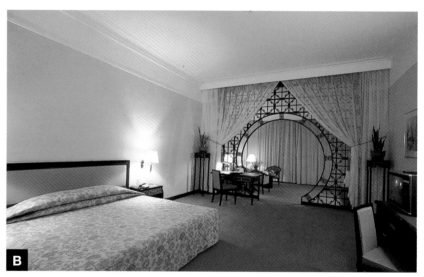

B

For film users, this can be achieved either by putting a deep blue filter over the lens, the 80A colour conversion filter, or by using film that is balanced for tungsten lighting. The only kind of film balanced for use with anything other than daylight, tungsten film is hugely important to interiors photographers. Balanced to 3400K, it matches halogen bulbs. As discussed already, digital photographers can rely on the automatic setting of the white balance feature or choose the tungsten light setting, which will again usually balance very accurately to the 3400K of halogen bulbs.

To balance to domestic tungsten bulbs users of daylight film will need to add to the 80A a further filter, the light blue 82C, while to balance with candles they will need to add another deep blue filter, the 80D. Digital camera users have the option of either using the 82C and 80D filters or of taking a custom white balance

reading of the lighting and using that (see pages 19–20).

The ugly green cast produced by fluorescent lighting on daylight film or digital images balanced to 5500K should be removed whenever possible. As usual, digital camera users have the option of choosing either the automatic or a fluorescent lighting setting on the white balance feature. However, unless the camera has several fluorescent lighting settings, the accuracy of even this may be in doubt as there are several types of fluorescent tube, each producing rather different colour casts. As earlier, this can be overcome by using a custom white balance setting.

Film users will generally need to put colour compensation filters over the camera lens (see Colour Compensation Filters box), combining varying amounts of magenta

COLOUR COMPENSATION FILTERS

These filters, called CC filters for short, are usually provided as thin gels, coming in the three primary colours (i.e. red, green and blue) and their three complementary colours (i.e. magenta, yellow and cyan). Each is available in a series of strengths gradated along an arbitrary scale increasing from the weakest at 5 up to a maximum of 50.

Each primary colour filter consists of one colour, allowing the passage of that colour and blocking the other two primary colours. Thus, for example, the red filter will allow red light to pass through, but blocks green and blue. They can be seen as additive filters, as they are used to boost the amount present of the one colour each transmits.

The complementary colour filters contain two colours, the magenta filter consisting of blue and red, the cyan of blue and green and the yellow of green and red. They allow the passage of the two colours they contain and block the third, for this reason often being considered subtractive as they are commonly used to block the passage of one particular colour. As already described, magenta is frequently used to block green light, for example, and as a result is sometimes known as 'minus green'.

While users of digital cameras will generally be able to use their camera's white balance system instead of all these filters (see Chapter 1, page 21), it may not always give sufficiently fine control to allow for wholly accurate colour compensation, especially in mixed lighting situations. In these few situations, fine tuning with colour compensation filters may be needed.

An assortment of some of the different colours and grades of colour correction (CC) filters available from Kodak and Lee Filters.

filtration with either yellow or cyan depending on the type of fluorescent lighting present. An alternative is to use the pre-made FL-D and FL-B filters made specifically to correct for fluorescent lighting on daylight and tungsten film respectively. They have the advantage over colour compensation filters of being easier to use, but the disadvantage of being less accurate for the different types of fluorescent tube in use.

COLOUR CORRECTION UNDER MIXED LIGHTING

Things start to get a bit complicated when more than one light source is present. It is often possible to correct for only one or the other source but not both and since it is normal for one source to be dominant in an interior it is usual to opt to concentrate on correcting for that.

When tungsten and fluorescent light-ing are present together, with tungsten the dominant source, correction is relatively straightforward. Film users can opt to use tungsten film and then correct the fluorescent lighting (which comes out a stunning blue on tungsten film) with appropriate CC filters. Digital camera users should similarly shoot with the camera's white balance set to tungsten and then balance the fluorescent with appropriate CC filters.

If the fluorescent lighting is dominant (as is usually the case in offices, for example), many photographers opt to simply correct for the fluorescent lighting and leave the tungsten alone. This is because, if shooting on daylight film or with a digital camera set to a fluorescent setting, small amounts of tungsten lighting will add an attractive glow only to those areas close to each light, often greatly enhancing the attractiveness of the final image.

An alternative method, which gives more accurate correction but which is more complicated, is to take a double exposure. Metering is done with both light sources switched on, after which one is switched off and the image exposed at the metered time and aperture settings plus any adjustment needed to allow for lens filters. Once completed, the same image is re-exposed with only the other light source switched on and the camera corrected for its colour cast. To do this, of course, needs a camera able to take multiple exposures and the camera must be kept absolutely rock still between exposures to prevent a double image being produced.

USING FLASH FILL-IN UNDER ARTIFICIAL LIGHTING

Both film and digital cameras suffer the same restricted band of sensitivity to lighting contrast under ambient artificial light that they do under natural light. For this reason it is again common to use fill-in flash to lighten up shadow areas, again setting it up with a quarter of the output of the ambient light.

The hugely different colour temperatures of flash and continuous artificial light sources immediately throws up quite a large problem, especially if more than one source of continuous artificial light is present. The principal way to correct for this is to clip coloured gels, available in large sheets that can be cut up specifically for this purpose, over the flash light(s) to give them the same colour cast as the ambient artificial lighting. If the interior has tungsten lights only, for example, the flash lighting can easily be converted to the same colour as the tungsten lights by putting an orange gel, the conversion filter 85B, over the flash and then shooting either with tungsten film or on a digital camera with the white balance set to tungsten.

If the interior is lit solely by fluorescent lighting, a green CC gel (approximate strength, 40G) can be put over the flash to give it the same colour cast as the fluorescent tubes, the view then being photographed either on daylight film with a magenta CC filter over the lens (approximately 40M to

Monobloc flash with umbrella reflector

Window covered for shot

▲ A view of a kitchen lit with tungsten halogen lamps and a little daylight. Image (A) was taken using the ambient light only, while in (B) a monobloc flash was added, its output set at one stop below the lens aperture setting for the ambient light, its colour corrected to match the tungsten lights by the addition of an amber 85B gel across the lamp. The flash has helped to reduce some unsightly shadows and has added a pleasant slightly warmer light. The latter indicates that the tungsten-corrected light of the flash had a slightly lower colour temperature than the ambient combination of tungsten lights and a little daylight. Shot on a digital camera with the white balance set to tungsten. *Canon D30, Sigma EX 17-35mm lens, white balance set to tungsten, ISO 100, tripod, Elinchrom 500J monobloc flash, 6 seconds, f/11 (for A), and 8 seconds f/16 (for B).*

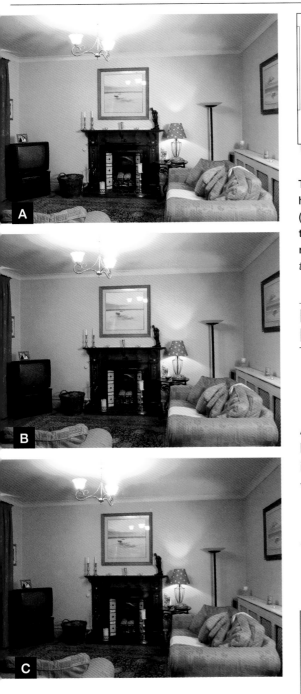

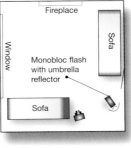

◀ Another example of tungsten ambient lighting combined with flash. In all three images an amber 85B gel is placed across the flash to correct its colour to mimic tungsten: (A) ambient tungsten light and flash balanced (4 seconds, f/11). Although the lighting across the room is not bad, note that the sofa arm close to the camera is much too bright; (B) in this image the flash is fired at one stop below the lens aperture for the ambient light (8 seconds, f/16 for the ambient, f/11 for the flash). The lighting is more natural, with the nearer sofa looking rather darker; (C) here the flash has been fired at two stops below the lens aperture's f number (16 seconds, f/22 for the ambient, f/11 for the flash). The room is darker and the shadows more natural in appearance, with the sofa showing a more natural colour and lighting. *Canon D30, Sigma EX 17-35mm lens, white balance set to tungsten, ISO 100, tripod, Elinchrom 500J monobloc flash.*

MIXED ARTIFICIAL AND NATURAL LIGHT

It is extremely common for an interior to be lit by a mixture of natural light and one or both of the two main artificial sources. Accurately correcting for this situation can be extremely difficult and for most instances it is simpler to switch the lights off and work with just daylight and flash.

However, for rooms where there is a modest amount of tungsten lighting, daylight and flash can be used as the dominant lighting sources, the tungsten being left uncorrected to add attractive warm spots around

balance the green on the flash lighting) or by using a digital camera with the white balance set to fluorescent.

If the ambient light consists of both tungsten and fluorescent lighting, the simplest solution is to decide which source is dominant or at least more unattractive (usually the fluorescent) and concentrate on correcting that one, leaving the other alone. However, it is also possible to use a multiple exposure technique for the three lighting sources (flash, tungsten and fluorescent) similar to the one just described.

◀ An office meeting room lit by a combination of tungsten and fluorescent lighting. The tungsten lights were the dominant source, so the image was shot on tungsten film, with a light yellow colour correction filter fitted over the lens to correct for the blue light coming off the fluorescent tubes (fluorescent tubes look blue on tungsten film). *Canon EOS 5, Sigma EX 17–35mm lens, tripod, 4 seconds, f/16, Kodak Ektachrome 64 ASA tungsten film.*

the room. With a long exposure it may be possible, provided the switches can be reached easily, to leave the tungsten lights on for only part of the exposure, allowing them to make their presence felt but limiting the amount of orange light they put into the room.

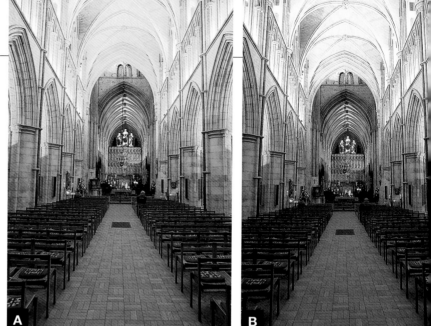

▲ A hotel lounge and restaurant lit mainly by halogen lamps, although with daylight coming through large windows on the far side of the room. The image was shot on tungsten film to balance with the tungsten lighting and no additional lighting was used. To combat the little bit of daylight that might penetrate so far into the room, a yellow CC filter was placed over the lens. The resulting image is quite well balanced, although there is still a little bit of blue present.
Canon T90, 28–70mm lens, tripod, 3 seconds, f/16, Kodak Ektachrome 64 ASA tungsten film.

Mixed daylight and fluorescent lighting is one of the hardest combinations to correct accurately, even with a digital camera, and for this reason it is often better to simply work with the lights switched off. If they have to be left on, provided the incoming daylight is reasonably strong and flash lighting is employed as fill-in, the impact of the green cast will be greatly diluted, even on daylight film. Anyone determined to achieve perfect colour correction can undertake a complex triple exposure operation, involving separate exposures for flash, daylight and fluorescent lighting, but for most general applications this is going a bit too far.

PROBLEM INTERIORS

Inevitably, there are many types of interior that provide their own special set of complexities, a few of which will be summarized here.

In very large interiors, clearly fill-in flash will be inadequate for anything other than foreground detail. Fortunately, however, many such places have very even lighting, either as artificial lighting or skylights. In such a situation, the simplest and often best solution is to take a long exposure using the ambient light, correcting for any colour casts if necessary.

At the other end of the scale, tiny rooms, such as some bathrooms, present problems simply of accessibility, let alone viewpoint and correct lighting. Again, such tiny rooms may be photographable without the need for any fill-in lighting, but if some is necessary a small flash can often be fitted into a corner, perhaps behind the door.

A room containing numerous mirrors can be enormously problematic, making it hard to keep both photographer and reflected lighting out of the final images. The solution is based on the fact that light is reflected from a smooth surface at the same but opposite angle to that at which it hits the surface. This makes it possible to line up a flash unit so that any light hitting a mirror will be bounced away from the camera. Obviously, the more mirrors there are in a room, the more complicated and less certain the calculations become,

▲ On a fairly gloomy day, it was hard to know whether daylight coming through the windows or the internal tungsten lighting would be the dominant lighting source in Southwark Cathedral in London. So I shot for both, using both daylight film (A) and tungsten film (B). The image shot on daylight film (A) is clearly quite orange, indicating that the artificial light is the dominant source. Note also the slight green cast at the far end of the cathedral, indicating the presence of some fluorescent lighting. When shot on tungsten film (B), the colour balance is much more accurate, but note the slight blue cast at the far end, again indicating the presence of fluorescent lighting.
Canon EOS 5, Sigma EX 28-70mm lens, tripod: (A) 8 seconds, f/16, Fujichrome Provia 100F; (B) 10 seconds, f/16, Fujichrome 64 ASA tungsten film.

making careful checking of instant prints or a digital camera's LCD essential.

MAINTAINING ATMOSPHERE

When setting up the lighting and attempting to correct colour imbalances in interiors, it is always important to think about the atmosphere present in that interior or which should be conveyed in the final images. One of the most important steps to this is to maintain a natural distribution of shadows even while lightening shadow details with fill-in flash, something that can be achieved by keeping the power of the flash output well below that of the room's ambient light.

In addition to this, there is the question of the mood evoked by the colour and warmth of the light. In a home or restaurant the warm, orange glow of tungsten lights creates a welcoming atmosphere that should be maintained in the final images. So, when tungsten or candle lighting is present in such views it would be a mistake to correct for them completely. Reduce their impact perhaps as leaving the lighting completely uncorrected (either on daylight film or a digital camera with the white point set to 5500K) is likely to generate images that are just too orange. If using a digital camera, shooting with the white balance set to either automatic or tungsten may correct for the lighting so well as to completely remove the atmosphere. To retain some of the orange glow it may be better to turn the white balance to a daylight setting and then use some more subtle correction using colour compensation filters over the lens.

▲ A large hall being prepared for a conference at a hotel in Beijing, China. Obviously flash could never be used to light up such a large room. Fortunately the ambient lighting was quite even and, shot on tungsten film, the final image is attractively lit. *Canon T90, 24mm lens, tripod, 4 seconds, f/11, Kodak Ektachrome 64 ASA tungsten film.*

▶ An atmospheric restaurant lit with tungsten lights and candles. Although the image was shot using tungsten film to ensure the lighting came out white (even the candles are nearly white!), a soft, warm mood has been retained as a result of the combination of deep red materials and low lighting. I did not use any additional lighting for fear of damaging the atmosphere, thus retaining the sense of low lighting, cosy shadows and deep reds. *Canon EOS 5, Sigma EX 17–35mm lens, tripod, 8 seconds, f/11, Fujichrome 64 ASA tungsten film.*

8 Still Life

◄ **This shot was commissioned for the cover of a west of England good food guide book. Lighting consisted of a small softbox, positioned and angled to produce the necessary highlights on the food. Mirrors and small white card reflectors were then placed around the dish to provide fill and localized highlights.** *Canon EOS 1Ds, 50mm macro lens, ¹⁄₁₂₅ second, f/16, ISO 100.*

Still life is the stylized photography of objects, often composed and lit in a way that is either evocative of certain scenes, such as a rustic farmhouse kitchen or modern hi-tech medicine, or aims to convey the beauty and qualities of the materials from which the objects photographed are made, such as glass, jewellery or wood. This is the stuff of the advertising world, whose photographers aim to produce striking images that convey messages of a certain lifestyle, a kind of wealth or a type of fashion. We are bombarded with such images every day and when executed well they can be incredibly effective.

While this type of photography in the professional world can range from aircraft to microchips, this chapter will concentrate on the kinds of objects that can be photographed at home, perhaps on any table-top, using materials that are easily to hand. When looking at many still-life advertising images, it is hard not to think that the photographic process must have been extremely complex, using a number of lights, expensive materials and a huge amount of post-photography computer manipulation – the kind of thing that an amateur at home could simply never manage. Yet, while many such images are, perhaps at some stage, manipulated in a computer, most are photographed in quite simple ways, using only one or two lights aided with an array of well-placed diffusers, reflectors and mirrors (surprising-

ly, often home-made), supplemented with coloured gels to add a splash of coloured light. This chapter aims to show how this can be done.

▼ **This image was shot as part of a series for a trout and salmon fishing magazine. A small softbox was positioned and angled to produce a highlight on the surface of the reel, to emphasize its fine detail and show off its highly polished surface. The background is a small piece of teak flooring board used in boat interiors.** *Bronica SQA, 150mm lens, ¹⁄₁₂₅ second, f/11, Kodachrome E100s.*

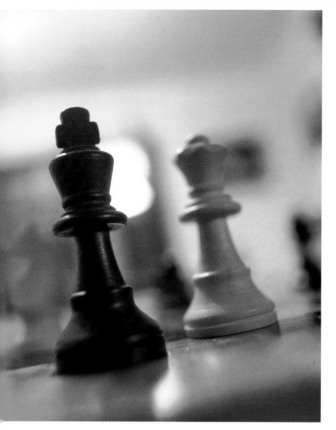

▲ A low-angle view of a chess game, lit by two small flashguns on either side of the camera. The right hand one was covered with a red gel; that on the left side covered with a blue gel, and the output from both balanced with the ambient room light. *Mamiya RZ67, 110mm lens, tripod, flash, 3 seconds, f/8, Fujichrome Provia 100.*

▲ Shot as part of a series of images for cooking recipes, thsee tiny grains were arranged on a white textured surface. A small softbox provided side lighting, and a small piece of mirror card opposite softened the shadows. *Canon EOS 3, 90mm macro lens with further extension rings, $^1/_{125}$ second, f/16, Kodachrome E100s.*

▲ Camera view from above

TYPES OF LIGHTING

Still life can be shot with almost any form of light, including natural daylight, provided it can be controlled and directed in some way to illuminate the subject as desired.

DAYLIGHT

Daylight can provide a very flat and even lighting if it can be used when quite high and diffused by thin cloud. For those lucky enough to have one, the frosted roof of a conservatory is also useful. This is excellent for producing even, almost shadow-free lighting, ideal for showing an object exactly as it is, so to speak, but no good at all at generating any kind of atmosphere. For that, the daylight needs to be low and strong, shining through a window in brilliant shafts, such as it does just before sunset.

TUNGSTEN LIGHTS

Of course, the problem with using daylight is having to wait for it to deliver just the right kind of light. It is not surprising, therefore, that most still-life photography uses artificial lighting – either tungsten lamps or flash. The former can be 500–1000W photoflood lamps or, for small set-ups, anything as simple as ordinary reading lights, provided they can be moved around and directed easily. It is also possible to use the modelling lamps

◀ A still life image to suggest reading and/or the news, this was taken using natural daylight, as a slowly setting sun sent shafts of strong light across the table, producing excellent back-lighting conditions. *Canon D30, Sigma 28–70mm lens, ¹⁄₆₀ second, f/11, ISO 100.*

on monobloc flash units as a main source of tungsten lighting.

Tungsten can be ideal as a lighting source since, being continuous, it is largely a case of 'what you see is what you get' – provided you do look closely, to see exactly the distribution of shadows and any highlights. Inevitably, as with any ambient light source, especially if using small domestic lights, long exposures are probable if a large depth of field and hence a narrow lens aperture are required. If tungsten is to be the only source of light, make sure that no other light can 'leak' into the set during a long exposure. Photographers using film are advised to use tungsten film if shooting with tungsten light, while digital photographers should use the tungsten setting on the white balance feature.

If this lighting is to be balanced with daylight, it will be necessary for those shooting on film to put filters on the tungsten lights to correct their colour temperature to daylight's 5500K. Use a dark blue 80A colour conversion filter for the photoflood and monobloc modelling lights, and an 80A plus a light blue 82C correction filter for household tungsten lights. Digital camera users may be able to get away with using a custom white balance setting (see Chapter 1, page 21) provided the daylight and tungsten lighting are evenly mixed across the set. However, if daylight illuminates mainly one part of the set and tungsten mainly another part, it will probably be better to use a daylight white balance setting on the camera and filter the tungsten lights as already described.

One point to remember when you are working with tungsten is that the lamps can get very hot, something that can limit their usefulness when photographing certain subjects, such as fresh food and flowers. It can also create problems (especially with ordinary household tungsten reading lights) when using filters, diffusers, flags or gobos close to or against them.

▼ A very small subject such as dice need only small lighting systems. In this image, a small flashgun was used, fired from the camera's left, with a reflector to the right of the view. The background was left to fall into darkness. *Mamiya RZ67, 110mm lens with extension tube, tripod, flash, 2 seconds, f/5.6, Fujichrome Provia 100F.*

a flashgun, something that is important in reducing the size and harshness of shadows. If this is the case, the monobloc's flash output can be reduced below its minimum setting by putting neutral density filters over the lights.

As with interiors photography, having the same colour temperature as daylight makes flash easily used as fill-in for or balanced with daylight without the need for any colour correction.

Two other commonly used forms of lighting are a lightbox (usually daylight balanced) and a slide projector, the former to provide a broad swathe of transmitted light from beneath or behind a subject, the latter usually to produce a narrow beam of focused lighting onto a particular part of the set.

SUPPLEMENTARY EQUIPMENT

Apart from the lights and their accompanying stands, a plethora of bits and pieces is needed. The usual reflectors and diffusers in the form of umbrellas and softboxes are commonly used, along with tracing paper or similar diffusing material and a variety of often homemade and quite small white card and silvered reflectors. Small mirrors are also commonly used, often acting more as a secondary light source than a reflector, used mainly to direct light into particular parts of a set rather than to

▲ **An image taken to suggest the idea of a mid-morning break, lit with two flash guns, quite high and mounted on either side of the camera.** *Mamiya RZ67, 65mm lens, tripod, flash, 1 second, f/8, Fujichrome Provia 100.*

▼ **A line-up of pea pods photographed on a lightbox and with an on-camera flash gun. The result is an image in which the subject has received both frontal and back-lighting, revealing the translucency of the pods and roundness of the peas.** *Canon D30, Sigma 28-70mm lens, white balance to AWB, ¹/₉₀ second, f/16, ISO 100.*

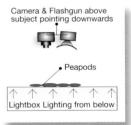

FLASH LIGHTING

Flash is the most commonly used form of lighting for still life, with monobloc flash units predominant (see Chapter 6, page 101), although for small setups these can be too powerful. In this situation, ordinary flashguns will do the job very well. The depth of field needed in the final images – and hence the amount of flash power required – is one of the main considerations here, linked of course to the size of the set, and this will often be the deciding factor in whether monoblocs or flashguns should be used. Even in situations where a monobloc appears to be too powerful, it may still be the lighting of choice due to its being a much larger light source than

▲ A typical table-top still life setup. The lighting consists of two studio flash monoblocs, each fitted with standard reflectors and honeycomb grids to provide a narrow beam of light on to the subject. Mirrors and mirror card have been strategically placed in the set to provide localised highlights and general fill-in light. Note the mirror card suspended over the set and held in position with a Climpex stand, arm and crocodile clip.

provide overall lighting. Coloured gel filters can also be useful, either over the lighting or, more commonly over the mirrors, to add splashes of colour.

LIGHT TENTS

A highly specialized form of diffuser is the light tent, literally a dome or cone of diffusing material that stands or hangs over the whole set, with a gap for the camera lens to be inserted. Used specifically for photography of highly reflective materials, such as jewellery or metallic houseware, light tents are available commercially, but it is not difficult to make a simple one.

BARN DOORS

Barn doors, four adjustable black flaps attached to a ring that fits onto a monobloc or tungsten photoflood lamp, can be important in ensuring that the light from a particular source does not spill onto the wrong part of the set or into the camera. The same function is performed by flags, simply black cards, that can either be stuck to the side of a lamp or mounted in some position near

the light, wherever it is needed to provide a blackout. Gobos are another important tool, cutout shapes that fit over a light to give a pattern, such as a fake window frame or to suggest dappled light under a tree.

CLAMPS

With all these reflectors, mirrors, diffusers and flags set up around a set and not attached to either the lighting or the camera, there must be some other way to hold them in place. Adhesives and modelling clay can be used in many situations, but also commonly used are a variety of clips, clamps and springy arms. Some are made specifically for this kind of photography.

▲ A small, home-made light tent consisting of a tracing paper cone attached to knitting needles with invisible tape. By covering the points of the needles with moulding clay and using small clamps on the other ends, it is possible to produce a small free-standing cone that covers reflective objects, such as jewellery.

▲ An image of an old twin lens reflex camera, shot using the tabletop set-up shown in the adjacent image (see 8/24). *Canon EOS1Ds, 50mm macro lens, 1/125 second, f/16, ISO 100.*

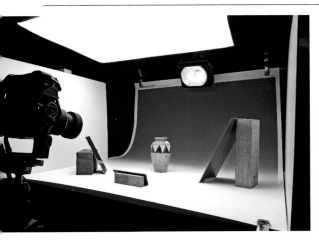

▲ A standard studio 'pack shot' arrangement. A graduated blue/white sheet of card forms both the background and base, sweeping from one to the other in a seamless curve. Lighting consists of an overhead softbox and white panels on either side. Note the back light with honeycomb grid to provide product rim lighting, and mirrors to provide fill-in light and soft highlights on the product.

THE BASE

Finally, there is the surface, or base, on which the set is created, plus the backgrounds. The base is usually a table or floor, of course, either bare or covered with paper or cloth. The set may be created directly on this or set up on a sheet of glass or perspex to create reflections or to allow for lighting from below. The base of the set, the table, cloth/paper or glass/perspex, may be distinguishable from the background not only by colour but also by the presence of a 'horizon', a thin, out of focus, line, cutting across the image behind the set. If obtrusive, this can often be removed by creating the base and background from the same sheet of material; the base in the foreground and then sweeping upwards in a seamless curve to form the background. Such sets can be bought commercially, made in pre-moulded plastic, but it is also easy to create a simple one from a large (and wide) roll of paper or uncreased cloth, held up in the background by a framework of stands, poles and clips.

LIGHTING TECHNIQUES

A variety of lighting techniques can be used to photograph different surfaces and to convey different moods and situations. A few guidelines are described here. These are not hard and fast rules. The only real rule is to experiment as widely as possible, using these guidelines as a starting point.

SIMPLE FRONTAL OR TOP LIGHTING

This is generally the simple lighting for what is known in the trade as the 'pack shot', an image, meant primarily for subjects that are neither highly reflective nor made of glass, that shows clearly what a product is and what it looks like: the kind of image you will see in countless mail-order catalogues. They are generally not particularly atmospheric, but they can be very good at conveying the feeling of a situation and hence an aspect of lifestyle.

Lighting often consists of a single flash with a softbox or umbrella reflector, directly above or a little in front of the set. The light is usually set up quite close to the set so as to maximize its relative size and hence help minimize shadows. White reflectors are frequently set up along the sides of the set, both to bounce light back into it and so reduce shadows, and also to shield the set from any coloured objects outside the

▼ This model car was photographed to illustrate the simple pack shot or product photography style. The image follows the normal arrangement of softbox overhead and reflector panels either side. In addition, mirror card was used to provide localised fill lighting and a snooted back light provided subtle highlight illumination on top of the car. *Mamiya 645 ProTL, 150mm lens, 1/125 second, f/16, Kodachrome E100s.*

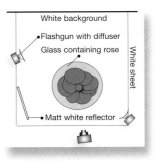

◀ A rose in a glass of water, photographed against a white background, a flashgun to the right, reflector to the left, and a second flashgun illuminating the background. This is a deliberately high-key image, also deliberately with a shallow depth of field to ensure that the background (and even the furthest rim of the glass) fade away. *Mamiya RZ67, 110mm lens, flash, 1/60 second, f/5.6, Fujichrome Provia 100.*

set that might 'leak' a colour into it. The same lighting can be achieved using diffused tungsten lamps. For small sets flashguns accompanied by diffusers or reflectors can work well, provided the guns are not such a small light source that hard shadows start to develop.

In situations where the room around the main subject also becomes a part of the set, such as when conveying the idea of a domestic setting, the wall of reflectors is likely to be dispensed with, replaced by a few discreetly placed reflectors or mirrors to insert a little fill-in light into shadow areas.

REVEALING SURFACE TEXTURE

A low lighting angle, usually side-on to the camera, or sometimes back lighting the

▶ An image taken to celebrate spring, showing daffodils on a dining table, lit by two flashes on either side of the camera, balanced with the ambient room light. *Mamiya RZ67, 65mm lens, tripod, flash, 1 second, f/11, Fujichrome Provia 100F.*

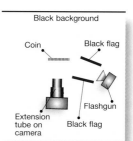

◄ For this shot, a single small flashgun was used, shone onto the coin from the right at a very shallow angle in order to reveal its surface texture and so show off the design. Two black flags were used on each side of the light, firstly to stop light spilling into the camera lens, and secondly to stop it lighting up the background, which I wanted to be completely black. *Canon EOS 5, Sigma 28–70mm lens with 25mm extension tube, flash, tripod, 1/30 second, f/16, Fujichrome Provia 100F.*

subject, is needed to reveal surface texture for a whole host of materials, such as metal, wood, cloth, wool, leather, stone and foodstuffs. This should be coupled with a relatively small light source to increase the development of hard shadows. This can be achieved by moving the main light further away from the set, decreasing the size of the light's diffuser or reflector, firing the light directly at the set or by using smaller flashguns or a slide projector instead of a monobloc or large tungsten photoflood.

Shadows formed with these techniques will pick out in great detail every small lump, hole, ridge and groove to be found in any kind of surface. The result is a very atmospheric image in which the viewer can almost feel the material, the grain in a piece of wood, the weave in a piece of cloth or the pattern on a coin. The shadows may be very dense, sometimes in parts of the set where they are not really wanted, with the result that the contrast range between the highlight and shadow areas may be too great for the film or pixels to record. If the contrast range looks superb to the eye, it may be too much for the camera to handle, so soften things a little by using reflectors and mirrors to direct a little fill-in light into the shadows. Furthermore, a flag or barn doors may also be needed to prevent

◄ British money photographed with a single flash gun off to the right, angled low to pick up the design on the coins, and a reflector off to the left. *Mamiya RZ67, 110mm lens, tripod, flash, 1 second, f/16, Fujichrome Provia 100F.*

▶ A simple arrangement of coloured glass bottles. The blue bottle was filled with plain water, while the yellow one was filled with water tinted green with food colouring. Lighting consisted of softboxes overhead and to the left, with another providing back lighting through a sheet of white perspex. The bottles were placed on another sheet of white perspex – in turn placed on white card – to provide the surface reflections. *Canon EOS 1Ds, 105mm macro lens, ¹⁄₁₂₅ second, f/22, ISO 100.*

light spilling into the camera lens, particularly if the subject is backlit. A hood must also be fitted to the lens for the same reason.

LIGHTING FOR GLASS

Photographing glass objects, such as glasses, jugs and bottles, with simple overhead or frontal lighting will not normally produce worthwhile images. The usual result of such photography is images containing a confusing clutter of reflections and burned-out highlights, with the outline, shape and beauty of the subject barely visible against the background.

The usual solution is to photograph using a silhouette technique, in which the main light is either bounced off a white background or fired through a diffusing background screen. This lighting highlights the shape of the subject – say a bottle – the thick edges transmitting less light than the central part of the bottle and so showing up quite black. With particularly thin glass, this effect may be quite limited, but it can be emphasized by putting black card on either side, just out of shot. The cards are reflected in the bottle's edges, making the edges darker and so more visible. The image can be given greater impact by standing the bottle on a reflective surface, namely a sheet of either perspex or glass, to produce an attractive reflection.

PHOTOGRAPHING LIQUIDS IN GLASS

Coloured transparent liquid poured into the bottle will greatly enhance the attractive-

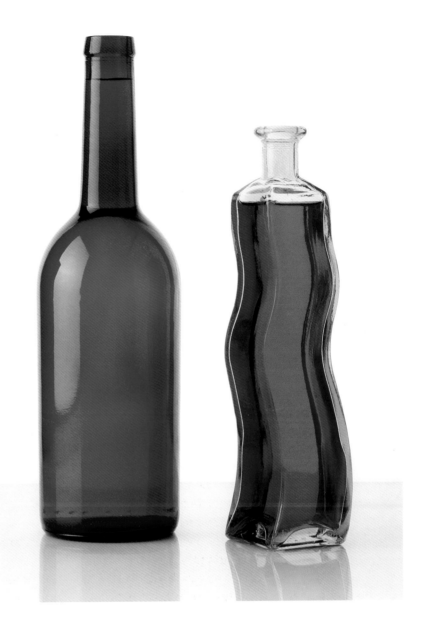

▼ A close-up of the spatula used to pick up the green tea powder used in the Japanese tea ceremony, plus part of the whisk used to beat the tea into a froth. Taken with a single tungsten light to the right of the image, with a flag to prevent light spilling onto the black background. *Canon T90, 100mm macro lens, tripod, tungsten light, ¹⁄₁₀ second, f/11, Kodak Ektachrome 64 ASA tungsten film.*

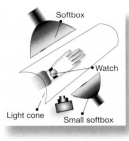

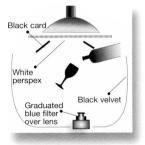

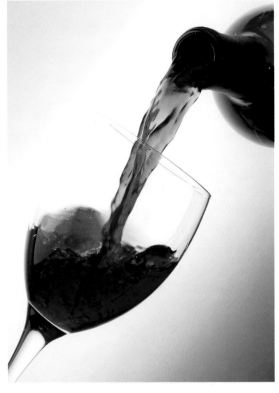

◄ An image used to support a marine equipment review article for a yachting magazine. Lighting consisted of a light tent placed over the watch and the man's wrist, with a mirror used to provide fill-in and a second highlight. A circular soft-focus filter was used to diffuse the edges of the image slightly, leaving the watch face sharp. *Bronica SQA, 150mm lens, 1/125 second, f/11, Kodachrome E100s.*

◄ In this dynamic image, the glass was held in position with a Climpex clamp and stand. Lighting consisted of a large softbox mounted overhead, with another firing from behind through a sheet of translucent white perspex to provide overall back lighting. Graduated blue filters in a multi-slot holder were used to provide a little additional colour and emphasize the diagonal element of the image. The flash allowed only two images to be taken on each pouring of the wine, so a number of exposures were needed to capture an attractive combination of movement and the right amount of wine in the glass.

ness of the image. Most useful here is water containing a few drops of food colouring: photographing two bottles each containing liquid the complementary colour of the other can be particularly effective. Photographing red wine in a glass and bottle side by side requires some dilution of the wine in the bottle, possibly by as much as one part wine to nine parts water, in order for it to transmit light to the same degree as the wine in the glass. This is because the thicker bottle, as well as its usual dark green colour, transmits considerably less light than a small, thin glass does.

The lighting should be generated by one or two diffused lights with an even spread across the reflector or diffuser background screen. If the background is a reflector, the lights should be positioned either at each end of the screen, firing onto it at an angle, or located next to the camera, high up and firing over the top of the set directly at the screen. In both instances, barn doors or flags are needed to make sure that no light spills from the lights onto the set or into the camera lens. Creating the set about 2 metres (6ft) in front of the background also reduces the risk of light spilling onto the set, as well as ensuring that any imperfections on the screen are well out of focus.

LIGHTING GLASS FROM BELOW

Some forms of glass, as well as other transparent or translucent materials, can be lit from beneath. Shot against a dark background, the subject stands on a glass or perspex base much of which has been blacked out, apart from the area immediately below the subject, and a light is fired upwards through the subject. The blackout on the

Black background
Perspex on a black card

Black flag

Flashgun with diffuser

◄ Fresh red pepper and tomatoes, sprayed with water and then photographed on a reflective base, against a black background. Two flashguns were used, both with flags attached to prevent their light spilling onto the background. Although the image contains a few highlights, the lighting has caught the subjects' fresh, saturated redness and rounded shape, making them look quite appetizing. *Mamiya RZ67, 110mm lens, tripod, flash, 1/30 second, f/8, Fujichrome Provia 100F.*

base should prevent any light leaking to the camera. To be sure, however, barn doors or a flag can be used on the light.

LIGHTING FOR REFLECTIVE OBJECTS

Shiny objects can be particularly tricky to photograph as by their nature they reflect back the world around them, both any lights shone directly at them and the face of the photographer. Bringing out the best in such objects, whether they be jewellery, watches, metallic dinnerware or utensils, involves persuading them to sparkle brightly without either any burned-out highlights or any recognizable reflections.

This is achieved using a light tent – a more or less continuous diffuser that stands or hangs over the subject as either a cone or dome, enveloping the subject from above and around at least three of the four sides. The fourth side, the side where the camera

is, can either be more diffuser or may consist of a reflector to bounce some of the main light back into the subject. Whatever it consists of, this fourth side must, like the other three sides, be as closed from the world as possible, so as to limit the possibilities for reflections in the subject. However, there must, of course, be a gap left for the camera lens to be inserted.

Light can be provided by a single, relatively large diffused light positioned above and slightly behind the subject. Alternatively, three diffused lights can be used, one locat-

Small monobloc with reflector

Light tent

Ring

Mirror card

Tracing paper

White card

► One of a series of product images for a jewellery company's website, this image was shot using a homemade light tent. A small softbox overhead and slightly behind the product provided the highlights on the Celtic-style ring. *Canon D60, 50mm macro lens, 1/60 second, f/16, ISO 100.*

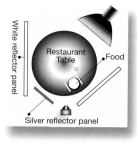

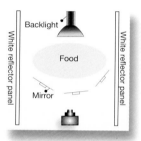

◄ This food shot was part of a series for a hotel brochure and shot on location in the restaurant. No natural light was available, so illumination was entirely by flash. A softbox provided the main light, which was placed opposite the camera's position and at the correct height to provide the necessary highlights on the table, the plate and glass of wine. Fill light was then provided by portable reflector panels placed around the table. *Mamiya 645 ProTL, 150mm lens, ¹⁄₁₂₅ second, f/16, Kodachrome E100s.*

▼ This image was part of a series showing the ingredients used in a recipe. Lighting consisted of a large softbox overhead and slightly to the back of the set, with white reflector panels on either side. Suitably placed mirrors were used to provide front fill and to lighten the shadows. *Mamiya 645 ProTL, 80mm lens, ¹⁄₁₂₅ second, f/22, Kodachrome E100s.*

ed above and behind the subject, the other two on either side. A reflector or mirror located below the camera lens (which must be fitted with a hood) will direct some of the light back into the subject, reducing any shadows that may form. The result of using this technique should be images in which the subject gleams beautifully, reflecting the white diffuser without burning out, the black area of the lens shown up, if it is visible at all, as simply an indefinable dark area that may actually enhance a sense of the subject's three-dimensional shape.

Any coloured material within the light tent, such as a cloth or mounting that jewellery may be sitting on, can affect the colour of the light inside the tent. Digital camera users can overcome this by making a custom white balance setting (see Chapter 1, page 21) inside the light tent. Those shooting on film may be advised to take colour instant prints before exposing roll or 35mm film and then filter with colour compensation filters if necessary.

Lighting Food

The usual aim in the photography of food is to make it look fresh and truly delicious – a goal that is not as easy as it might sound. In fact, so tricky can it be that food photography

exists as its own specialist discipline within the field of still-life photography, peopled by photographers who take pictures of nothing else.

Making food look delicious relies on achieving a subtle blend of shape and texture with saturated colours and, for reflective foods at least, the right amount of shine. Emphasizing the shape and texture requires a low lighting angle, something that also helps achieve saturated colours, especially

if care is taken to angle the lighting so that reflections are bounced away from the camera. However, increasing the colour saturation generally means decreasing the amount of shine and, when coupled with the low lighting angle, will increase the density and extent of shadows. This will be especially so in a complicated mix of oddly shaped fruit and vegetables, possibly resulting in the loss of important parts of the foods into darkness. Shadow can be reduced by raising the light to give frontal or top lighting, but now shape and texture are lost and the likely increase in reflections will decrease colour saturation.

A compromise usually consists of a relatively low lighting angle, coupled with some highlights in reflective foods to give it shine without damaging colour saturation too much, along with the judicious use of small reflectors and mirrors to direct light into the main shadow areas. Finally, lighting angles (and colours) may be used not just to convey texture and shape but also times of the day or even year. A low angled warm glow, for example, suggests early morning.

LIGHTING FOR LATER DIGITAL MANIPULATION

While post-photography digital manipulation of images is beyond the scope of this book, it is worthwhile briefly mentioning the lighting that may be used on a subject when it is known that it will subsequently undergo manipulation in a computer to combine it with other elements or backgrounds.

Techniques here might, for example, involve spilling some coloured light onto the subject as it is photographed, in the knowledge that once in the computer it will be combined with a background of that colour. In the final image it will appear as if the background light has spilled across the subject, even though they were actually produced separately.

Another technique would be to combine a foreground scene, photographed as a still life, with some background scene: a glass of wine, for example, photographed on a table in the studio, combined in a computer with an image of a restaurant and made to appear as if it is in the restaurant.

▲ Shot originally for the product review section of a yachting magazine, this image was taken knowing that later it would be cut out from its background and placed on the magazine page with text flowing around it. To facilitate this in-computer separation the product was placed close to a plain white background, raised a little above it on a small wooden block. Lighting consisted of a small softbox placed low to provide the main light and highlight on the top of the product. A mirror was placed opposite to provide fill, soften the main shadow and provide a secondary highlight. A second mirror provided the small highlight in the product's lens. *Bronica SQA, 150mm lens, ¹⁄₁₂₅ second, f/11, Kodachrome E100s.*

For this kind of combination to be believable, the lighting for the still-life set-up must mimic that in the image with which it is to be combined, with the lighting coming from the same angle, with the same intensity and with the same colour. Some of these features can, of course, be played with in the computer, but it is far safer to get the lighting right in the still-life shoot than trust to subsequent digital alterations.

For such combinations, it is common for the principal element in the still-life image to have to be cut out from its background; in this example, the glass of wine and the table on which it sits. So, while it is not too important what the background looks like (provided it does not put any colour casts into the subject), it must be quite clearly distinguishable from the main subject, making the cutting-out process straightforward. For this to be possible, it is common to have to insert flags and/or reflectors that are visible in shot – a process that goes against the grain for many photographers and that, although it may generate an ugly image, produces one from which the subject may be easily excised.

Index

Biographies

Nigel Hicks, an Associate of the prestigious British Institute of Professional Photography (BIPP), is a highly experienced and well known landscape, nature and travel photographer. Although today based in the southwest of England, he spent a number of years living and photographing in East Asia, and his projects and assignments continue to take him around the world, working for a variety of agencies, publishers and commercial clients. His vast wealth of experience with both outdoor and indoor photography, as well as with digital and film techniques, has made him uniquely qualified to write *The Photographer's Guide to Light*.

He has previously written and provided the photography for a number of books on the wildlife of China and the Philippines, as well as numerous travel books. This is his third book on photography. Portfolios of his work can be seen on his website at *www.nigelhicks.com*.

All text and photographs in this book are by Nigel Hicks, except for those listed below.

Contributing Photographers

Peter Phelan ABIPP is an award-winning and highly experienced commercial and editorial photographer, whose pictures have apeared in a wide range of media worldwide. Equally at home in the studio or on location, Peter's work covers a huge diversity of subjects important to the commercial world.

After 20 years as a professional photographer, Peter has now switched to working entirely digitally, his work now combining the best of traditional photographic techniques with modern digital imaging facilities. Further examples of Peter's work and details of his photographic courses can be found on his website, *www.peterphelan.com*.

Contributions: 9 (bottom), 16 (bottom), 128–9, 130 (right), 133–4, 137 (top), 138, 139 (bottom), 140–1

Bjorn Thomassen FBIPP has won many photographic awards including the accolade of being the BIPP International Fine Art Photographer of the year. Bjorn has a Fellowship in illustrative photography and specializes in contemporary portraiture. Examples of his work have featured in many of the UK's leading magazines and journals.

Bjorn has also become very popular as a speaker at both national and international courses and seminars and has also worked as a photographic tutor at Cornwall College. He is able to draw on his teaching skills as well as his many years of experience as a professional photographer.

Contributions: 9 (top), 16 (middle), 19 (top), 81, 84 (top), 85 (middle & bottom), 88–90, 92 (top), 95 (bottom), 96–8, 103, 105–7, 108 (top), 109, 114–5

Images on pages 100, 101 (middle right) and 102 were kindly provided by Swiss lighting manufacturer Elinchrom.